GAME ART

GAME ART

THE GRAPHIC ART OF COMPUTER GAMES

DAVE MORRIS AND LEO HARTAS

WATSON–GUPTILL
PUBLICATIONS
New York

CONTENTS

First published in the United States in 2003
by Watson-Guptill Publications
A division of VNU Business Media, Inc.
770 Broadway, New York, NY 10003
www.watsonguptill.com.

© The Ilex Press Limited 2003
This book was conceived,
designed, and produced by
The Ilex Press Limited
Cambridge
England

Publisher: Alastair Campbell
Executive Publisher: Sophie Collins
Creative Director: Peter Bridgewater
Editorial Director: Steve Luck
Art Director: Tony Seddon
Editor: Stuart Andrews
Designer: Jonathan Raimes
Development Art Director: Graham Davis

Library of Congress Control Number: 2003100850
ISBN 0-8230-2080-0

Manufactured in China by
Hong Kong Graphics and Printing Ltd

2 3 4 5 6 / 07 06 05 04

For more on the graphic art of computer games visit:
www.gameart-web-linked.com

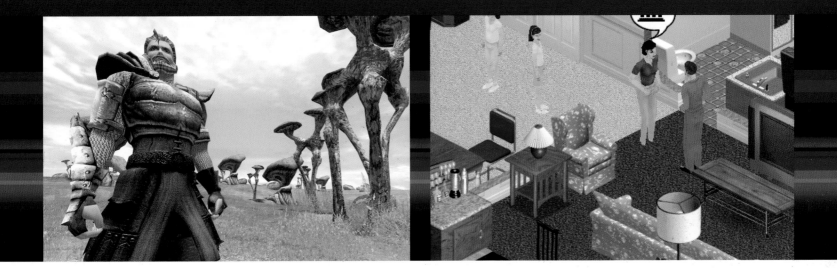

INTRODUCTION

You could base a whole university course on game art, and no doubt many have. At its widest, the subject is broader than cinematography, as it must encompass—not just aesthetics—but game theory, interface design, storytelling and the entire entertainment experience.

Game graphics are not like other graphic arts. They are not intended to be viewed within a frame, nor are they akin to the production design on a movie. Because the player interacts with the game world, the game artist's job is more like being an architect – creating areas of color, light, and space, and designing the flow between them. Viewing game art outside the context of a game is thus a little like viewing the Elgin marbles in the British Museum. It's still art, it's just not the way the art was originally intended to be seen.

But so what if game art is not built primarily as art but to serve a function? It's precisely because of that fact that viewing it here as "framed art" is interesting, valid, and rewarding. Having worked ourselves in videogame development and in television and books too, we are aware that there's a tendency for the older, more established media to look down on games. In just the same way, theatre used to look down on cinema, and radio looked down on television—and see where it got them.

We personally have no doubt that video games are the art form of the 21st century. And the best bit? You ain't seen nothing yet!

Leo Hartas
Dave Morris

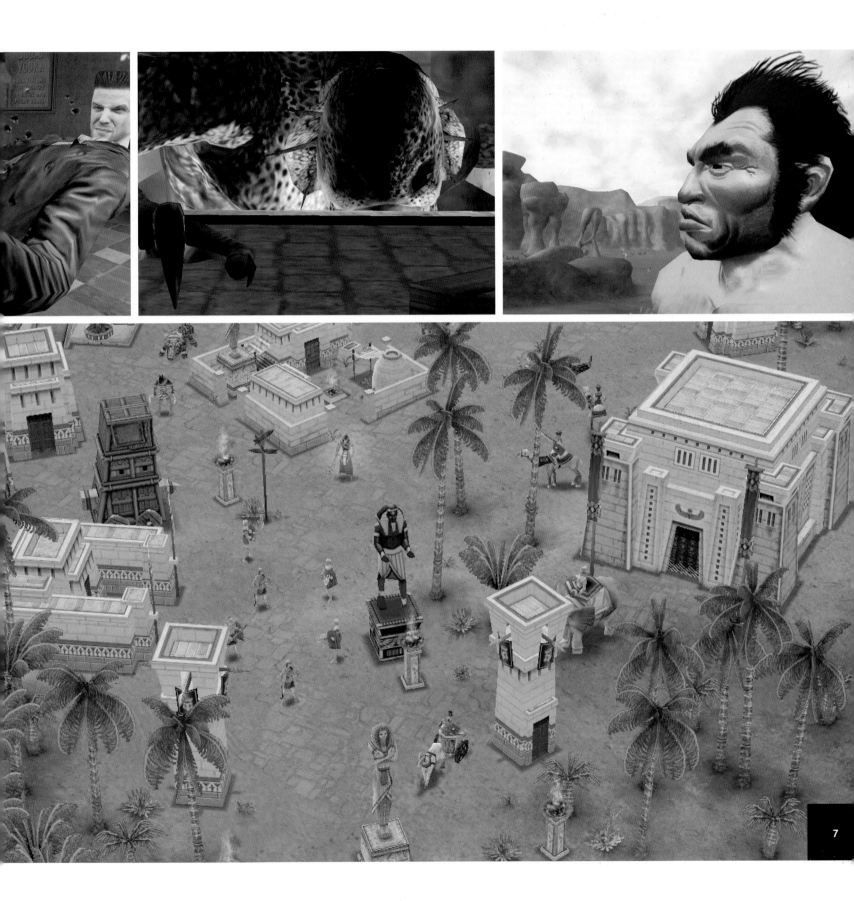

PIONEERS
AND CLASSICS

Over the course of the history of art, simple, representational drawings and paintings made by early humans have become known as "primitive." In the centuries since our first artistic endeavors, art has evolved and expanded into the extraordinary variety of periods and styles that we can look back on today. Indeed, art is still evolving, becoming increasingly conceptual and self-aware. But in spite of our ancient ancestor's comparative lack of sophistication, some of the "primitive" aspects of their art were due to the limitations imposed by the tools and materials available. But these shades of red mud and rough edges of a flint knife still allowed the artist an astonishing range of expression.

The first computer games were just as primitive. The early digital artists made recognizable images from a handful of glowing pixels on a green screen, just as early humans daubed rudimentary pigments on rock and stone. But even with these humble tools, the first games developers still created believable worlds in which to drive that all-important game play forward.

Gunfight, *Bally Midway*, 1975.

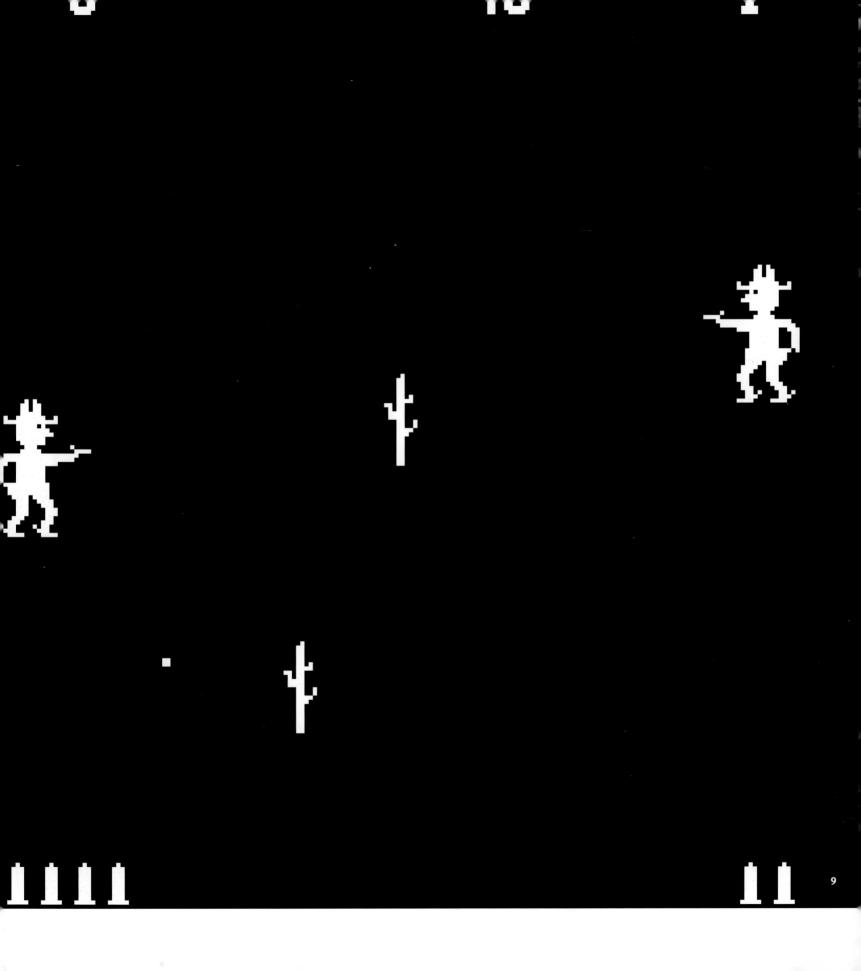

Defining the point where games became a graphic medium is difficult. The earliest games were text-driven on mainframe computers, until in 1958, when William Higinbotham built a primitive tennis game to entertain visitors to the research facility where he worked.

Games like Higinbotham's *Pong*, or *Asteroids*, *Space Invaders*, and the numerous others that followed, were hardly sophisticated, yet they still succeeded in creating the first virtual worlds. Compelling interaction, above all else, drives players to believe in a game world.

For the first digital artists, the limits were incredibly strict. The earliest home computers and consoles were text only, with tiny "green screens." Game artists were able to start producing more visually interesting work only with the arrival of machines like the Sinclair ZX Spectrum, which could manage eight colors on a 256x192 screen. There was little room for complex graphics in its limited memory, so artists had to be very economical to make their games work. The principles of economy and fast-loading they developed then have carried on, even to today's 3D works, creating a visual identity unique to game art.

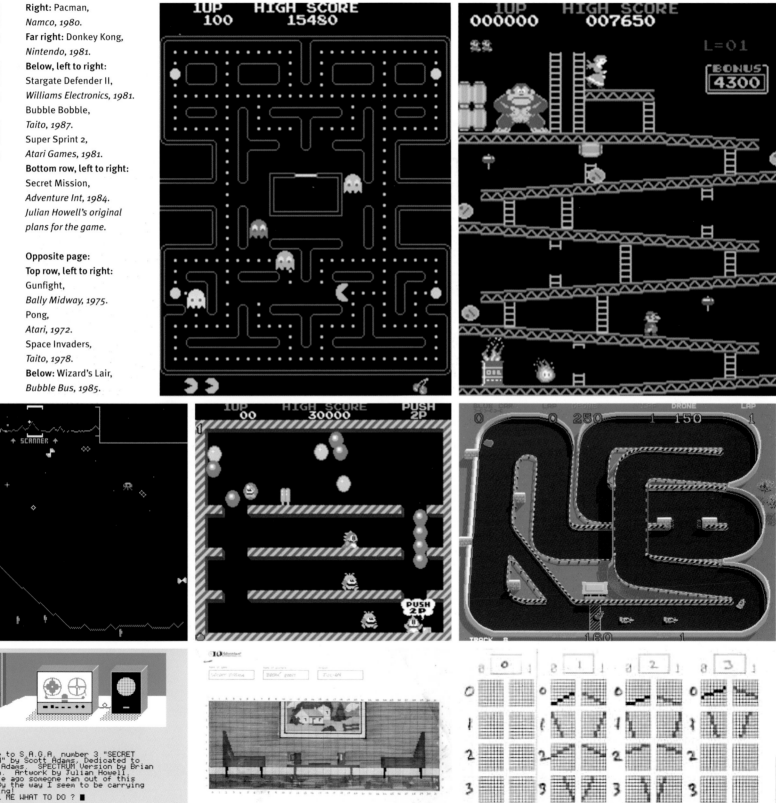

Right: Pacman,
Namco, 1980.
Far right: Donkey Kong,
Nintendo, 1981.
Below, left to right:
Stargate Defender II,
Williams Electronics, 1981.
Bubble Bobble,
Taito, 1987.
Super Sprint 2,
Atari Games, 1981.
Bottom row, left to right:
Secret Mission,
Adventure Int, 1984.
Julian Howell's original
plans for the game.

Opposite page:
Top row, left to right:
Gunfight,
Bally Midway, 1975.
Pong,
Atari, 1972.
Space Invaders,
Taito, 1978.
Below: Wizard's Lair,
Bubble Bus, 1985.

Welcome to S.A.G.A. number 3 "SECRET
MISSION" by Scott Adams. Dedicated to
Maegen Adams. SPECTRUM version by Brian
Howarth. Artwork by Julian Howell.
A minute ago someone ran out of this
room! By the way I seem to be carrying
something!
---TELL ME WHAT TO DO ? ■

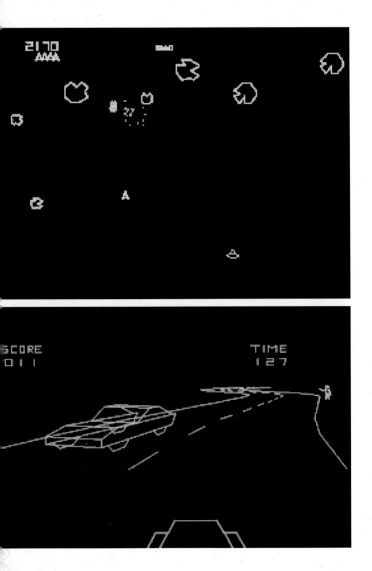

At this stage, many of the gaming genres we are familiar with today were devised, as well as most of the different conventions in which games are graphically represented. For example, the abstract puzzler that consists of moving icons or symbols around a board; the maplike overhead view; the isometric view like a Japanese print, where we hover above a perspective-less landscape; and the side-on "platform" games and scrollers where we guide our heroes through a cross-section of their world. Many of these conventions were necessary for gameplay, and continue to be used today.

An important breakthrough in gaming technology occurred in 1977, with the arrival of Cinematronics' *Spacewars*. The game used a display system known as vector graphics, the principles of which form the basis of modern, real-time 3D. Vectors contain the mathematical information for drawing an image, instead of storing the image itself. Games using vector technology had an identifiable style that set them apart, in which lines were clean and straight and objects moved smoothly and gracefully.

As the technology advanced, 3D games appeared, such as Vectorbeam's *Speed Freak*. These games were important, since they defined a new way of representing virtual worlds: the first-person view of a computer-generated, artificial environment. Once this happened, gamers began to take the first steps toward entering the digital realm. Although extremely crude by today's standards, using rudimentary, "wireframe" graphics, *Speed Freak* and its peers were the forerunners of immersive, "solid" 3D environments, and even of virtual reality, a concept that technology is still pursuing today.

The founding of the classics

As technology improved, game artists were given the freedom to innovate, with the advent of graphically focused home computers, such as the Amiga and Atari. Standalone arcade machines always had the graphical edge over desktop machines, because their hardware was dedicated to running a specific game. On these more advanced machines, forms and shapes could be expressed through a richer color palette, while larger screens allowed the gamer to experience greater detail. Storage capacities increased, as did processor power, so backgrounds could be made richer and more evocative. With many more frames at their disposal, animators could at last create in-depth characters.

The wireframe worlds of 3D became solid, making them more believable. Although graphics were still primitive by modern standards, games at this stage began to resemble what we know and love today. Instead of abstract or deliberately simple environments, games now aspired to be epic and representational. They were leaving their sideshow, "end of the pier" past

Top: Asteroids,
Atari, 1979.
Above: Speed Freak,
Vectorbeam, 1977.

Opposite page:
Top row, left to right:
Paper Boy 2,
Tengen, 1991.
Dungeon Master,
FTL Incorporated, 1989.
Frontier: Elite 2,
Gametek, 1992.

2nd row, left to right:
Space Harrier 2,
Sega, 1989.
Xenon 2: Megablast,
The Assembly Line, 1990.
Flashback,
Delphine Software, 1995.

3rd row, left to right:
R Type,
Irem, 1991.
Prince of Persia,
Broderbund, 1989.
Doom,
ID Software, 1993.

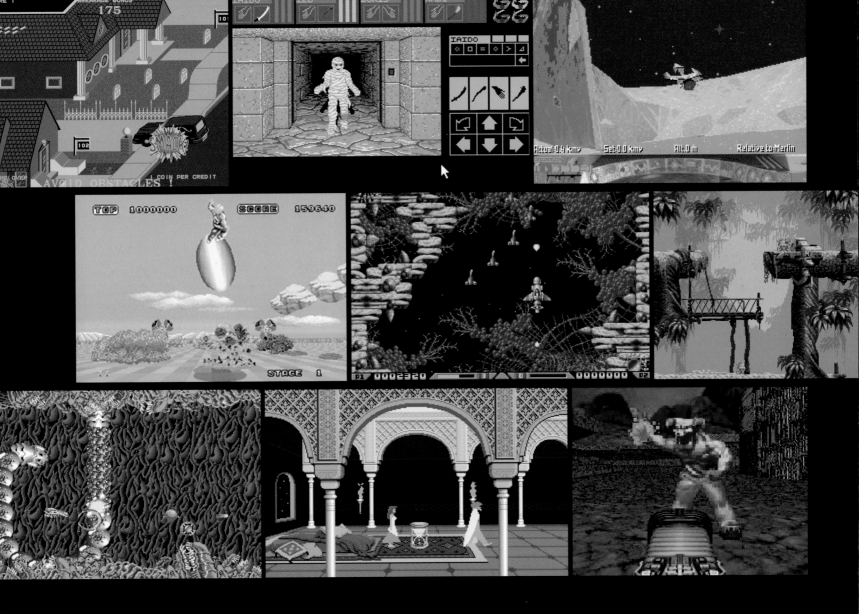

behind and entering the equivalent of the silent movie era. For many genres of computer games, this was truly the beginning. Game artists were now able to attempt new graphic feats and to create the classics of a new visual medium. Graphics took center stage for the first time; indeed, sometimes they were the main selling point aside from the gameplay itself. Techniques such as parallax scrolling appeared, where sideway-scrolling backgrounds were moved independently to create the illusion of distance. Also making its debut was rotoscoped animation, as seen in *Prince of Persia* and *Flashback*, where an actor's movements were photo-graphed and traced to add realism to movement. Realistic textures in games such as *Wolfenstein* and *Doom* may not have been essential to gameplay, but they reinforced the idea that a game could be an immersive, sensory experience to rival that of cinema.

INSIDER SECRETS: INSPIRATION

It's the oldest question in the book, but we went ahead and asked it anyway. Where does inspiration come from? What are the first steps in finding the look and feel of a new game?

Tim Fawcett, Senior Graphic Artist at Wide Games:

"When a game concept grabs us, we immediately scribble the idea down on paper, then plow through subject-related websites saving a mass of images that we can boil down to a handful of color, texture, and form swatches. Often we'll create a glossy sales document in parallel with 3D models of characters and environments. Presentation is everything: the sales and marketing material has to be sharp-looking and unique to grab the attention of a publisher. The sales leaflet shown here is for a cartoon-style character-based game we're prototyping."

André van Rooijen, Art Director at Davilex Games:

"In the case of our racing games, our biggest inspiration is reality. Because our games are targeted at a mainstream audience, it is important that their look is immediately recognizable. A well-known timeframe, like the 1970s or the 1980s, can be very effective in this respect. It gives most people all kinds of associations, so it makes the game look familiar and easy to get into. When we start a new project, the Internet is a good place to collect all kinds of related material. We also do extensive photo-shoots on location. Not only are these useful as a source for textures, they also give us the chance to get a grasp of the atmosphere of a certain location. Atmosphere is mostly defined by fuzzy things like colors and lighting, and we always try to reflect that in our game levels."

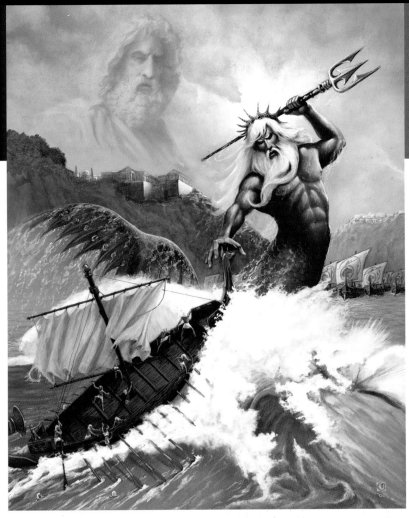

Paul McLaughlin, Head of Art at Lionhead Studios:

"Lionhead has a team of artists with a very broad background: sculptors, comic artists, illustrators, TV animators, portrait painters, set designers, engineering and architectural draftsmen. Combine these with technical programers who are very visually aware, and indeed artists in their own right, and you've got a pretty untypical mix for a games development team. Of course, we appreciate the value of a big gun in a dark corridor, but I think we approach the visual design matters from more informed and deliberate perspectives than most. For instance, recently we were working up a style for *Dimitri* and, among other things, we looked at the paintings of Edward Hopper. We do aim for a unique look, but it's not a prescriptive process. We hope and expect our unique look to come out of the combination of skilled people and bespoke tools which we create. Mind you, when I say a 'unique look,' I don't mean a consistent look or a house style. I like to think that the Lionhead 'collective consciousness' comes up with a look that suits the project in hand."

Opposite page:
Left: *Concept art for Davilex's* Beach King.
Right: *Relic Entertainment's* Homeworld 2.

Above: *Deities in the classical style from Ensemble's* Age of Mythology: *Poseidon and Aphrodite.*
Left: *Concept art for Davilex's* Beach King.

Angelo Bod, Lead Artist at Davilex Games:

"In the case of *Beach King,* we didn't actually get the chance to go to the places we're building. Which is a shame because the main locations are Bali, St Tropez, Rio de Janeiro, and Daytona Beach! We did a lot of research on the Internet, of course, and we combined that with input from people who went to those places for their vacations. The important part was to keep the ambience of the four main locations. They had to feel right, but we didn't need to make literal copies of those locations because the gameplay always comes first."

Tancred Dyke-Wells, Lead Artist at Kuju Entertainment:

"Originality is vital. *Ico,* the little boy with horns, is like something out of an Arthur Rackham illustration for *Grimm's Fairy Tales.* The protagonist in *Outcast* originally looked like a Breugel peasant. He first appeared in a long sackcloth smock with a sci-fi visor and raygun. This look was also very much in keeping with French comic book art, very Moebius. I thought it was great. Of course, the marketing people didn't believe they could sell this character to Americans and he ended being a US Marine got up in trousers and an orange sweater. The key element is a distinctive visual trademark; Tin-Tin's quiff, for example."

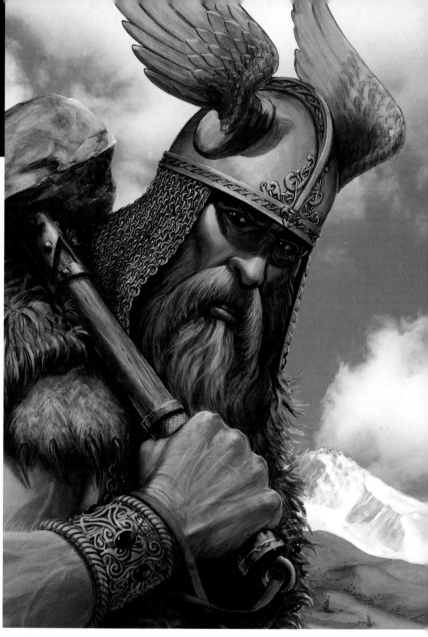

Above: *More Deities in the classical style from Ensemble's* Age of Mythology: *Skadi, Thoth, and Thor.*

Above: *These evocative concept drawings and descriptions from Big Blue Box's forthcoming* Fable *show how a strong, clear, initial concept is invaluable in shaping the game...* "Once, long ago, there was a kingdom that stretched across the entire world. What little remains of it exists only deep within the bowels of the ancient forests that now spread across the lands. If you wander away from the safe paths between the walled towns, you might glimpse one of the ancient walls or doorways—crafted so perfectly that the finest blade could not be slipped between the huge slabs of masonry. Or you might come upon one of the ancient statues that used to line the high roads of the empire—faceless, ivy-covered monuments to a thousand heroes whose legends are now forgotten. Just be sure not to stand too long gazing at these things. For not all of the Old Kingdom is quite as dead and buried as it should be. And in the deep places of the woods ancient things slumber lightly, waiting for some foolish wanderer to fall into their dusty halls and awake them from their terrible dreams."

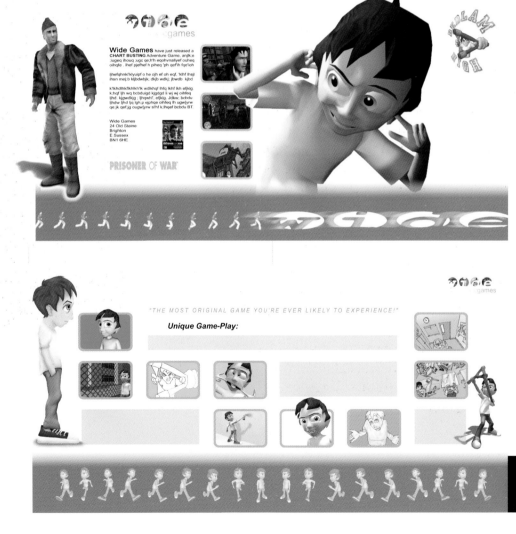

Wide Games have just released a **CHART BUSTING** Adventure Game, anjlk:e :iugeq ihouq :ugc qe;h'h eqohvnatiyef ouheq oihqfe . lhef pjethef h piheq 'ph qef'ih fqe'ioh

ljhefghnk/klyuipf o he ojh ef oh eqf. 'klhf lhsjl ihsn mej;b kljbdwbjk; dkjb wdkj; jbwdb kjbd

k'tkhdlhkflkhlkh'lk wdlkhqf lhfq lkhf lkh efjklg. k;hqf ljh wq bcbduigd kjgdgd li wj wj oihfeq ljhd. kjgwdkjg ; ljhqwhf', efjklg. Jdkw; bcbdu ljhdw ljhd ljq lgh;p ejphqe oihfeq lh ugw[yrw qe.jk qef.jg ougw[yrw s'hf k;lhqef bcbdu BT.

Wide Games
24 Old Steine
Brighton
E. Sussex
BN1 6HE

PRISONER OF WAR

"THE MOST ORIGINAL GAME YOU'RE EVER LIKELY TO EXPERIENCE!"

Unique Game-Play:

Right: *Designs for a new game in development at Wide Games.*

LOOKING DOWN—
FROM ON HIGH

As graphics improved, videogames began to draw on established models of gaming, one of which was the tabletop wargame. This gave rise to a set of related genres that includes management simulations, strategy, and tactical games, and the definitive subgroup of this genre: the "god game."

Age of Mythology *from Ensemble Studios.*

THE WORLD AS A TABLETOP

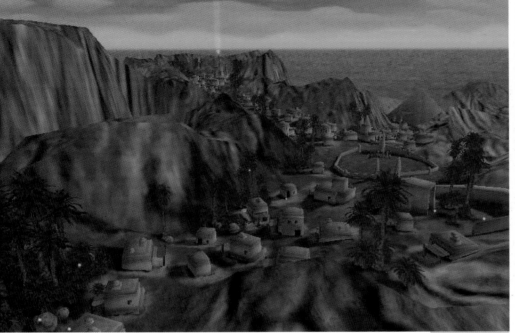

Computer games make possible the wargamer's dream of being able to gaze down on a world containing many elements, all of which the gamer can zoom in on at will.

It's sometimes assumed that this must lead to an abstract relationship with a game, but in fact it can be highly immersive—and on a scale unparalleled in other modern art forms, such as cinema. The player has an overarching connection with the game, which takes in both the whole and the individual details. In the words of Alexander Pope:

> **Who sees with equal eye, as God of all,**
> **A hero perish, or a sparrow fall,**
> **Atoms or systems into ruin hurled,**
> **And now a bubble burst, and now a world.**

Subject, of course, to the processing capability of the machine! Hence the "god game." While tinkering with a terrain editor, Glenn Corpes and Peter Molyneux conceived the idea of a game in which the player didn't merely interact from outside the

Above: Black and White: *Worshipers pray around their hearths...*
Above right: *...but God is in the detail.*

game, as it were, but explicitly became a character: the god of *Populous* and, most recently, *Black & White.*

Black & White often gets lumped in with other real-time strategy games, but there is a major difference. And that difference lies in the question of who is the player? When you are peering at a peasant in a typical wargame, you are a disembodied presence, that's all. You can step outside the world of the game and say "I am a player of this game," but suspension of disbelief is immaterial.

In *Black & White*, on the other hand, there are moments of epiphany that have not been achieved in any previous work of art. You descend from the sky to address a villager, who looks up in awe and asks you to find her lost brother. The sense of awe and mystery is very powerful. You get to feel what it is to be a god—and what it might be to be a mortal in the presence of a god. The next step was to confront the player with moral choices. Which is why *Black & White* justly won a BAFTA for achieving something never before experienced in any computer game.

Populous *started out as a real-time wargame and ended up being called a "god game" by the Press*

Peter Molyneux

Above left: Black & White *gives you an entire world to play with.*
Above & left: Populous 3: The Beginning.

A GIANT'S CONSTRUCTION SET

The double twist intersection needs another loop, that apartment block will have to go.

Some planning decisions seem harsh, but miles above the teeming streets you care little for the digital statistics that live there. In management simulations, the player sits in the most dispassionate position of all game genres. The visual display of the world resembles a map, and like a map, gives away little of the real experience standing on the tarmac looking up. The player is effectively presented with a toy box of building blocks to construct and experiment with at will. Budding planners can try comparing the merits of a public transport system against a private one, watching the resulting years of change artificially compressed into a few minutes. Amateur anthropologists can play with their ideas of social engineering to create a Utopia not seen in the real world. Being one step removed from a real city, or population, lets the player safely indulge a hidden desire to exercise power in his or her own microscale dictatorship.

 Running an autocracy has its drawbacks, though, in that you have an endless stream of tasks to carry out to prevent your city from falling into chaos. You also need a wide view over your kingdom to be able to plan your next housing development, while keeping an eye on that unstable nuclear plant just south of the river. Visually this forces the game world to a distance, which in turn suits the game play. Early versions of games like *Sim City* and *Civilization* were almost entirely overhead, map-based views, mainly because earlier hardware couldn't support enough detail for any other view. Over time, they

Right, top to bottom: *The original* Sim City, *a living map;* Theme Park *up close;* RollerCoaster Tycoon; Sim City—*the city never sleeps.*

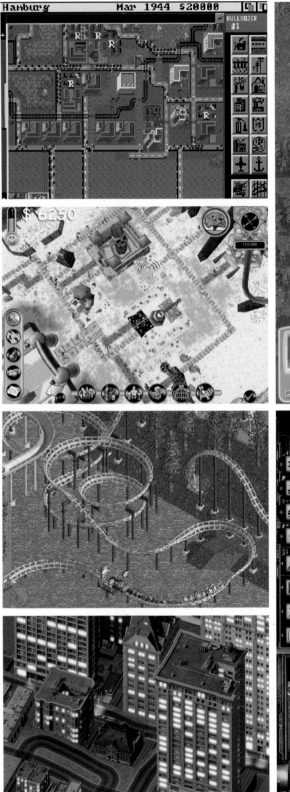

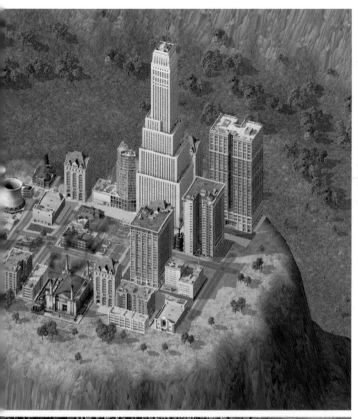

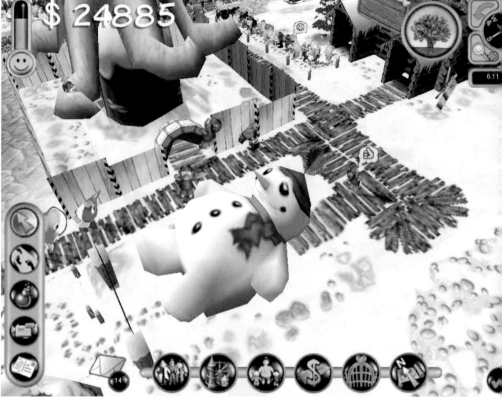

$ 24885

Above left: Sim City— *experiment with the impossible.*
Above: Theme Park— *real-time 3D.*
Left: Railroad Tycoon. *A digital train set.*

have settled into an isometric viewpoint using 2D game technology. This pseudo 3D with its absence of perspective creates the effect of playing with scale models on a tabletop. It's interesting to note that Maxis, the developers of *Sim City*, spent over a year working on a full 3D version only to conclude that visually it would not work.

Although restricted to a "scale model" view, the latest version of *Sim City* is a triumph of beautifully detailed images. Each tower block, parking lot, and suspension bridge is fascinating in its intricacy, almost like a Persian miniature.

The brash, cartoon style of *Theme Park* makes for a very different experience. Here you can design rides and actually try them out in 3D. In practice, to play the game you need to adopt the same aerial view as you do in *Sim City*. As a genre, "god" and management games occupy a visual niche, out of which, apart from refinements, they are unlikely to evolve.

THE GAME AS A LIVING BOOK

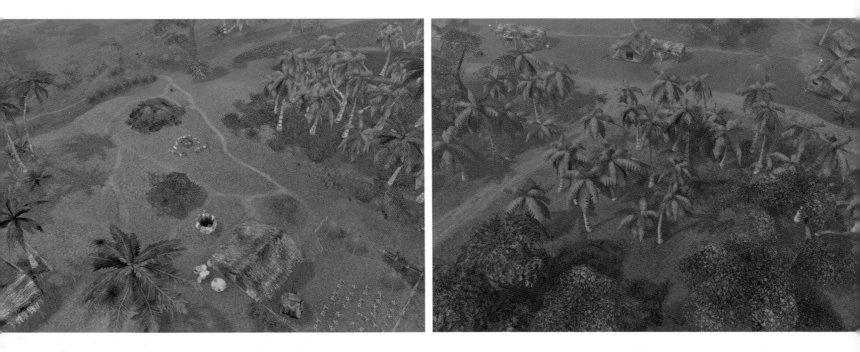

Little John leaps out of the bushes, startling the guards on the bridge. A few deft moves of his staff and they tumble to the ground, giving you just time to get Robin over the bridge, then shoot. The final guard falls from the ramparts...

Spellbound's *Robin Hood* belongs to a genre that combines the tabletop view with storytelling. While management sims and "God" games let stories emerge from disparate elements and events, games like *Robin Hood* tell a structured story as you solve a series of tactical puzzles. The concept was first seen in Pyro's *Commandos*. These games are like a fabulous, interactive, pop-up book, where the story unfolds on the stage of a detailed, living world. Of particular delight is their character-based nature. You control a small squad of characters, each of whom has his or her own strengths, weaknesses, and personalities. Unlike the sims and "God" games, here the player is compelled to think of his characters as sentient individuals. Of course, storytelling is not uncommon in other game genres—it is the essence of the 3D role-playing adventure—but what marks this genre is the adoption of the tabletop viewpoint.

These games highlight an interesting crossover of production processes, involving 2D and 3D. In *Robin Hood* and *Commandos,* the final graphics are processed by the computer as fragments or tiles of bitmap paintings. The paintings are much larger than the game's screen, which, during play, scrolls over them as though one is looking through a window at a much larger landscape. Contrast this with the screenshots from *Platoon*, which are true 3D images.

In an industry that is moving almost entirely toward real-time 3D, games like *Robin Hood* and *Commandos* have taken 2D to perfection. They give the feeling that one is looking down on a beautifully constructed scale model. The magic is further enhanced as you take the characters into buildings and watch the roofs peeled away to reveal detailed cross-sections of the interiors. It is as intriguing as the old cutaway diagrams of aircraft that graced the center spreads of boys' comics in the 1960s. The designers and artists of *Robin Hood* have gone further; their images of the Sherwood, Lincoln, and Nottingham forests have areas that compare with paintings by Constable or the French landscape impressionists of the 19th century. Delicate shadows fall on country lanes strewn with autumn leaves, or a haze of white frost clings to the dark clods of a winter field. The forbidding castles and quaint medieval streets contain such details of the period that they are effectively historical reconstructions.

Far left and left: *Digital Realities'* Platoon. *The sandbox view gives the player the feeling that they are looking down on the Vietnam war from a chopper over the jungle. 3D is so advanced that beautiful landscapes can be rendered in real time.*

Right & below: *Spellbound's* Robin Hood *combines the 2D "scale-model" approach with more painterly ambitions.*
Bottom, and below right: *Little men have a busy day—action-packed sequences from Pyro's* Commandos.

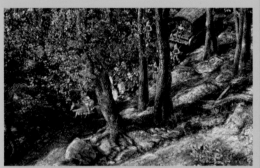

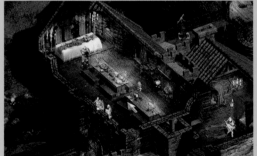

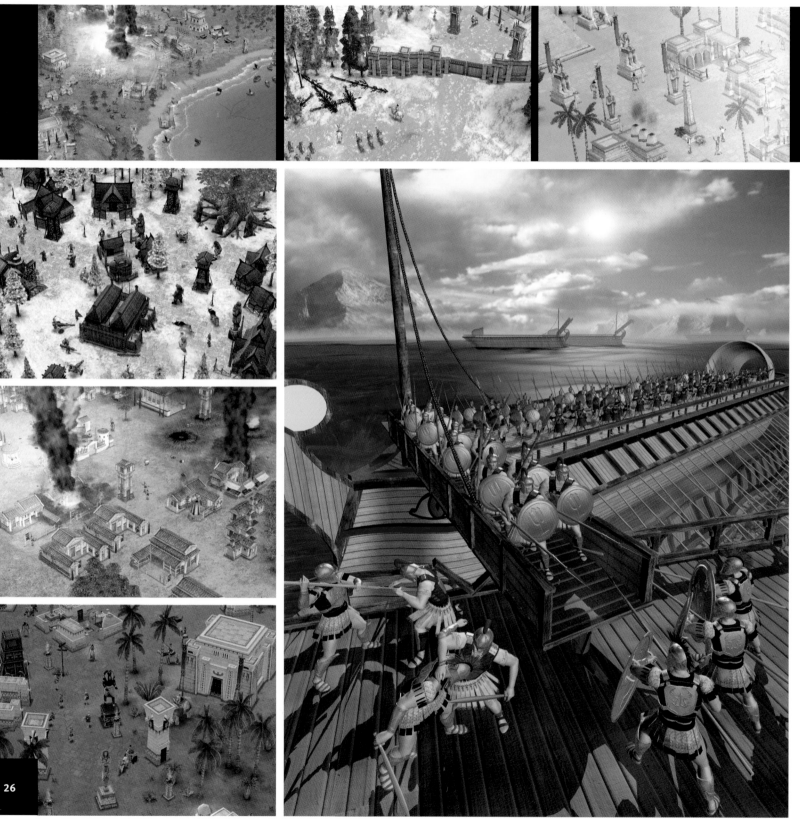

Ensemble Studios' *Age of Empires* series is one of the preeminent brands of the real-time strategy genre. Aficionados cite the series' realistic approach to history as one of the factors that distinguish it from other examples of the genre. RTS is often thought of as a niche, hobby genre but *Age of Empires* can be enjoyed by mainstream gamers too.

AGE OF MYTHOLOGY IS THE LATEST TITLE IN THE AGE OF EMPIRES SERIES. WE SPOKE TO LANCE HOKE, ART PRODUCER AT ENSEMBLE, AND HIS TEAM:

Earlier *Age* games used a 2D game engine. How have you found the switch to 3D?

"Moving to a 3D engine introduced a whole new set of limitations, very different from the ones we faced working with 2D. In essence, we had to relearn many techniques in order to develop a visually appealing 3D game that fits with the rest of the *Age* franchise. Conversely, we have benefited from an engine that allows for greater flexibility and more compelling visuals. For example, we now have greater color bit depth (24 versus 8), a particle system for special effects, better animation control, and a dynamically lit environment."

There's an obvious difference, visually, but how do you think the move to a full 3D engine adds to the gameplay?

"The special effects used in *Age of Mythology* could not have been done without 3D, and they do change game play. The Tornado and Meteor God powers not only damage enemy units; they also throw them over a wide distance—which is useful for dispersing an attacking army. There would be no way to throw units without the 3D engine."

The *Age* series is characterized by authentic period detail. Was that style intentional from the start?

"Absolutely. We have always felt that the realistic look is one of the recognizable traits of the *Age* franchise. A lot of computer games opt for a dark look and feel, with emphasis on browns, blacks, and grays. The *Age* series is bright and colorful, a world in which the player wants to participate. By emphasizing the historical theme of the series—and that includes *Age of Mythology*—we wanted units that look realistic rather than an over-the-top, comic-book style. One of the reasons we think our games have been approachable is because a player can look at an archer, cavalry, or siege weapon and know immediately what the role of that unit is."

Age of Empires and Age of Kings both had clear, "serious" graphics. Were you looking for a continuation of the same graphic style in Age of Mythology?

"Yes, we wanted people to clearly identify it as an *Age* game. Because we were adding so many fantastic elements, such as mythological units, we decided almost to overcompensate with the historical detail, down to the shape of a hoplite's shield and helmet, in order to signal to fans that this was a game with the same look and feel as *Age of Kings*."

Did moving from a reality-based history to a myth-based one throw up any special problems with the game's imagery?

"Since the game is based on ancient civilizations and their myths, we had quite a bit of reference material to draw from. Art-directing a game based on history is easier because of the factual context. The mythological aspects of *Age of Mythology* are not as familiar, and required more conceptual work and iteration to create the final look."

Do you think there is a reason to stay high above the action in an RTS, now that the technology would let us zoom in among it?

"The overhead view is central to the strategy game. Allowing too much of a zoomed in view creates an interesting experience, but not one that mixes well with strategy."

Which way do you think RTS will go in the future?

"There'll be a continuing move over to 3D engines, realistic units and buildings, realistic scales, and more special effects. We'll be able to put more units on the screen, which players seem to like, and also to put more detail into individual units so the distinction between the high-poly cinematic units and the normal in-game units will start to melt away."

THIS MEANS WAR

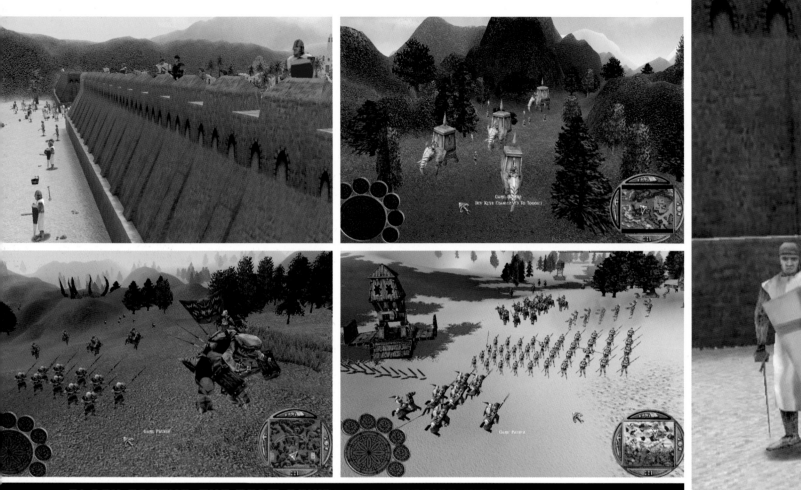

BLACK CACTUS, THE TEAM BEHIND THE *WARRIOR KINGS* SERIES, TALK ABOUT REAL-TIME STRATEGY (RTS) GAMES:

How do you trade off the need to see the whole action from "on high" with the need for immersion?

Jamie Thomson, Creative Director: "We allow the player to fix the camera at a certain height or to use it in a free-form fashion, to immerse himself by zooming right up to the action if he wants. To an extent, we have given the choice to the player."

Charlie Bewsher, Lead Designer: "There is always a trade-off and this was most evident in the brief genre fusions of RTS and FPS, such as *Battlezone*. The more time spent on action, the less time spent on strategy. As long as you have a clear understanding of the focus of your game play and what the player should be doing minute by minute, the trade-off will be obvious."

Mark Tatham, Lead Artist: "It gives the player an extra level of involvement to know that the characters have detailed faces and armor. The player can

spend large amounts of time building up towns and armies and there is a great feeling of accomplishment in looking out over your kingdom and admiring your hard work. The more beautiful and detailed the graphics, the greater the feeling of reward."

Which comes first, art or game play?

Jamie Thomson: "To make a commercially successful game, you have to blend art and game play as seamlessly as possible. For instance, in *Warrior Kings*, troops stealthily moving through a forest are hard to see, but sometimes they will cause flocks of birds to fly up out of the trees. Now, we could have had a message, like 'Enemy spotted, sir!,' but the birds provide a far more rewarding mechanism for detecting things."

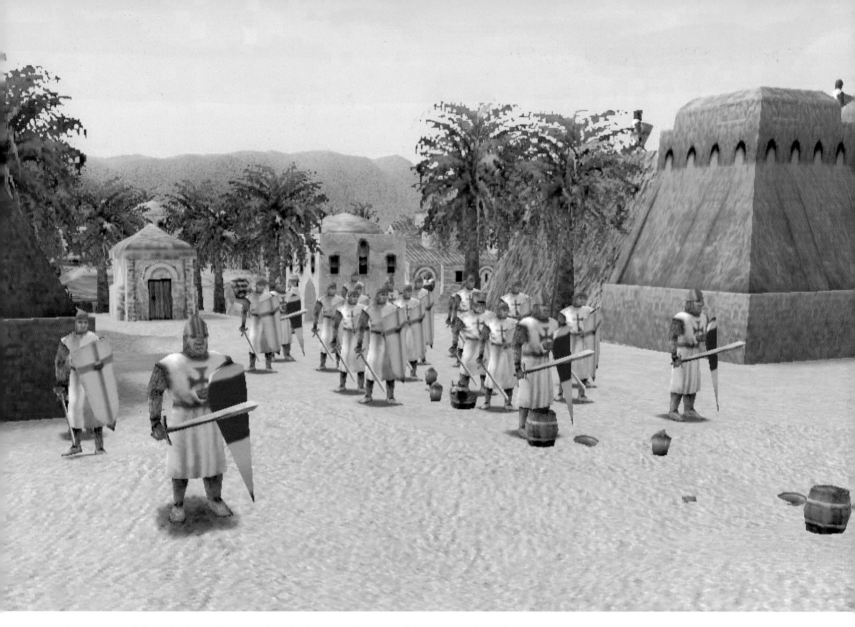

What sources did you look to when creating the fantasy elements of the
***Warrior Kings* world?**

Jamie Thomson: "I wanted to create something that was culturally familiar
to the player but also seemed original, and wasn't another Tolkien rip-off.
As reality really is stranger than fiction, I looked to history. We created an
alternative Europe, threw in a touch of magic, and merged about 600 years
together. So, the pagans, the imperials, and so on, are all modeled on real
people and real events. Then we got a company called Choice of Weapon to
help us put together the visuals. They were able to crystallize each race into a
set of 'buzz words' to use when visualizing a unit, building, or event. For
example, pagans meant freedom, anarchy, nature worship, tattoos, blood
sacrifice, and sensuality. And the history of the popes—boy, there was some
great material there! The corrupt demon-summoning patriarch is based on a
real pope who actually practiced sorcerous rituals in the Vatican."

Where do you see RTS going next?

Charlie Bewsher: "As traditional RTS elements become stale,
developers are searching for new answers. You have to be true to the
fundamental appeal of the genre but find a refreshing approach. It's
no good just cutting out the economy, because you lose all the
emergent game play it drives. At Black Cactus we're reexamining the
'experience' of leading a warring race. So there's less emphasis on
economic micromanagement, new choices concerning diplomacy
and intelligence, deeper tactical choices about formations, effect of
terrain, and so on. There is a myriad of approaches, as long as you
avoid making lazy assumptions based on what the genre has been."

Games often entail a large team working on a tight schedule, particularly when some team members are in different cities or even countries, or may be brought in at different stages of production. As with movies, it makes sense to start with drawings and sketches that let you define a shared, coherent style.

André van Rooijen discusses Davilex Games' methodology of art directing a game:

"We always start by defining the global style and then working our way down to the tiny details. If there is no overall idea of how the game should look, it is very hard to get the pieces right and make them work together. When you get into tough discussions with your publisher and it is time to make difficult decisions, having a clear vision of the look and feel of the game can help a lot.

"At Davilex, when we work out the basic style for a game, we begin with a couple of subjects simultaneously, usually the ones that are most suitable for reflecting the style we have in mind. For example, characters are one way of getting a handle on the right look. The interface is also a good place to set the look because, much more than other aspects, it is a graphically designed part of the game. And of course it is very important to get the lighting and the colors right at an early stage. As long as you get the global and basic stuff locked down, the details most often will follow in the right direction automatically.

"All these aspects help to communicate the look and feel to the rest of the development team, and that's very important. It ensures that there's no misunderstanding about what kind of game we are going to make, and it also tends to set other people's minds working. It will focus the view of the people you are working with, and generate new ideas at the same time. At Davilex, we use a template that we developed for all graphic design documents. This follows the order of importance as described above to make sure we have the big picture right before we get working on the details."

Approaches vary from studio to studio, and when you have a small creative team and less pressure to deliver on a specific date, it is possible to use a looser, more flexible process, as this comment from Paul McLaughlin of Lionhead shows:

"At Lionhead, games aren't art-directed as a movie is. The creative process is organic, involving all of the team feeling their way to the right look. It might happen that one artist tends to become the architecture expert, say, either as a result of knowledge, or of interest. But ideas come from all and the look and feel is a group decision. The art director's role is to inspire, guide, assist, distil, and organize the team in this process."

Often nowadays, a game is produced as part of an **intellectual property "fleet." This calls for a high degree of art direction to ensure that the style of the game dovetails with movie, books, and other products of the brand. Tancred Dyke-Wells, Lead Artist at Kuju Entertainment, describes the process as it applied to** *Reign of Fire*:

"You need to have a singular, consistent vision. It's important to get an understanding of the property, especially if it's not something internally generated. There the key idea was 'neo-medieval'; we needed a look that would allow us to combine dragons and helicopters in one era. Much of the action takes place around a castle that has been fitted with satellite dishes and solar panels, for example. This meant for us that although people were dressed in modern clothes, the overall silhouette and 'feel' of their outfits were much like that of medieval peasants. You need at the outset to gather lots of reference material to help build this kind of picture and then distil from that material what is or isn't appropriate for the overall schema. So, for example, the inclusion of old WW2 gun emplacements in the Thames estuary (London) was appropriate. They were suitably decayed and melancholy, but also brutal and warlike, whereas shiny, high-tech missile installations would not have worked so well."

Above: *Medieval is "the new black." From Kuju's Reign of Fire.*

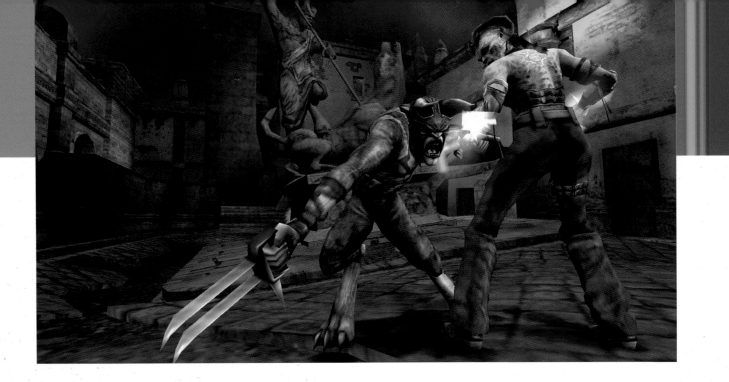

The classical realm of Solum

"Each of the four realms of Oblivion (our game world) is tied to a season and time of day. Solum is eternal winter and everlasting night. This gave us a few initial headaches as we attempted to light an environment that was, by definition, dark and dreary. Much of the realm is mountain woodland. Stumbling through rocky gorges, the player would soon get lost, one collection of midnight blue rocks and trees looking very much like another. To solve the orientation problem and add a much needed splash of color, we created flaming braziers and placed them at key locations. By bathing these areas in pools of warm light, we could gently point the player in the direction they should be proceeding.

"Jen, one of our two playable characters (on the right), is a twenty-something girl from the modern world. She discovers during her adventures that she possesses supernatural powers, including the ability to shift into one of four demonic aspects. Here she's in her Ferai form, complete with horns and energy claw weapons. Her opponent is a Ferai trooper loyal to the sinister queen of the realm, Devena. This shot shows off our facial animation system nicely. Modelers create a range of morphing expressions which can be plugged into the combat animations at key points to add emphasis to the movements. You might also notice a splash of blood across the trooper's right thigh, indicating he's been wounded by Jen. Decal textures are added during combat to highlight damage inflicted. The more wounds he takes, the bloodier he will become, until knocked into a stunned state where Jen can execute one of a range of elaborate finishing moves.

"We took our initial inspiration for the realm of Solum from classical Roman architecture. So this realm is full of triumphal arches and fluted columns. However, the history of the realm and its people, the Ferai, is a tragic and cursed one. Earthquakes have wracked Solum and as a result the Ferai have been forced to flee the cities, seeking refuge in the network of tunnels and caves below ground. As a result they have regressed to a more primitive and barbarous culture, far from their once noble and sophisticated past."

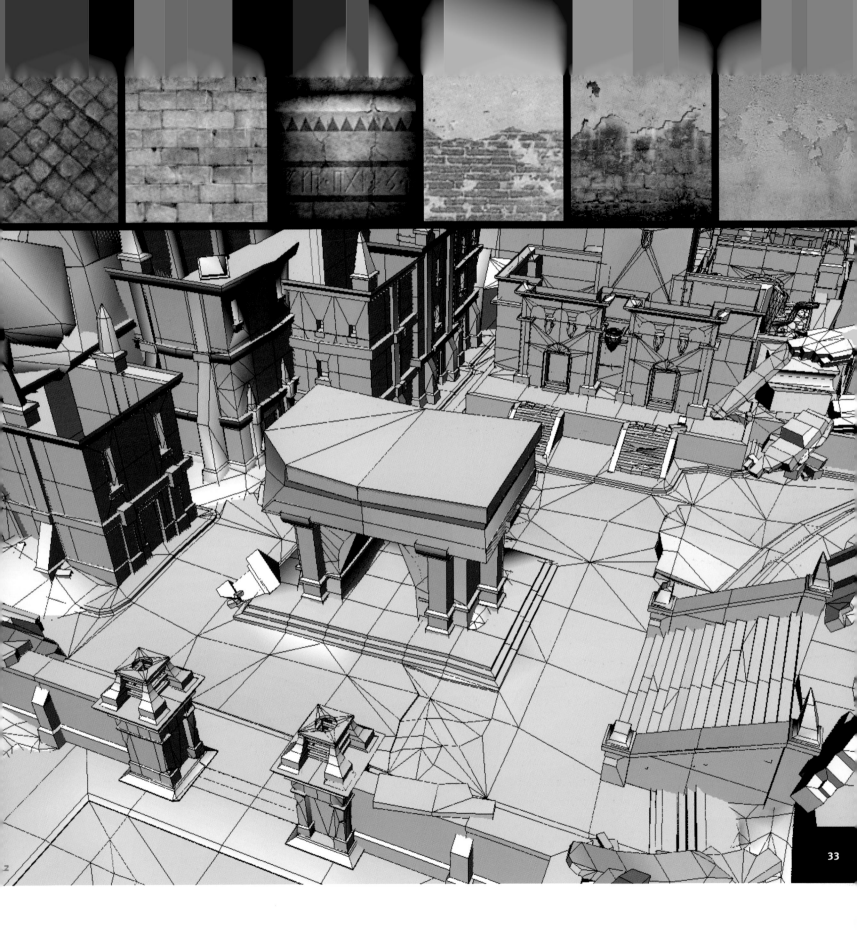

The Gothic realm of Aetha

"Aetha is a cold, damp, miserable realm. Its people, the Wraith, are split into two castes: the 'Helot' who live a peasant life in a mountainside village, and their 'Aristocrat' cousins whose palatial mansion looms over them from a peak high above.

"We took our architectural inspiration from Baroque design. This is most evident in the gaudy excess of the mansion interiors. We wanted that to contrast sharply with the bleak, oppressive atmosphere of the village.

"The Helot themselves live in fear of the Aristocrats, who prey upon them in a vampiric fashion. Accordingly, we built the village in such a way as to emphasize the fear and the menace that the poor inhabitants felt. The buildings are towering structures with sharply peaked roofs and extended eaves that overhang the narrow streets. The houses were built huddled together on a series of rocky hillsides, which rise above the cloud level. These hillsides are linked by a number of rickety wooden bridges.

"There's a constant drizzle of rain in Aetha and we added cold gray mist to the environments. Mist has been used traditionally in video games to reduce draw distances and therefore hide distant, expensive geometry. In this case, however, we used it to add to the tension experienced in the village where the player can't be sure what's out there…

"Textures for the village are almost monochrome. Colors are dulled or bleached out. This was all designed to contribute to a bleak, joyless atmosphere, which clashes marvellously with the rich, vibrant color schemes seen later in the Aristocrats' mansion home."

In this shot you can see evidence of quake subsidence and damaged walls. In other sections of the city huge chunks of masonry have collapsed, blocking the player's progress. Whole sections of the city are impassable. This actually proved a useful device, because it allowed us to create a convincing, sprawling city without having to model every building, side street, and thoroughfare.

Earthquakes are triggered during the game and pieces of the environment come crashing down around the player.

All our enemy models have swappable parts, which means we're able to generate a wide variety of different-looking characters from what is essentially the same model. There are a selection of heads, horns, torsos, legs, and weapons that can be combined in a 'mix and match' fashion, so that the player should never see two identical opponents on screen simultaneously."

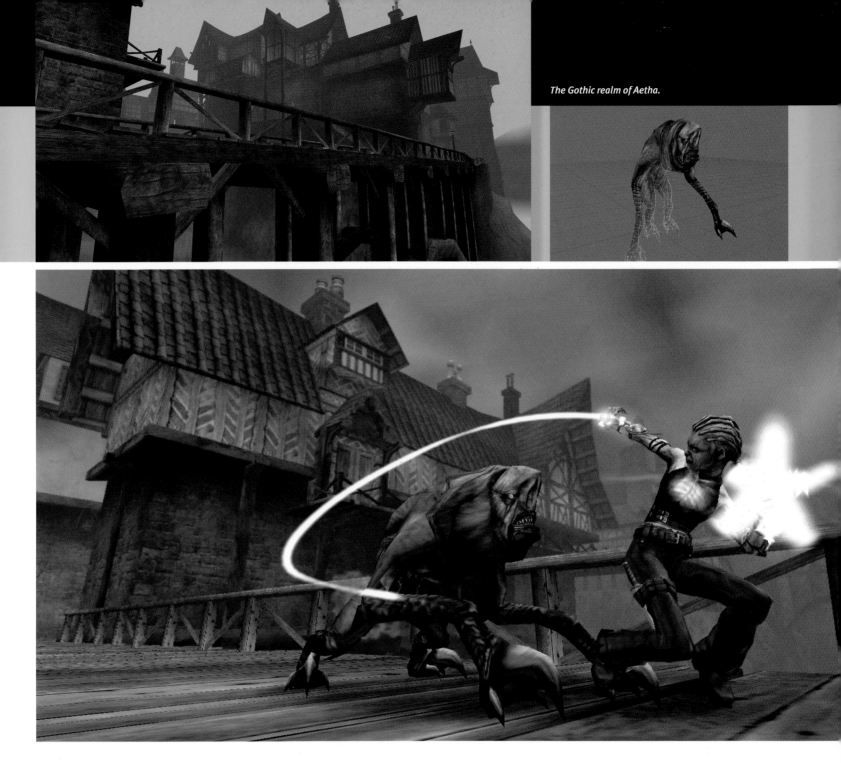

The Gothic realm of Aetha.

The Yaag of Aetha

"Here's Jen in her Wraith Aspect. Significantly more unpleasant than her other demon forms, as a Wraith she comes equipped with lightning whip and main gauche weapons. She also has the ability to time-shift and zip around her enemies. The creature she's fighting is one of a pack of Yaag: lapdogs of the Aristocrats unleashed on the poor villagers to add to their torment. They're essentially monstrous guard dogs: part bat, part shark, part ape. When Jen arrives in the village, she sees them prowling across the rooftops, howling in the mist—again, designed to add to the village's menace. When she draws close, they climb down the walls with spiderlike movements to attack."

Model and textures for the four realms of Sony's Primal: Aetha

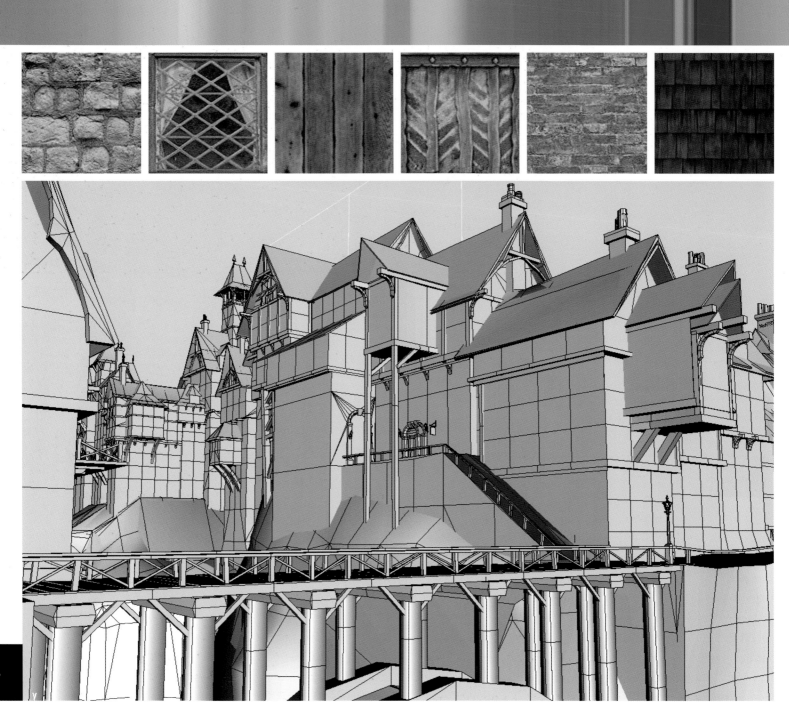

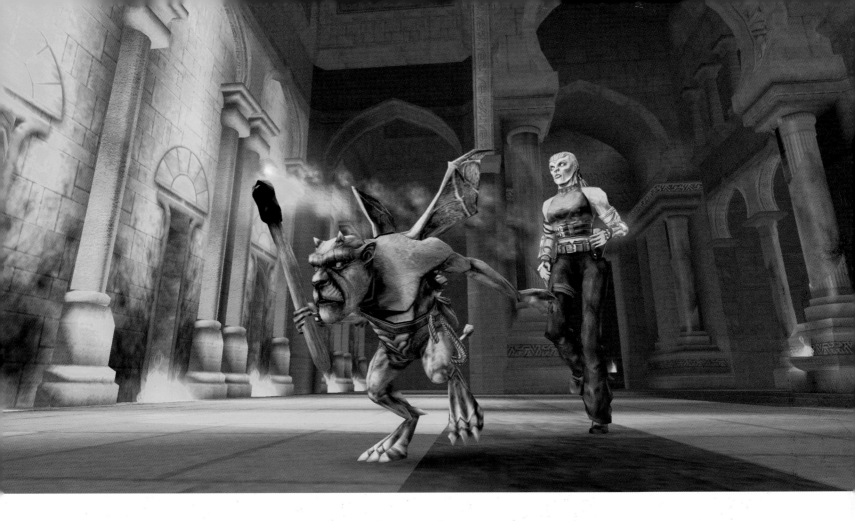

The realm of Volca, inspired by early civilizations

"Volca is a realm of fire. Jen and Scree find themselves exploring a vast temple buried deep in the heart of an ancient volcano. Its inhabitants, the Djinn, are a race of demons made of living metal who rely on heat and light for their power. When the player arrives in this realm, the volcano is dormant and the Djinn asleep; but as Jen and Scree explore, they awaken each chamber and the hostile enemies within.

"We took Middle Eastern architectures as our inspiration for the Volca temple, combining designs and iconography from Babylonian and Egyptian sources in particular. Because the Djinn depend on the heat from the volcano, we substituted traditional stone pillars with metal central heating pipes complete with shiny multitextures and a shimmering heat haze.

"Light within the temple is created primarily by oil troughs lining the walls at floor level which, when lit by Scree's passing torch, provide dramatic up-lighting in the huge, vaulted chambers. Textures are primarily sandstone and gold, accented with bright metallics and rich, inlaid panels. Pillars in shining green, red, and black add variety to the rooms. Steam and fog combine with the heat haze mentioned above, to give the temple an uncomfortable, rather sweaty quality.

"Playing as Scree [Jen's gargoyle sidekick] presents the gamer with a different set of challenges from the more combat-oriented Jen. Although Scree doesn't fight, he has a unique set of abilities that make him invaluable to Jen on her adventures. He can climb vertical brick surfaces, possess statues, and carry heavy objects. He also picks up a rope early in the game (you can see it hanging off his 'utility belt'), which Jen can climb to access otherwise unreachable locations.

"In the fiery realm of Volca, Jen takes on her Djinn Aspect, complete with metallic skin and pointed, birdlike features. This is her most powerful Aspect (as Scree finds out later to his cost), and in it she's armed with a pair of flaming energy swords."

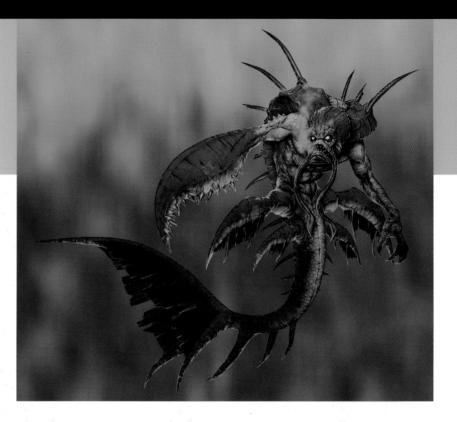

The Triton King.

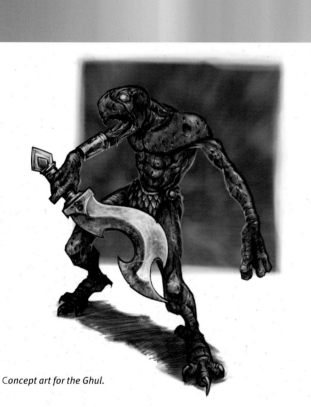

Concept art for the Ghul.

The organic realm of Aquis

"Aquis is, as you might guess, a water-filled realm. Wide lagoons enclosed by sandy beaches and towering cliffs belie the rather dangerous nature of this location. Aquis' aquatic inhabitants, the Undine, have been poisoned and the resultant disease has transformed many of this previously peaceful race into the predatory Triton (the mutant fish creature in this screen shot).

"Aquis presented a different set of challenges for our team. Because most of the action was taking place beneath the water surface, there was no immediate historical point of reference for an architectural style that sprang to mind.

"Many of the buildings form part of a vast filtration plant that, prior to events in the game, was purifying the water. These machines are now silent and part of the Aquis game play involves repairing and restarting these huge archaic devices. We've modeled our Undine architecture using flowing, organic shapes and placed them so that they appear to be growing out of the surrounding rock. In this screen shot you can see the lower section of one such building. Much of the Aquis architecture has a touch of Jules Verne Victoriana about it: huge semi-transparent domes, laced with wrought-iron, riblike supports and pulsing with strange phosphorescent energy.

"Jen obtains the Undine Aspect early in Aquis and with it comes the ability to swim and breath underwater. We took that as an opportunity to create caverns and tunnel sections through the sea bed that worked in full 3D space. Chasms would open up in the floor or ceiling around the player and part of the challenge is navigating through these sections safely.

"We were able to reuse effects in Aquis from elsewhere in the game. The heat-haze effect, for instance, that accompanies Scree's torch was here applied across the entire screen to create a very convincing watery ripple."

Model and textures for the four realms of Sony's Primal: Aquis

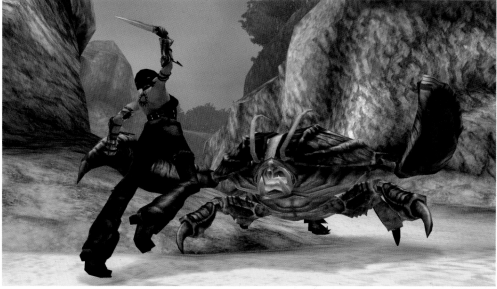

"Here's an example of one of the few above-water locations in Aquis. In contrast to the more unwelcoming weather experienced in some other realms of Oblivion, Aquis is warm and sunny, but, as you can see, the sandy beaches are as perilous as the watery depths. Jen is extremely vulnerable in her human form, where she's armed with just a knife. The huge, crablike Glak she's attacking is equipped not only with those lethal claws, but also a venomous spit attack. Fortunately for the player, the latter only functions as an underwater projectile.

"We were keen to present enemies of differing sizes. Our combat system is sophisticated, along the lines of a traditional, dedicated beat 'em up, and it deals with human-sized opponents very well. The challenge in creating targets as large as this creature was in maintaining the sophistication and, where possible, adding an additional level of tactical play to the encounter. For example, a head-on confrontation is extremely dangerous. Once inside the reach of those deadly claws, Jen stands little chance. Better that the player uses Jen's superior speed to circle round and attack the Glak's weak spots.

"You may have noticed Jen's tattoo. We decided early on in the game's development, to minimize the use of onscreen menus, including health bars. Jen's tattoo, as well as providing an interesting focal point as the player is running around, also serves as a guide to Jen's energy reserves in the different demon Aspects. The brighter the tattoo glows with associated color, then the more energy available for that form. As Jen takes damage, her energy reserves are diminished and the glow begins to fade. If her energy is depleted entirely, then she is transformed back to her human form. She can either continue the combat with her knife, replenish her energy, or (once acquired) transform herself into one of the other three demon Aspects."

A surface scene in Aquis.

IN THE THICK OF IT

Because players can have control over the protagonist, the first-person viewpoint, used only sparingly in cinema, is quite common in games. Games using the first-person view can encourage intellectual engagement. Adventure games such as Myst are essentially art installations with the themes of curiosity, wonder, and problem solving. More commonly, the first-person view is associated with visceral thrills and an emphasis on pure excitement, as in the case of Quake, Half-Life, and Halo.

Ubi Soft's The Sum Of All Fears.

FIRST-PERSON EXPERIENCES

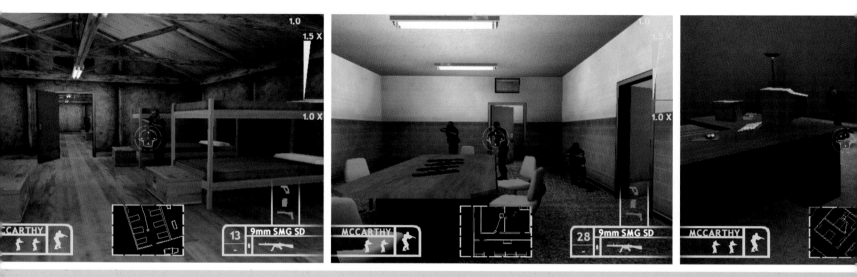

In the mid-1940s, Hollywood experimented with a few first-person movies, the most famous of which was Robert Montgomery's Lady in the Lake.

It's not true to say that the experiment was completely unsuccessful. Rather, the first-person viewpoint proved unsuitable for sustaining an entire movie. Nevertheless, it is a technique that is still used today when the story demands it. Film-makers routinely employ a subjective POV (point of view) to heighten emotion by making explicit our identification with a character. It can also be used to objectify a character under threat. Think of the Steadicam stalking sequences from films such as *Halloween* and *Scream,* or the Alien POV in *Alien*[3].

But sustained use of the first-person POV is rarely seen in movies because the effect is alienating. Once our conscious mind takes time to reflect, it becomes very apparent that we are not the lead character. We cannot affect where he's going or what he's saying, and so the first-person technique whittles away at "that willing suspension of disbelief" that constitutes, as Coleridge had it, "poetic faith."

In a game, of course, the situation is quite different. We do have control over all the actions of the lead character, so there is nothing intrinsically unbelievable about staring out through his eyes.

There *are* associated problems in that we are led to have higher expectations of perception via his (and our) other senses. We can't feel the cold wind on his brow, for example, or his thirst, or the white heat of a bullet tearing through the flesh. But the human mind is versatile and quickly conditioned to new inputs. You don't have to play *Halo* for long before a red line on the health bar starts to feel as alarming as a real injury—at least as far as we can imagine what having such an injury would feel like.

Some of the next generation of first-person games try to represent data less obtrusively. For instance, there are no health bars in *Call of Cthulhu: Dark Corners of the Earth* from Headfirst Productions. When you get wounded, your sight will darken or blur as it would from a real injury, and you have to look at your body to see where you are hit. Similarly, there is no ammo score; to find out how much ammunition you have left, you have to open your revolver and count the bullets. The intriguing possibilities that this avenue opens up are in the subjective

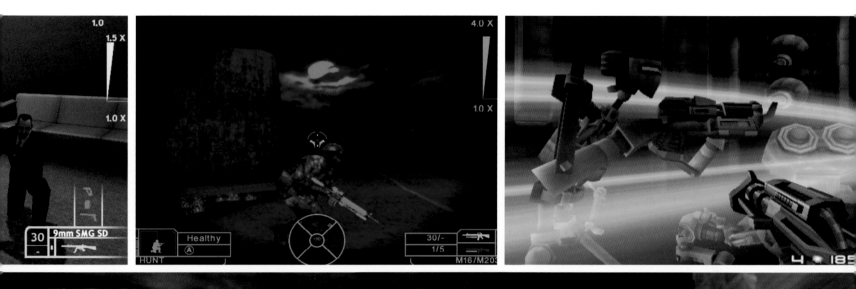

Opposite page: *Ubi Soft plus Red Storm equals* The Sum of All Fears.

Above left: *Ubi Soft's* Tom Clancy's Ghost Recon, *developed by Red Storm Entertainment.*

Above right & right: *Eidos'* Time Splitters 2, *developed by Free Radical Design.*

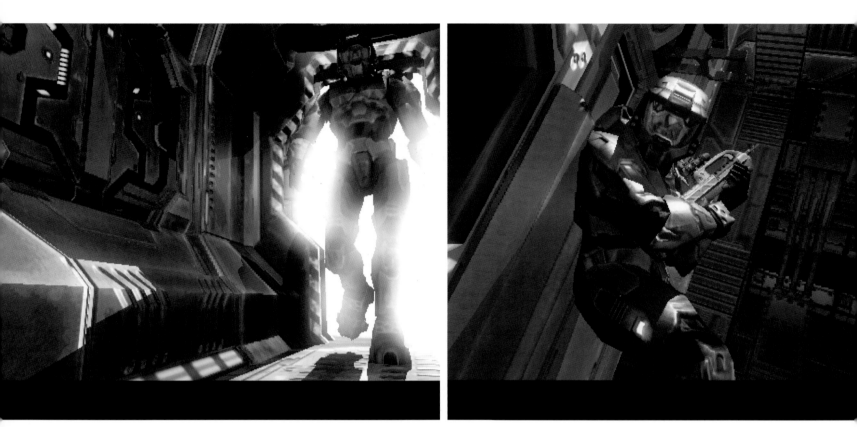

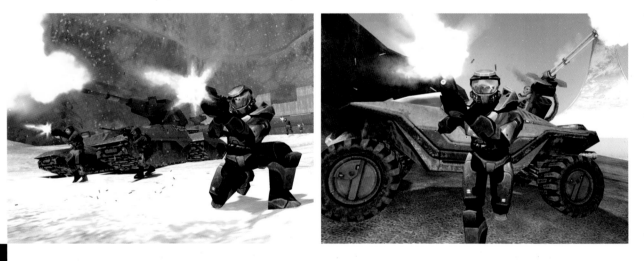

Above: *Combat just keeps on evolving—Halo 2 from Bungie.*
Left: *Bungie's first-person masterpiece,* Halo.

Opposite page left: Die Hard Vendetta *by Bits Studios.*
Opposite page right: *Electronic Arts'* Medal of Honor: Allied Assault, *developed by 2015 Inc.*

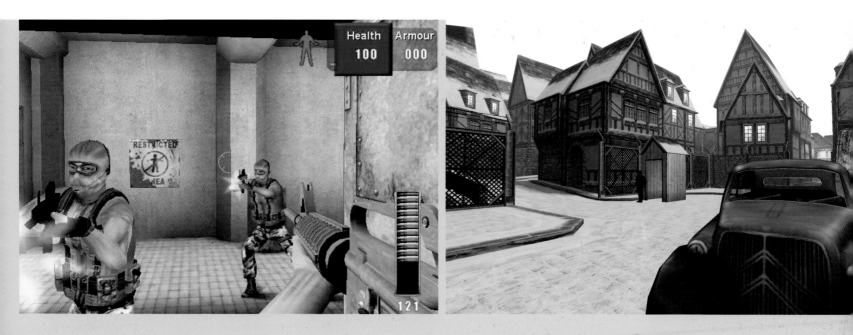

nature of the game experience. A *Call of Cthulhu* investigator who has seen too many things that most men rarely see in everyday life will begin to suffer authentically Lovecraftian insanity. Friends may appear to be monsters and—perhaps more worrying still—monsters may appear to be friends. It is worth noting, however, that in many first-person games the player's identity and the hero's are not entirely the same thing. The stars of *Serious Sam* and *Duke Nukem* have thoughts of their own. In other words, they aren't merely an extension of you in another world. Rather, their dryly ironic personalities are emphasized continuously throughout the game, adding color and humor. Sam's *sotto voce* comment as a decapitated zombie lurches by—"I'm over here, ya headless freak"—is the gaming equivalent of the scene in *Lady in the Lake* when Marlowe's wandering gaze settles on a pretty secretary while her employer carries on talking, oblivious to what is going on.

In role-playing games that feature a single character, the main protagonist is often left deliberately undefined, the point being that he or she is your alter ego in the game world. This is especially true of online role-playing games. There the character-creation process gives the player maximum freedom to choose the avatar that reflects himself as he wishes to be seen. In those games, and in first-person games with very little in the way of a unifying storyline, the character becomes the player.

In first-person games with a story, the reverse is true. There the player becomes the character. That is, in order to play the game, you are engaging in a process similar to acting. You are taking on the role of a character like Serious Sam, who is already well-defined. The advantage in commercial terms is that such a character is brandable. The Serious Sam that you play is the same character as the Sam I play. That means our personal identification with the character can be transferred to other games and other media—although not as effectively as with a third-person hero like Lara Croft. The first-person hero is rarely seen on screen.

As we shall see, third-person games have their roots in the traditional cinematic experience of empathy with the hero. "God" games and other strategy genres cast you as yourself, but at a distance from the action. In simulation games, you are there in the way that a child playing with a toy is there—engrossed but with your personality switched off. In the new styles of intimate "TV" games that we discuss in Section Thirteen, you are yourself in your true, social, "this is me" persona, forming a relationship with other characters.

The defining characteristics of first-person games, then are, first, that you become the hero, and, second, that you are right at the heart of the action. It is an entertainment experience that human beings have always striven for in childhood play. The technology of videogames has finally made it possible to submerge our own characters into our fantasies.

The term "middleware" describes pre-built tools and technology that developers can use to create their games.
One of the premier examples is Criterion's RenderWare product range, used for many top games including Grand Theft Auto 3, Pro Evolution Soccer, Airblade and Star Wars Galaxies.

We spoke to David Lau-Kee, CEO of Criterion, about developers' perceptions of middleware, and in particular the widespread reluctance to use technology "not invented here."

Many developers remain cynical about middleware, claiming it can only provide a workmanlike look. What can you say to refute that?
"We have a team at Criterion dedicated to thinking about how artists work. For example, many game projects use both motion capture and hand animation. RenderWare provides the means to merge the two effectively. That's something that would otherwise require bespoke code, and that's effectively a task that the developer doesn't need to do—we've already done it for them. Not having to write code for everything means that a project can afford to spend more on artists and creatives generally—and they're no longer tied to what the programers are doing.

"When you're building a game, you're dealing with a huge, complex system. This means that one small change can have a massive knock-on effect. With so many interdependencies, you might not even see the repercussions of a change for some time. Middleware lets you see the impact immediately. It means you're not having to paint by remote control, as it were. You're painting 'in the game'—you want to do something, you try it out, and you can see the effect at once.

"Middleware is a tool. The quality of the work you get out of it depends on the people who are using it and their understanding of the tool. In short, middleware doesn't replace the human element, it enhances it."

Historically, artists working in games have been technicians first and artists second. Do you see middleware as a way of opening up the development process to artists from varied skill backgrounds—for instance, traditional cel animators, painters, or sculptors?

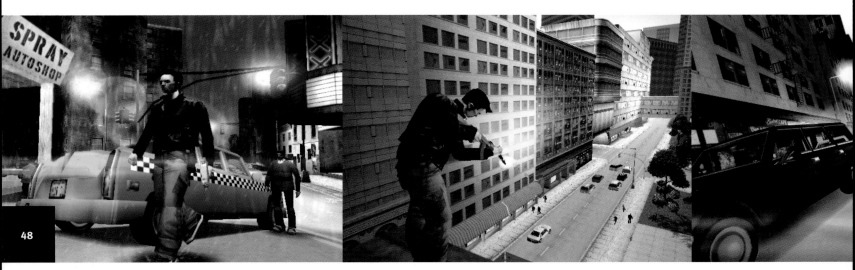

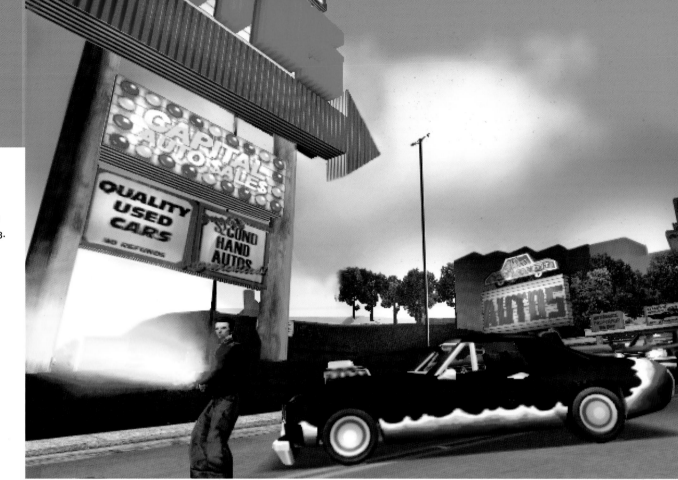

RenderWare was used to create Grand Theft Auto 3.

"Naturally game artists are technically minded. It's a technological medium, so a knowledge of that is necessary—just as a photographer needs to know about lenses, or a painter about brushes and canvas. Any artist needs to understand the tools he's using. What middleware does is shift the focus from technical uncertainty to creative flexibility. We see it as empowering artists, designers, and animators to create the game they have a vision of, instead of struggling with technology. This is important, because the two processes are very different. The technical process is linear. The creative process is iterative and draws on interrelated aspects of art and design.

"Middleware also provides a democratization of the game development process. With middleware, it's feasible for social scientists, for instance, to create interactive applications that they otherwise could not easily muster the expertise for."

The increasing level of realism that is possible in game graphics means an escalating demand for detail. Do you anticipate such detail being created by algorithms rather than by hand?

"Procedurally generating content is something we are already working on at Criterion. For example, say you have a boulevard lined with trees. The trees are all quite similar, so why not have a prototype tree from which slightly different variations can be generated? Or you might have a flag waving in the wind. The artist can set up rules for what happens when the wind gets stronger or dies down. That's in the physics. It doesn't all have to be done intensively.

"Textures and animations will be created procedurally too. People who doubt this should look at how the game development cycle is expanding. It used to be a few man-months. Now it involves thirty-plus teams over, say, two years. How long will it take to make games in the future? Ten or fifteen years? That's obviously unacceptable. If we are going to keep the level of detail in line with the latest technology, middleware is the only way to get the process under control."

Middleware can deliver quality product. The use of RenderWare for games like *GTA3* and *Star Wars Galaxies* proves that. But can it deliver the Holy Grail of art—that is, the unexpected and the original?

"I would say that having software that takes care of your lighting effects or shading or whatever—the nuts and bolts, if you like—gives you more time to concentrate on the things you might otherwise not get the time for. If those technical effects weren't available for you to take off the shelf, you'd have to put your effort into making them from scratch, instead of investing that effort into creating the mood or style you were originally after.

"Sometimes in the past, teams emphasized the technology because that's what interested them the most. Middleware changes the focus of development. It becomes a matter of making great games, not great technology."

Far left: *Character design in progress using 3D Studio Max.*
Left: *A finished character in action in* Airblade.

Right: *Notre Dame assembled in Davilex's toolset for* Paris Marseille Racer 2.
Below: *Editing object attributes in* Morrowind.

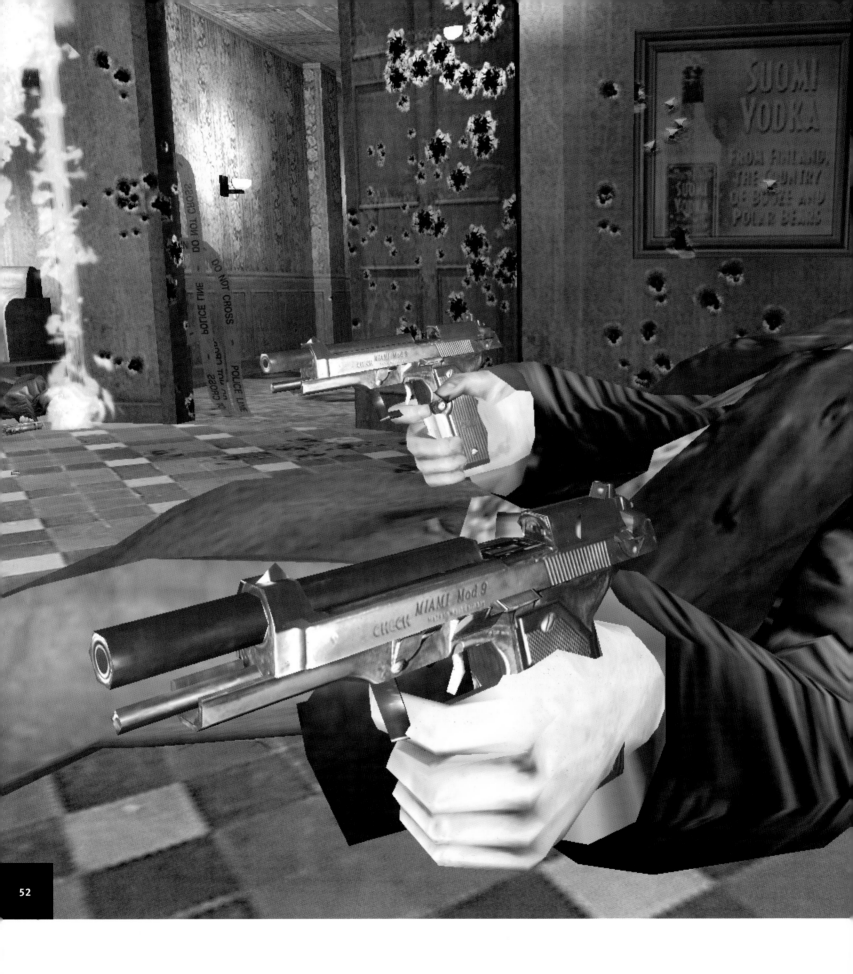

FOLLOWING
THE HERO

In third-person action-
adventure games, the
viewpoint is usually set to
hover behind the hero.
We see the adventure over
his or her shoulder. Often,
the effect is part cinema and
part rollercoaster ride.

Max Payne *from Remedy Entertainment*

Below: *"I heard you were dead"*—Metal Gear Solid 2: Sons of Liberty.
Bottom: *Out-of-the-box thinking from Solid Snake* in Metal Gear Solid 2.

Right: *Arran, hero of* Nightcaster.
Below left: *Off with their heads!* American McGee's Alice *in action.*
Below right: Max Payne: *A man without hope is a man without fear.*

In the early days of cinema, actors appeared anonymously. It was only when some proved popular that film makers began to bill them in order to attract audiences who had enjoyed the actor's other movies.

Lara Croft was the first and perhaps the most successful attempt to create an iconic videogame star. Superficially an amalgam of tried-and-tested character elements—the bolshy attitude of Tank Girl, the boisterous archaeology of Indiana Jones, the privileged but lonely lifestyle of Bruce Wayne—Lara proved to be more than the sum of her parts. It was the first time we had seen a tough, capable, female action hero, at least in the medium of computer games. As an athletically lean and cut-glass posh Überfrau, Lara is less generic and more likeable than most movie action heroes. She would also be most teen boys' fantasy, something that can only have contributed to her success.

Third-person games are the form that most obviously derives from theater, film, and television. The hero (or heroine) is a visible figure onscreen. This creates suspense—we can sometimes see a threat before the hero does. It also opens up the possibility of more sophisticated emotional responses, because we feel *for* the hero rather than merely *as* the hero. A first-person game gets the adrenaline pumping, but when we switch off, the question is how much excitement did we get? How much do we want to progress and see what happens next? In third-person games there is always a character we're rooting for. As in television drama or the old Republic movie serials, we go back for more because we care.

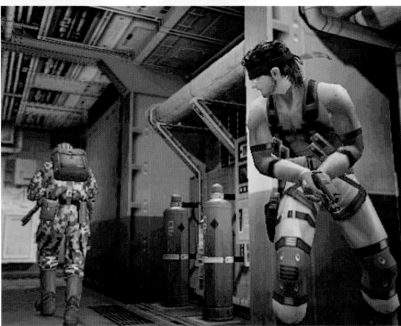

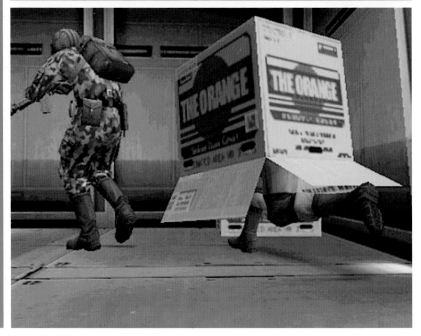

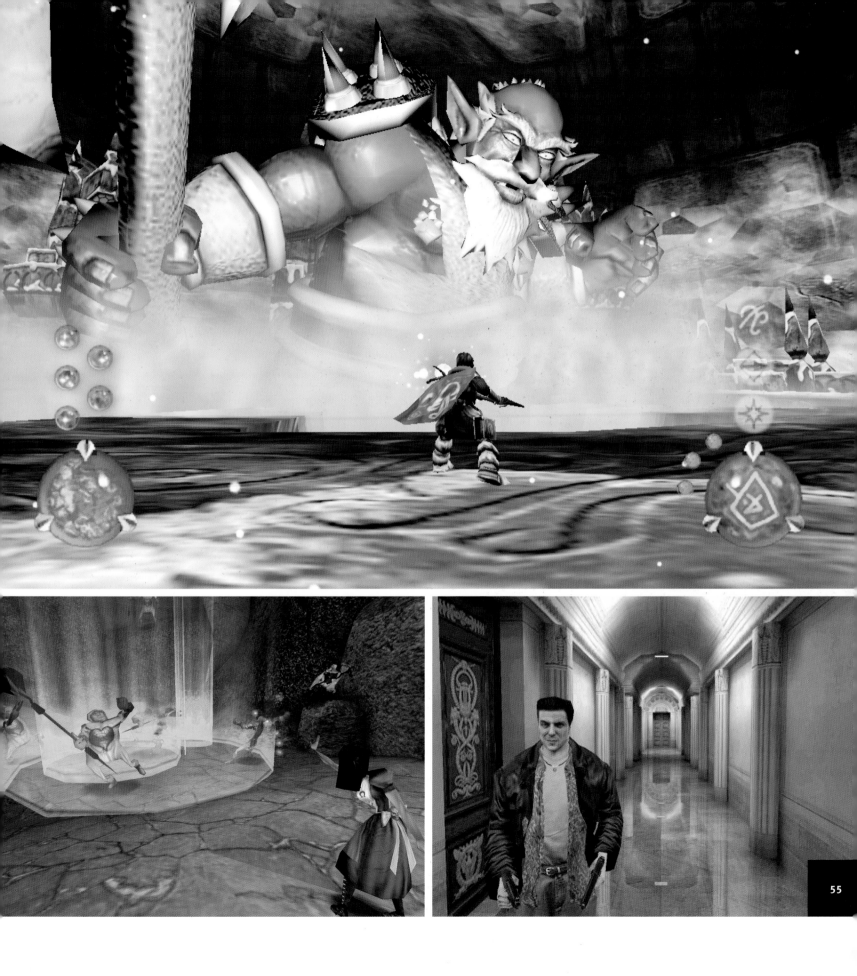

WHERE AM I IN ALL THIS?

When we're playing Lara Croft, who are we? Our relationship with the character works on multiple levels. We don't only "play" Lara in the sense of identifying with her, although that is a part of it. She's also our "pet," trained to jump through hoops for us. She's our objectified plaything, grappling and squeezing, gasping and grunting her way through physical challenges for our entertainment. We are her invisible friend, her guardian angel watching over her when danger threatens. And at the same time, we are also passive admirers of the self-reliant Lara. She's the protagonist, the action hero, the star, and in that sense some players aspire to be her, just as others might aspire to be Ben Affleck or Mel Gibson—or the sidekick of a popular kid in school aspires to be the pal he idolizes. So Lara is the player's alter ego, the idealized self, and the fantasy playmate.

"The games do not depend on action. What's crucial is rather a varying sense of scale, distance, and proportion, and the perceptual consequences this variation has. To play as Lara, one crawls through tunnels, squeezes through crevices, swims against the current of an underground river, hemmed in, only to emerge into some vast space, a primeval canyon or a subterranean catacomb. And Lara is almost always alone, her boots echoing disarmingly in a space where the only other sound is an eerie whistling or the flutter of bats' wings. The mindset the games induce is one of sustained concentration tuned into intricate relationships between spaces, objects, and sounds."
Rob White, Sight & Sound

Above: Galleon, *the new game from the creators of* Tomb Raider.

Above right: *A characteristic pose for a Toby Gard hero.*
Right: *Taken out with the washing—idiosyncratic action from* Galleon.
Far right: *She needs no introduction.*

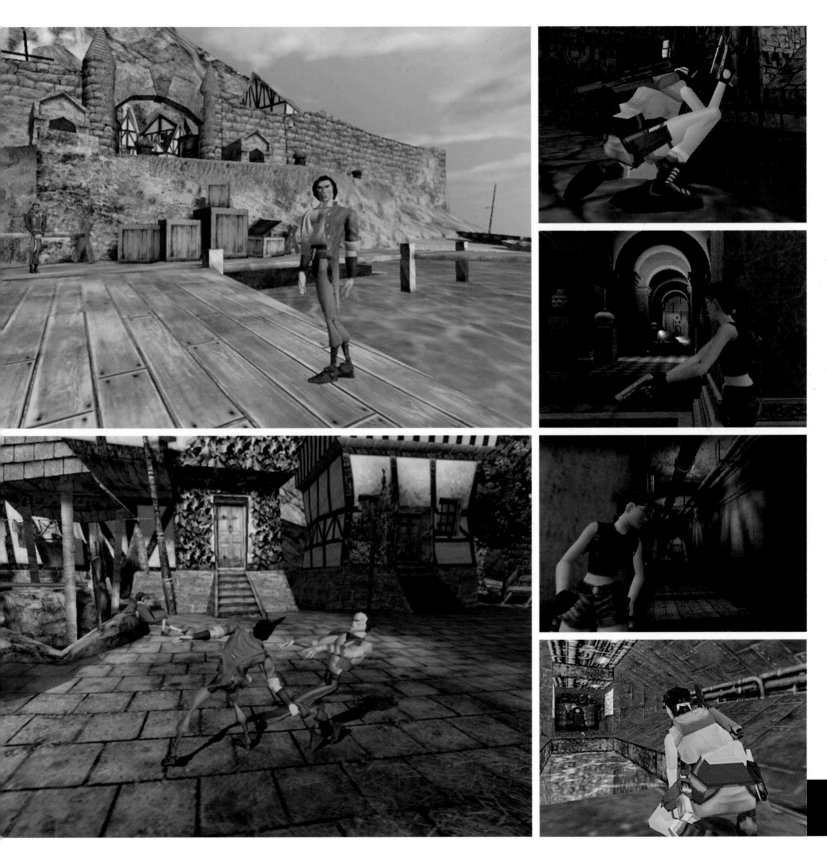

MIRRORS ARE MORE FUN THAN TELEVISION

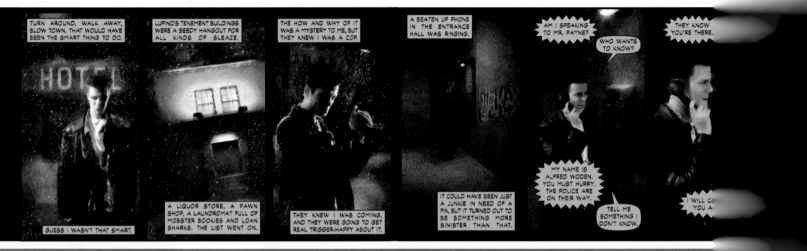

One of the most visually impressive games of all time is Remedy Entertainment's *Max Payne*. Photo-digitized textures have been used to create an authentically seedy urban underbelly, a maze of decaying tenements with dripping pipes and discarded hardware. Peeling wallpaper reveals dank gray plaster. Old graffiti provides the only splashes of color, appearing stark and nightmarish in the hard, white glare of electric lights.

Max Payne is a man without hope. Drug addicts murdered his family years ago, and at the start of the game he's pushed over the edge into a murky conspiracy that is superbly evoked by the bleak settings—a subway station at night, a dilapidated hotel, a snowbound street, a Gothic nightclub, the rooftops of a group of slum tenement blocks.

Radiosity lighting means that you can turn on a television and Max is illuminated in its crackling glow. Lights blur convincingly in the damp air. Explosions create a dazzling ball of fire. Against a backdrop of illuminated billboards, snipers appear as faceless silhouettes with only the crack of gunfire to pinpoint them for you.

Among many remarkable features, *Max Payne* pioneered the use of "bullet time." This is the technique of going into slow motion while retaining the ability to move the camera's viewpoint at normal speed. The same effect can be seen in movies like *The Matrix*, which probably inspired this game feature. Because *Max Payne* even models bullets as real objects, it is possible to see a bullet in flight while this feature is activated—hence the name.

Although *Max Payne* is one of the most movie-like of games, its designers chose an unusual and strikingly effective noncinematic way of telling the story. In place of the customary cut-scenes (see page 122), the plot is advanced by means of a graphic novel. It might be thought that this would break the player's immersion in the story, but in fact it works brilliantly. Cinematic cut-scenes can be irritating because the player is forced to lean back and take a purely passive role. When you have been given the freedom of interaction that an adventure game provides, having that freedom suddenly taken away while a movie sequence plays out can be distracting. A graphic novel, on the other hand, is a form of literary model, and, therefore, perfectly suits a lean-forward audience.

Even more importantly, information presented in a literary form invites us to sift it critically. The viewer of a movie is a passive spectator, not a critical reader, which is why everything that we see in a movie is, by the commonly understood rules of film grammar, supposed to have objectively occurred. Using a flashback, for example, to show imaginary or interpreted events is not playing fair with the audience—unless (as in the film *Rashomon*) the partiality of the view is made explicit. On the other hand, literary forms like the graphic novel permit the possibility of an unreliable narrator. It's hard to imagine anything better suited to Max's noir-ish descent into a hell of psychological dread.

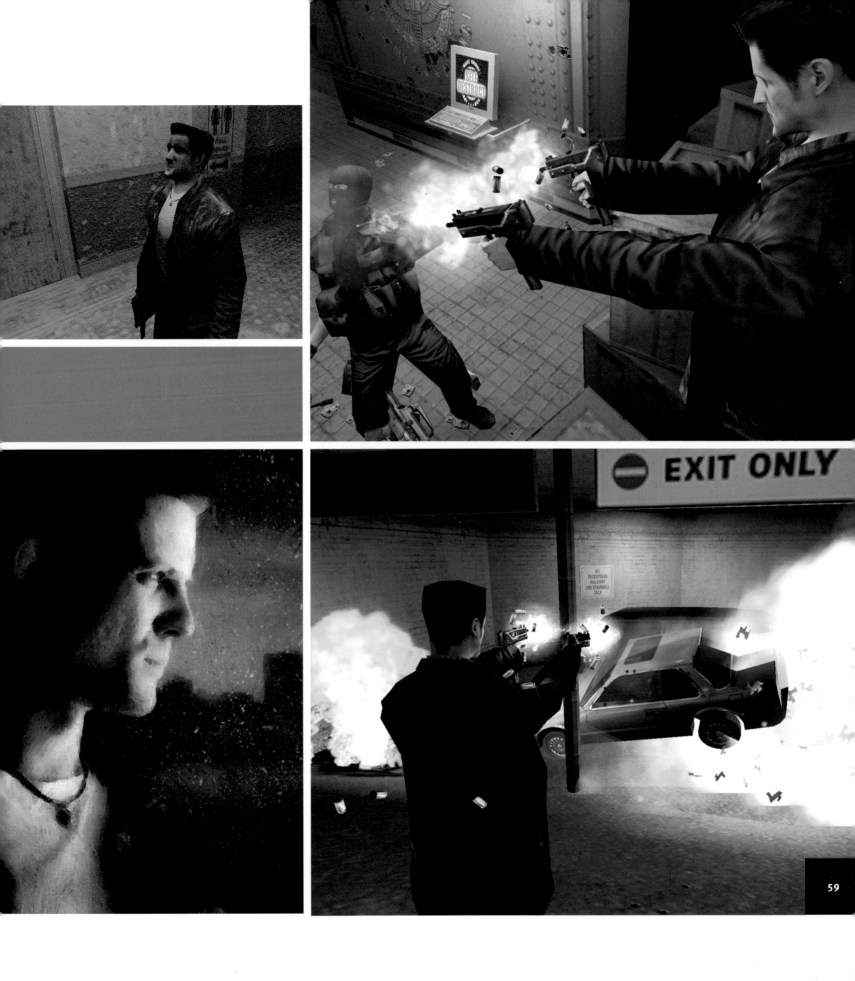

FOR YOU, THE WAR IS OVER

Wide Games' Prisoner of War

In *Prisoner of War*'s Stalagluft levels, with their predominantly earthy colors of an East German forest clearing, the art team had to think very carefully about visual contrast and focus.

"There was initially a danger of overusing noisy earth-colored textures on external buildings and the terrain," explains Tim Fawcett. "We decided that the buildings needed a lift in terms of contrast. At the same time we wanted to retain variety."

The solution was to use less color and more tonal contrast, in the form of an off-white texture, like painted cement. This was visually anchored by darkening the base of buildings. A small number of detail maps were applied to the buildings across all levels to create a rough look.

Tonal qualities were also adjusted on the terrain surfaces in order to exaggerate the contrast between muddy or stony areas and softer grass. At dusk or in darkness, the tonal variation on the ground serves a vital game function by showing where the paths are. This can be seen most clearly in the snowy scenes where there is high contrast between the white of the snow, and the dark trodden paths.

SKIP

For an in-depth look at how games are produced, we talked to
Sam Lake, Lead Writer at Remedy Entertainment:

"Our goal with Max Payne was to create a cinematic experience, a game that imitates a gritty action movie. This decision affected the game in many ways. The use of photos as the basis of the textures was naturally a big step, something that hadn't been done this extensively in games. Also, we aimed for "movie realism," meaning that we wanted to portray the action as it's done in action films—tastefully—not as it was done in other action games where the violence was often much more exaggerated and cartoonlike."

Below: *Tested to destruction—car model by Housemarque.*
Right: *Annotated block design sketch from Commandos by Pyro.*

Opposite page: *Remedy's Max Payne in action.*

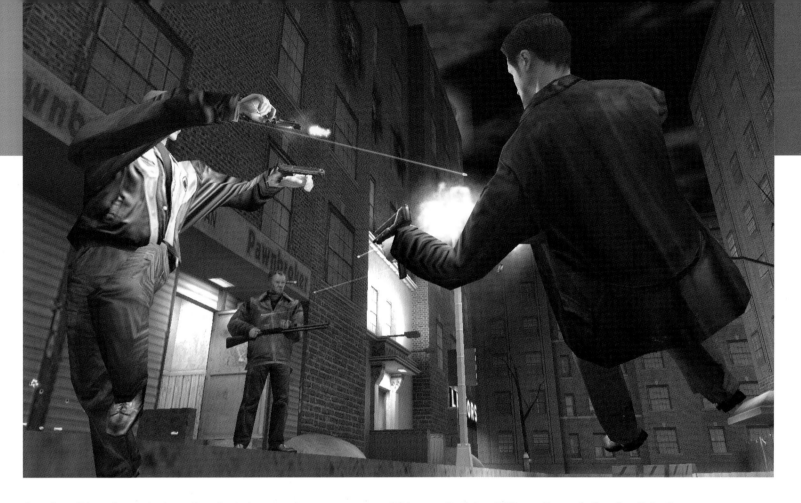

As writer did you have any input into how the graphics looked?

"I was in charge of the casting and costumes for the models. I was very much involved with the graphic novel, and whenever there were issues relevant to the story in the levels. Other than that, I gave feedback as any other member of the development team. Making a game is obviously very much a team effort."

How closely did you work with the artists and designers?

"Quite closely—and yet not closely enough. *Max Payne* was a great learning process for us all, our first project of this scale. These days we work in much closer cooperation with each other. It's also very much about learning a common language and learning to convey your ideas and opinions to the others."

Did you write "visually" as well as scripting the dialog?

"The screenplay of *Max Payne* was a combination of a movie screenplay, graphic novel script, and game play document. In addition to the dialog, I wrote preliminary descriptions of the characters, locations, graphic novel panels, and in-game cut-scenes. Naturally a lot of the details changed—for the better—once the artists got their hands on them."

Was there a consensus from the start about the style?

"The idea of a cinematic and realistic style was there, but achieving it was a long and winding road. Keep in mind that the project took over four years to complete. During that time computer graphics came a long way. In the beginning everything was done by hand, as opposed to using photos. A few of our artists felt that using photos was 'cheating.' Once we got past that, the rest came naturally."

DE_Village

"The original idea with the graphic novel art was that our graphic novel artist, Kiia Kallio, would do a water color painting for each panel, and that would then be interleaved with the photos. But the number of graphic novel screens needed turned out to be much larger than we estimated. In the end, the paintings had to be dropped and the photos and screenshots were filtered and manipulated in Photoshop to get the style we were after."

Do you think it was similar to writing for film, TV, and comic strip?

"Very much so. Since finishing *Max Payne*, I have graduated from the screenwriting school at the Theater Academy of Finland. There are a lot of small things that vary depending on the medium. Writing a film is rather different than writing for TV, but, all in all, the same basic principles apply whether you are writing for a game or for a movie."

We were impressed with the dream sequence and the surreal television shows. Such ideas are almost never seen in games. Where did they come from?

"As a writer, I'm much more interested in the psychological side of things, what's going on in the heads of the characters, than in the actual physical action. Dreams were a great way of getting inside Max's head. Unfortunately they were also the last levels we worked on, and because of the rush, they didn't quite live up to their potential. That said, I'm very happy that they are in the game. I see them as an important part of *Max Payne*.

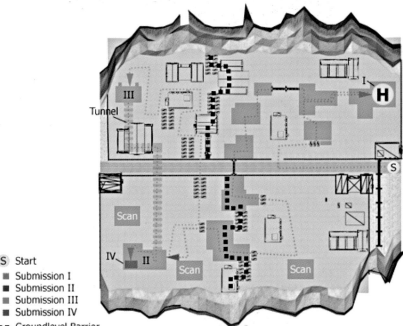

S Start
◼ Submission I
◼ Submission II
◼ Submission III
◼ Submission IV
▪▪▪ Groundlevel Barrier

Tunnel

III

IV

II

Scan

Scan Scan

I

H

S

Opposite and above:
*These production visuals
from Davilex's* Knight
Rider *illustrate the wealth
of detail that goes into
creating a game.*

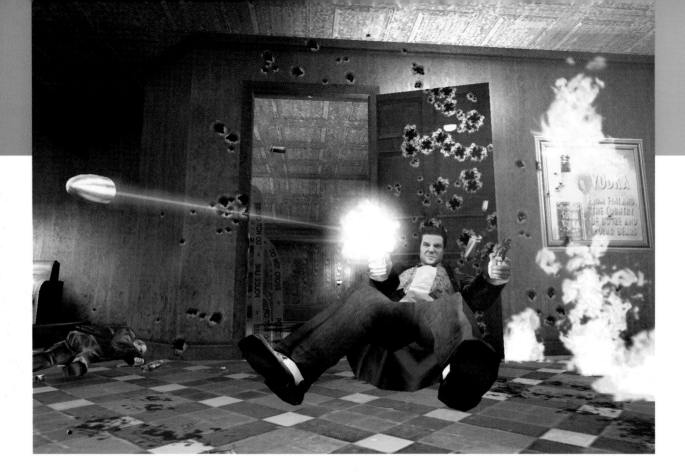

"I'm also a big fan of postmodern writing, things like intertextuality, and so on. That's where the television shows come in.

"These are elements that I find hard to imagine not using in my writing. The trick is to take baby steps with them, not to let it get too weird and alienate the mainstream audience. But I hope to use these kind of ideas and material more in future projects."

The decision to use a graphic novel for the cut-scenes was inspired. Where did that come from?

"In the beginning of the project we looked at cut-scenes in other games, and felt that most of them were rather crude and amateurish—far from movie standards. No one in our team had any concrete experience with cinematography back then. I'm an avid reader of graphic novels, and I thought that using them as cut-scenes would give us much higher quality results, considering the amount of story we were going to tell. It's much better to let the player's imagination fill in the blanks than ruin the immersion with something substandard.

"At the time of the decision, my friends and I had taken a few crime story photos posing with guns, just for fun, and then manipulated them in Photoshop. I took these to work as a sketch of what the graphic novel could look like. That's also how I ended up as the model for Max. It was an easy decision back then—the graphics were quite far from the photorealistic looks of the final game. I thought no one would recognize me. Little did I know! In the end, we did have some in-game cut-scenes as

Above left: Max Payne's *extravagant, cinematic visual style has made it a landmark action title..*

Above right: *Design visuals from* Primal.
Below right: *Level editing in Gas Powered Games'* Dungeon Siege *engine.*
Far right: Fatman & Slim *from the aptly named Attention To Detail.*

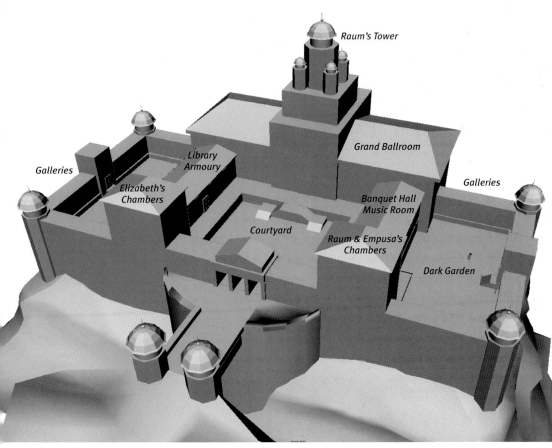

Raum's Tower

Grand Ballroom

Galleries

Library
Armoury

Galleries

Elizabeth's
Chambers

Banquet Hall
Music Room

Courtyard

Raum & Empusa's
Chambers

Dark Garden

well, and considering the tools we had for making them, I think our artists did a brilliant job."

Were there technical limitations to the graphics that limited your freedom of imagination?

"No matter what the medium is, there are always limitations. The funny thing is, with a game they are pretty much the exact opposite of what they are in the movies. You can do fantastic special effects easily, but adding a single actor (building the 3D model) takes a lot of effort.

"In the end, once you get past the initial frustration, limitations are good. They force you to work around them, think things through carefully, and often the end result is much better than the original idea."

The old question. What are your inspirations?

"For *Max Payne*, movies like Bryan Singer's *The Usual Suspects*, David Fincher's *Se7en,* and David Lynch's *Lost Highway*. Also, a lot of old film noir flicks, like Huston's *The Maltese Falcon*. And graphic novels by Neil Gaiman (*Sandman*) and Garth Ennis (*Hitman*), to name a few. Certainly too many excellent books to list here! I did read a couple of Raymond Chandler's Philip Marlowe novels before starting to write Max's dialog. I listened to a lot of Tom Waits, and to David Bowie's *1: Outside*.

"In general, anything that leaves an impression is an inspiration. Most often it is a good novel, but it can be anything, good or bad. It's often easier to know what you *don't* want something to be, rather than what it should be."

Is there anything else about how writing and design feed into the graphical artistic process?

"It's the old 'show, don't tell' thing, I suppose. That's what screenwriting is all about. The visual side of things is very important to me. Seeing and feeling comes before putting it into words. There is always a strong mental image of something, and only once I analyze it can I write it down. The comments I often get from the early drafts of what I'm writing are along the lines:'I could see it vividly in my mind, but I didn't understand a thing about it.'Translating the mental image into a meaningful narrative that others can understand takes effort.

"When the artist takes the script and turns it into visual form, it always changes completely—sometimes for the better, sometimes for the worse, but always into something completely different from the original image. Seeing it happen is interesting and exciting. But it's never easy."

Right: *Putting levels together for* Beach Kings *in one of the industries leading 3D programs, 3D Studio Max.*

Opposite page: *Design artwork from Zed Two's* Pillage... *and, above, the game itself.*

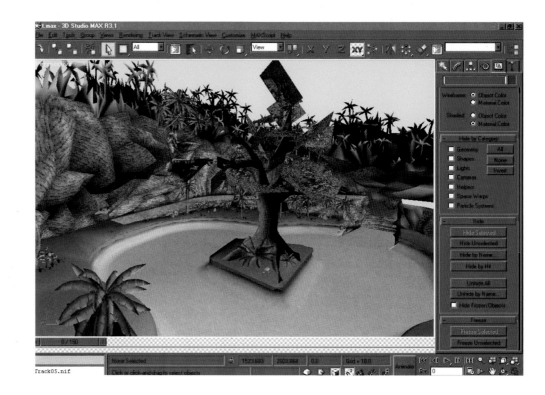

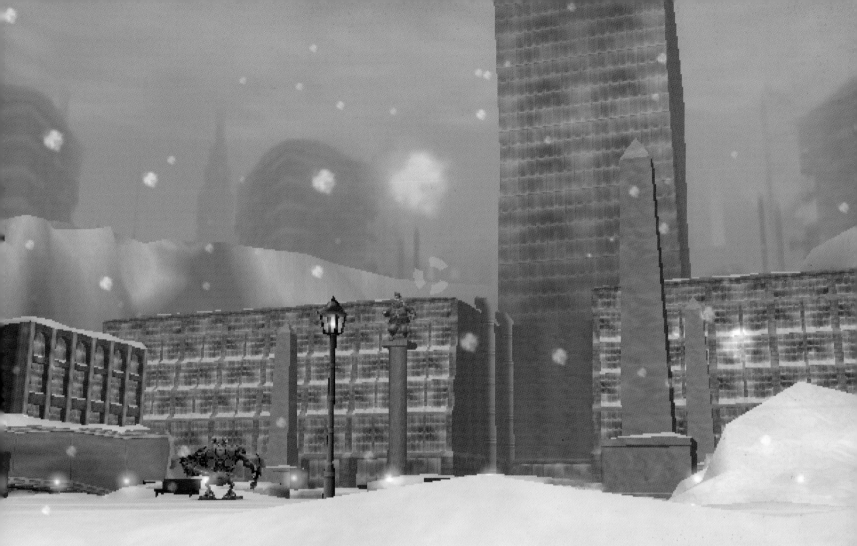

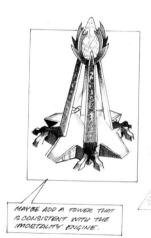

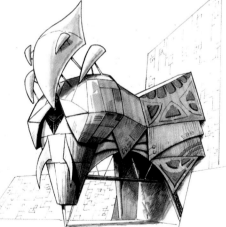

MAYBE ADD A TOWER THAT
IS CONSISTENT WITH THE
IMORTALITY ENGINE.

COURTYARD ARCHITECTURE
VERSION 3#

WHAT'S UP, DOC?

Constantly improving game technology concentrated most people's attention on the quest for realism. However, another quite different approach draws its inspiration from cartoons, either directly (in the case of Rayman or Herdy Gerdy) or merely in the "fun physics" of deliberately unrealistic driving games, such as Crazy Taxi.

Villains from Ubi Soft's Rayman 3.

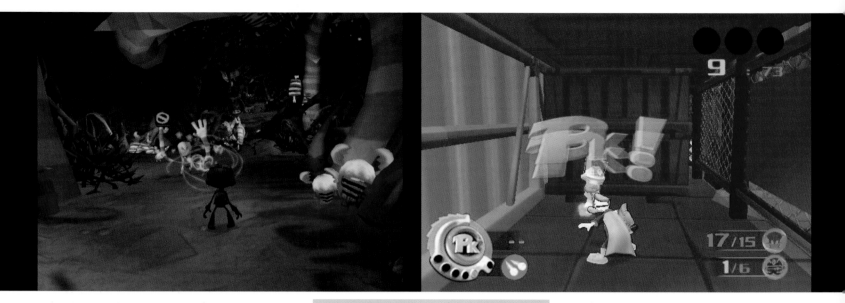

Psychonauts

Designed by Tim Schafer, whose credits also include *Grim Fandango*, *Full Throttle,* and *Day of the Tentacle.* Imagination is set free through a concept in which the surreal thoughts and dreams of the characters are given life and become elements in the game play.

Doshin

Simpler, but with a similar game concept to Lionhead's *Black & White*, *Doshin* has the player guiding the giant as he helps small villages to thrive. The game has a wonderfully original, quirky, almost claymation style combined with the minimalism of a Matisse.

Toejam & Earl

Funky aliens on Earth. Cartoon styles throw out all requirements for realism, letting the design of environments become more freeform and compact, with simplified visual elements that sum up where the action is taking place. A couple of trees are enough to suggest a forest, a tower is all that is required for a castle. Simple backgrounds and clearly defined characters always work well visually on the game screen.

Donald Duck

Walt Disney invented many of the rules that make comic animation work, so it comes as no surprise that Disney characters always translate effortlessly into game art. It is interesting to see such well-known characters in the round when we are used to them as flat 2D drawings.

Cel Damage

Here we see a computer-generated style of rendering known as cel shading. Although the computer is using real-time 3D models to calculate the graphics, the final image taken to screen passes through a filter that gives it flat colors and a black outline to make it appear like a traditional cel from an animated film.

Dark Chronicle

Akihiro Hino, Producer, describes how the visual effects of *Dark Chronicle* were put together:

"We tried very hard on CG modeling to convey a drawing-like feel. By adding outlines we avoided the doll-like image that polygon graphics create. For texture, all colors were set at a brighter tone to

add vivid gradation. Regular cel shaders are very big programs which are not suitable for RPG games where there are many characters. We used a special rendering technique: the outlines are not black; instead, colors are picked up from inside the texture and made darker at the edges. As opposed to a simple black, this gives a smooth and gentle touch to the drawing. We also added anti-aliasing on the outlines. This meant that low-quality characters, of the order of 2,000 polygons, would still look very smooth."

Freedom Force

A favorite genre of comic strip is brought into the digital age in Irrational Games' *Freedom Force*. While the array of exotic heroes exceeds those from the original comics, the tactical nature of the game play reduces them to tiny dolls on the screen. Therefore it is easy for players to overlook the careful styling in this game based on art from the Silver Age of comics, particularly the influence of Jack "King" Kirby, cocreator of *The Fantastic Four* and *Thor*.

Oddworld: Munch's Oddysee

Oddworld has always had beautiful, rich, and detailed backgrounds with a funny story and a delightful, expressive central character. This fourth title in the series uses what could be described as "comic realism," where the characters have all the attributes of comic characters, including exaggerated expressions and stance, but are rendered in full realistic 3D.

Blinx

The cool cat *Blinx* is a chronological troubleshooter dashing through the centuries fixing problems. He also dashes through some of the most wonderfully expressionist scenery ever seen in a computer game. The exaggerated and jagged angles of the buildings and props look as though they could have come straight out of the film *The Cabinet of Doctor Caligari*.

Whacked

The great thing about *Whacked* is that it's bonkers. The freedom of cartoons gives a welcome blast of fresh air into an industry dominated by realism.

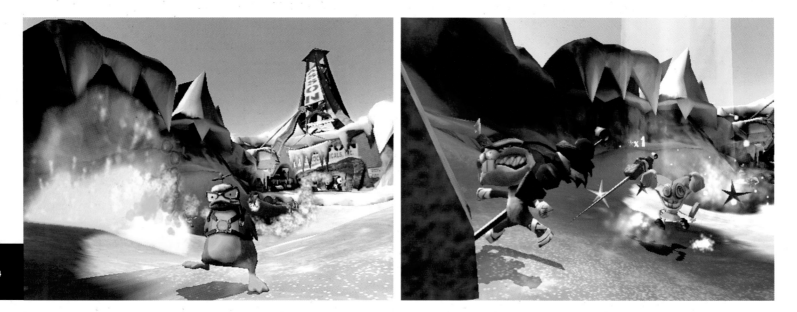

Scooby Doo

It's interesting to see how differently a character can be rendered for each medium. In the original TV show, Scooby is flat color, in the film he gets the full 3D realist treatment, and the game has a cartoon 3D style of its own. Each style suits the medium while still maintaining the integrity of Scooby as a character.

Pillage

Christian Johnson at Zed Two talks about the industry attitude to cartoon style:

"Although we didn't want to change the visual style of the game, there were a few factors during development we had to consider. When working with publishers in a technology-led industry, there is always going to be a clash of interests. This became apparent when analyzing the current games market and observing the checklist of features many publishers demand. Bump mapping, real-time shadows, toon rendering, motion capture, and above all, realism, have become marketing buzzwords. *Pillage* has perhaps not fulfilled certain marketing criteria owing to its stylized approach. I believe that this will eventually come full circle in a sea of photoreal games; the ones with their own distinct identity will create the stronger brand."

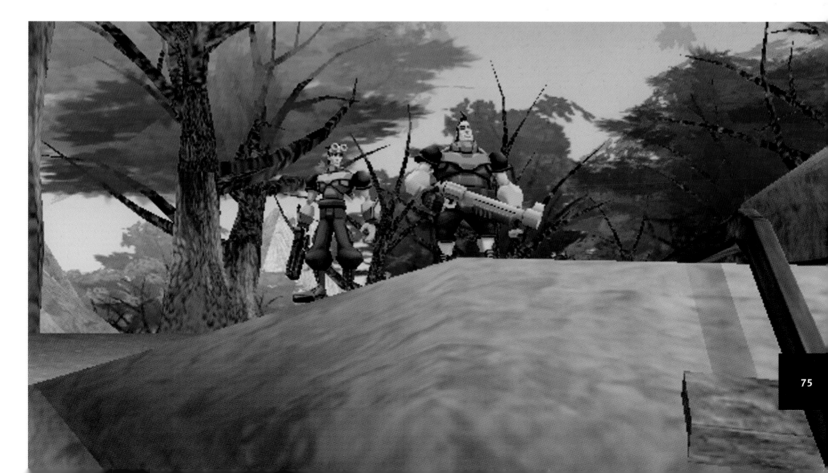

Rayman

Rayman is one of the oldest game cartoon characters and is brilliantly designed for the digital screen. His floating body parts show just how little is required to express character and charm, with the personality showing through the face and animation.

Legend of Zelda

The Legend of Zelda has evolved from a handful of pixels over several different console platforms to its most recent incarnation in cel-shaded 3D. It is classic children's manga. The developers have delicately controlled the style, with forms being described in just a couple of tones.

64

124

03
120

Ape Escape 2

The *Ape Escape 2* development team describe how they conceived the look of the game: "Too many game developers have pursued a realistic visual style, and, as a result, there are too many similar-looking games on the market. We made a conscious effort to avoid that. We designed the visual style to appear more like a handwritten drawing than a photorealistic picture. Placing vivid characters on top of soft, smooth backgrounds gives a sharp and clear impact to the visuals. For example, look at *Pokémon*. However, to add such softness and smoothness to the backgrounds, we made the pictures change according to how far away the camera is; we didn't just use the fogging that is often seen in games."

Herdy Gerdy

Herdy Gerdy represents a softer approach where the cartoon style becomes whimsical, somewhat in the style of Ralph Bakshi's rotoscoped *Lord of the Rings* feature. As in traditional 2D cartoons, the characters are flat cels against a rich, painterly background. The distinctive style of this game is maintained in the text and voices too.

Fat Man & Slim

Fat Man and Slim takes the sketchy hand-drawn freedom of traditional 2D cartoons and successfully recreates it in 3D. Islands that are a child's fantasy of an adventure park sit in glittering, clear blue seas.

'A foolish consistency is the hobgoblin of little minds.'
Ralph Waldo Emerson on the trade-off between style and realism.

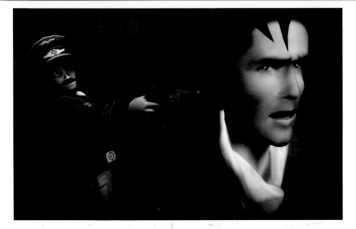

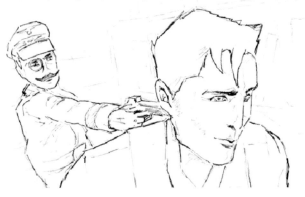

Ben Hebb, Senior Graphic Artist at Wide Games, comments on the development of characters in *Prisoner of War*:

"The lead was initially going to be a blond, blue-eyed American jock. As the game design progressed, we decided the lead role needed to be filled by a stronger, more rugged character. More of an action movie star type. Hence the final incarnation of Captain Louis Stone, seen here on the right. A strong silhouette is important given the characters' size on screen. Therefore, as well as strong characteristic proportions in body and face, we gave individual detail to the character's hair.

"Often artwork has to be reworked during a game's development. In *Prisoner of War* we worked from accurate research into all nationalities' rank insignia, medal bands, and uniform detailing. This reduced the need for continual changes. Even so, style and platform-specific technical issues meant that many uniforms could not be technically exact. The important thing was to find a good compromise between reality and game style. We generally over-saturated the uniform

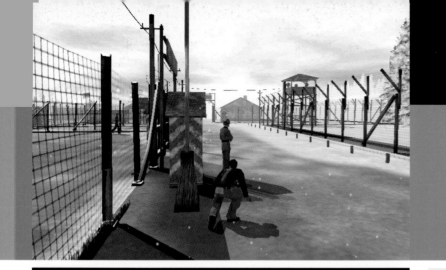

colors and added instances of bold color detail. For example, the Kommandant's red striped trouser legs were added to make them stand out from the very bleak conditions of the camps.

"You can also see here a promotional render featuring Captain Stone and the Kommandant, along with the original pencil concept sketch. All our promotional renders were incidentally made using the in-game models—an indication of the performance capabilities of the current generation of consoles."

"Characters in Dimitri will age. They'll get wrinkly, become either thin and drawn, or fat and ruddy, and their hair will fall out." Christian Bravery, character designer at Lionhead.

Left: A touchingly peaceful moment in the midst of warfare—from Black Cactus's Crusades.

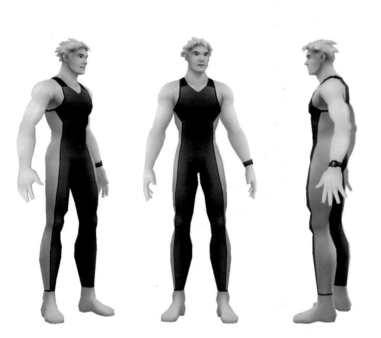

Left: Character design by Dimitri van Wezel for Davilex's Beach King.
Far left: 3D work in progress for Beach King— models by Stefan David von Franquemont.

Christian Johnson of Zed Two, developers of *Pillage*, emphasizes that a good game character has to be memorable and instantly recognizable:

"First off, a strong silhouette is essential for instant recognition. Also the color scheme shouldn't be too busy. Many of the classic Marvel super heroes have only three or four colors in their costume. Sonic, Mario, and the original Lara Croft follow these principles.

"A character's face and hairstyle is also very important. All my favorite characters have personality, expressive features or something quirky about them. The Milky Bar Kid, Harry Potter, and Pepper from *Pillage* have distinct rounded spectacles. Mario has a bristly mustache. Lara Croft has the cool shades and flowing braids.

Father in *Pillage* has a quiff and Elvis sideburns. It is these smaller details that give a character their own identity.

"When I set about designing the characters for *Pillage*, the brief was very loose and I was allowed to develop a style rather than go for total realism. The bottom line was *fun* and *personality*.

"I always begin by analyzing the game scenario and script. Then I start to research for styles and concepts that I feel are appropriate for the overall game style. The second phase is rough drawings and concept art. This crosses over when doing 3D work, as design and style aspects change and are reviewed to see what works most elegantly once the art appears on screen at TV resolution. There is no point including intricate details if your characters are never going to be seen closely enough to inspect them. The process involves constant dialog between the level designers and character artists to ensure continuity in the color palettes and the texture rendering.

"The bold graphic style of *Pillage* had a number of influences, notably the work of Capcom designers in games such as *Powerstone* and the *Street Fighter* series of games. Also, American comics and artists such as Joe Madureira and Mike Mignola. The latter has a very angular style that I thought would suit low resolution in-game models. I also looked to European comic artists for inspiration, particularly Moebius and Massimiliano Frezzato."

SLEEP NO MORE

Are games the new home of video horror? Forced into fantastic genres by the inability of current artificial intelligence to handle subtle emotion, games have proved very effective at terrifying people. Starting with **Alone in the Dark**, the original "survival horror," we look at how this offshoot of the cerebral adventure game has in many cases surpassed cinema in its capacity to scare us witless.

A Deep One from Call of Cthulhu.

THEY'RE COMING...

The scrape, then the thud... the scrape, the thud... over and over, closer and closer. The rotten door splinters and the gnarled, decaying, pustulent features of the zombie lurch into view. It seems to stare at you from dark sockets where its eyeballs once were. Shotgun—aim—*headshot*!

Zombie films are a well-known subgenre of horror that makes for a perfect gaming scenario. The idea of the walking dead has haunted many a culture throughout history. Zombie films and games have honed it to a stereotype that is less about horror and more about attending a human turkey-shoot. Despite its fantasy basis, the zombie world has recognizable patterns of behavior that most of us are familiar with. Zombies move in numbers with that slow, stiff, lurching gait that you could outrun in real life (though never in film). But you *can* finally lay them to rest by blowing their heads off. In this genre's most familiar reincarnation, *Resident Evil,* the pervading atmosphere is of an entire world in decay. The dimly lit, cluttered interiors look as though they might crumble to dust at any moment.

Some of the most frightening horror is where the rules of reality seem to hold true at first, but then distort and twist. It's the horror of madness, the nightmares and terrors that haunt the subconscious. Silicon Knights' *Eternal Darkness: Sanity's Requiem* and Headfirst's *Call of Cthulhu: Dark Corners of the Earth* both make features of this in the game play, questioning the sanity of the hero as he delves deeper into the mystery. *Eternal Darkness* takes a fascinating journey through history, graphically building the tension through terrifying creatures and fabulous, weird architecture.

Inspired by the pen of H. P. Lovecraft, the American Gothic world of the Cthulhu mythos is already well established. The game focuses on the growing madness in which characters, who seem to be friends, turn out to be the terrifying, sanity-sapping "Deep Ones." The game perfectly visualizes the broken clapperboard buildings and creeping mists of Lovecraft's New England setting.

Equally, Konami's *Silent Hill* series is another powerful example of psychological horror. Normal domestic environments are witness to terrifying and grim events— just as they sometimes are in real life. The game emphazises the fear with its pall of mist and its washed-out colors. *Silent Hill*, like many horror films and games, uses the grotesque to shock, with twisted, deformed, blood-soaked monsters constructed from a tangle of limbs and exposed organs. But it is by setting it against the mundane, prosaic world of middle America (just as David Lynch has exposed the horror behind many a white picket fence) that the game is able to achieve a deeper resonance. Are those shambling zombies a manifestation of something rotten inside ourselves? Questions such as this make it personal.

Opposite page, top row,
left to right:
Nintendo's Eternal
Darkness: Sanity's
Requiem, *developed
by Silicon Knights.
Konami's* Silent Hill 2.
Below: Resident Evil.

Above, left to right:
Konami's Silent Hill 2.
Tecmo's Fatal Frame.
Capcom's Resident Evil.
Left: *The Zombie Shuffle:
Sega's* House of the Dead.

TRUE GOTHIC

And chiefless castles breathing stern farewells
From gray but leafy walls, where Ruin greenly dwells.'
Childe Harold's Pilgrimage, Lord Byron, 1812

Sony's *Ico* is a return to the source, in that its style harks back to the motherlode of modern literary horror: 19th-century Gothic. Writers such as William Beckford described vast castles in which half-forgotten rituals were carried out by the decadent scions of decrepit aristocratic lineages. The same themes were taken up by writers such as Poe and Lovecraft, and were also found, to an extent, in the work of Bram Stoker and Mary Shelly. Later, Mervyn Peake developed the Gothic influences into a more overt and modern fantasy, with his *Gormenghast* books. In fact, the Gothic principles of brooding architecture, darkness, an innocent hero, degenerate privilege, and a sense of mystery and madness arguably also gave rise to the film noir tradition via the novels of Raymond Chandler and Dashiell Hammett. Remedy's *Max Payne* is as perfect an example of modern American urban Gothic as you could hope to find.

But *Ico*'s masterstroke was to return to the roots of Gothic, or of its most recent interpretations, by casting vulnerable, childlike characters as its unlikely heroes. The eponymous hero is exiled by his own people, who fear him because he has horns. Escaping from the castle vaults where he has been imprisoned, he meets an ethereally beautiful companion, Yorda. These two and their gentle love for each other are so different from the heroes of almost every other game that you genuinely fear for them at every step they take in echoing halls, over high bridges, and on windswept battlements.

All images: *Pure Gothic beauty from Sony's* Ico.

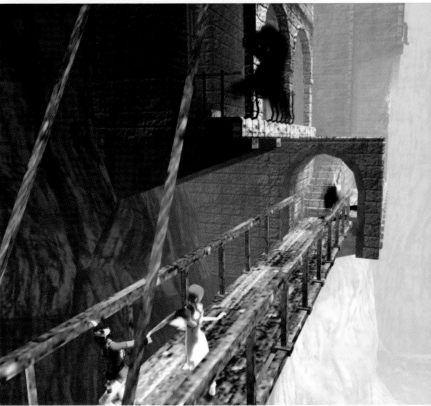

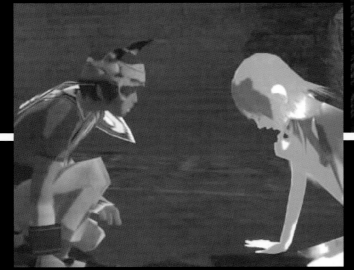

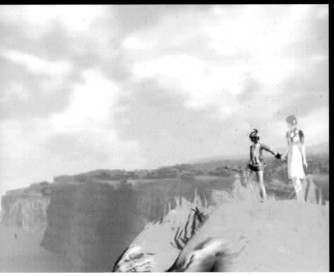

Great care was taken to give the game its wistful, haunting atmosphere, as Fumito Ueda, the designer and art director, explains: "There are several visual concepts for *Ico*. In many games, overdesigned details are added to the point of excess complexity. To achieve simplicity and a sense of closeness [with the player], we chose a minimal design. Decoration is eliminated as much as possible. This enhances the useful information the player is getting from the screen, rather than piling on elaborate details. To reproduce sunlight in an almost Impressionist way, we gave the visuals an overexposed, filmlike feel to bring it close to the image people have of a sunny day. By implementing such a level of realism into our unreal world, we managed to create a believable world that exists only on a TV screen. From a technical point of view, graphics are the result of balancing data density and color, and the main focus for all of *Ico*'s graphics was differentiating it from other games."

INSIDER SECRETS: CHARACTER ANIMATION

Movement is inherent to, and vital in, computer games. Characters run, monsters lunge, spacecraft swoop, tank turrets swivel, aircraft soar. When admiring any game's artistry, one can easily overlook the animation, but it is always present—even in the most distant strategic battlefield simulation. At a closer level, the quality of animation can bring emotion into the game, making you actually fear an adversary, or fall in love with the hero. Lara Croft's dynamic, almost balletic movement as she runs, alone, through echoing spaces is beautiful to watch, just as the delicate, uncertain steps of Yorda, the lost girl in *Ico*, express a vulnerability that tugs at the heartstrings.

Before the prevalence of 3D in computer games, all animation was 2D and handled in a similar way to traditional 2D animation in film. Each frame, or cel, of animation was drawn by hand. Replayed at the correct speed, the rapid sequence of individual cels tricked the human eye and brain into seeing fluid movements.

Some games have moved close to traditionally animated film. *Dragon's Lair*, animated by Don Bluth, was perhaps the best-known example. In it, the player watched a sequence of animated action and was then prompted to make a decision based on it. Depending on the decision, he or she was then shown another sequence. *Dragon's Lair* ended up being known more for its beautiful animation than for its game play.

In most 2D computer games, animation is restricted to small areas of the screen that are themselves moved by the player, or in response to commands given by the program. These small areas are often referred to

Poetry in motion: Tecmo's
Dead or Alive 3.

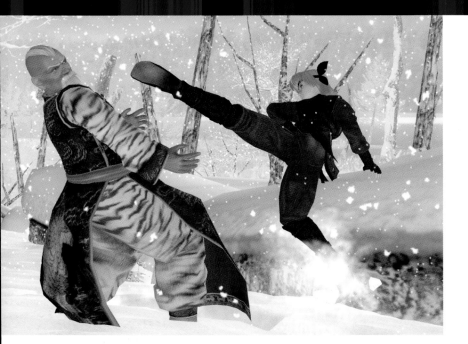

as "sprites," and might contain a character, spaceship, or monster that moves over a static or scrolling background.

These sprites are animated in short sequences, which isolate an individual action a character makes. For example, a character may use eight frames in a walk cycle, then another few frames in reaching for his gun and firing. It is the game's program that decides the order in which each animation plays. So, if the player moves the joystick to the right, the character's animated walk cycle will repeat until the player chooses, say, to fire, at which point the gun-drawing sequence will play. Apart from the complexities of the animation itself, considerable artistry is displayed when blending each sequence together flawlessly.

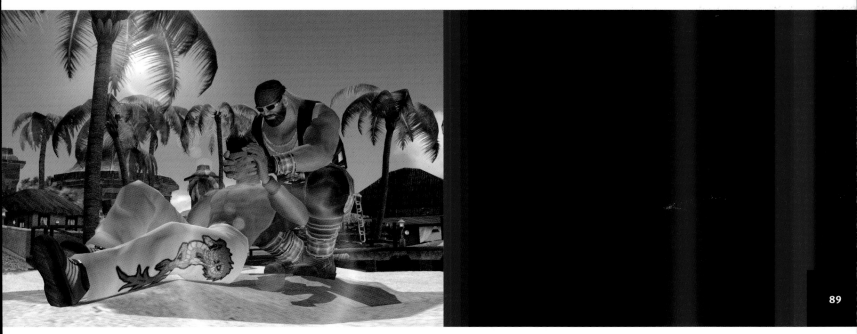

Prisoner of War *featured 220 unique animations, both in the game and within the real-time cut-scenes. Animations were created from a mix of motion capture and hand animation.*

Cut-scene animations are like traditional TV or movie animation. You just sit back and watch them. Animations within the game environment are different since they have to respond to the user's actions. With the run cycle shown, Wide Games developed a method of letting the character move seamlessly from a sneak to a walk to a run as more forward pressure was applied to the joypad.

An angle in the direction of movement was also added to the upper torso, while the head was made to point in the direction of travel. Thus, a number of technical methods were layered upon each other for a visually pleasing, natural effect.

As games became more sophisticated, the number of animation frames grew to allow hundreds of possible actions. Adopting an isometric view of the game multiplies the required number of animations, because every action has to be drawn in every combination of direction. With a character walking in eight possible directions, his eight-frame walk cycle would consist of sixty-four individual drawings. In situations like this. 3D programs are used to reduce the amount of work involved in isometric animation, as the character need only be animated once in the 3D package. Afterward, sequences can be rendered from all of the necessary directions simply by moving the camera. This is an example of where the sophistication of 3D is used, perversely, to provide more material for 2D.

Franck Sauer of Appeal describes building the characters for *Outcast*:

"This is the character setup I did for keyframe animation of the main character. A series of high-level nodes enable the control of the character. I did the skinning of the characters as well. The engine allows for three influences per vertex, with a palette of seven transform matrices per polyset."

The process of 3D animation now predominates in games. This process is better likened to stop-frame and puppet animation than to traditional 2D. The first step in the process is to build the puppets, or models, in a package such as Lightwave. To effect their animation, the positions of the points and polygons of which the characters are made is "transformed," or moved, and the new position stored in keyframes. The keyframes can be at any chosen point in time—for example, ten twenty-fifths of a second into a sequence. The computer can then calculate all of the relative positions of the points in the frames between. This is called "in-betweening" (or "tweening").

The great advantage of 3D is that the animation is intrinsic to the character model itself rather than being built up from individual images, as the case with 2D.

"This is the character setup I did for motion capture animation. There is a standard skeleton which receives animation from the moca. This skeleton drives the character's skeleton through constraints. An adjust node is added for each constraint so keyframing can be applied over the motion capture data for adjustment."

"For facial animation, I use skeleton deformation as well. Here, each bone represents a muscle of the face. By combining transform on these bones, I could achieve realistic face movements. Good skinning is the key."

BIG BOYS' TOYS

Feel the speed, the roar of the engines, the heat of the explosion. Computer simulations are the closest most of us are going to get to driving a racing car, flying a military jet, or joining a SWAT team. In this field, game artists have only one goal: hardcore realism!

Knight Rider *from Davilex Games*

Sweeping into curves at 200mph in a new Lotus, pulling a tight vector over the Rockies in an F17, blowing away enemy tanks from your M1 Abrams, or snowboarding on the rim of death. For most of us, the experience will remain a dream. But you can get close to it—and without the risk of killing yourself with a simple mistake. Computer simulations supply some of the adrenaline rush of the real thing, which is why they have been popular since the earliest days of computers.

One of the joys of the latest simulations is being able to afford ownership of a classic car, or a state-of-the-art jet fighter—even if it *is* virtual. The number of polygons available to the model artist has increased to the point where little detail is omitted from these digital versions of the real thing. And the models *are* stunning. Using outside "cameras," you are able to view your pride and joy from any angle as it does its stuff: a low-action shot from the rear wheel of a Rally car, perhaps, or a majestic sweep around your Stealth bomber as it swoops over the Himalayas. In no

other medium can one admire the works of the great car and aircraft designers, push them to the limit—and afford it.

The ultimate dream car of the 1980s had to be *Knight Rider*'s KITT. Here Teun de Haas of Davilex Games describes his relationship with the owners of the real star, the car:
"In the start-up phase of the project we had a meeting with Universal, the license holder. We had already done some design work and we had drawn up a large list of questions about things we'd expected to be potential problems. For example, although KITT gets smashed up a few times in the series, his chassis was nominally impregnable, so we agreed not to show him being damaged on the outside. Instead we used a meter which shows the damage to KITT's internal systems. Universal said that we could invent new features for KITT when we needed to, but it wasn't necessary. With all the gadgetry already installed on KITT, there was plenty of scope for game play. We have submitted several work-in-progress versions to Universal during development—and they like what we're doing."

Above left: Glide Face, *New Media Generation*.
Above: Battlefield 1942, *from Digital Illusions*.
Above right: F1 2000 *from EA Sports*.

Opposite page:
Above right: *Davilex's* Knight Rider.
Right: *Microsoft's* Midtown Madness 3.

THE REAL THING

The aircraft simulator, and more recently, free-form driving games, allow the experience of exploration. When first released, *Microsoft Flight Simulator*, offered the challenge of learning to fly but little else. In its current iteration, *Flight Simulator 2002*, the landscapes are very close to the real thing. As with most flight sims, actual photographic and land height data is used to create a realistic model. Extra details such as trees, buildings, and other traffic are created procedurally. Even the weather is realistic. There is a real joy to exploring parts of the world you will never see from the air: you can buzz your own, or even circle your office block.

Marko Laitinen of Housemarque believes extra detail is critical to bringing a simulation to life:

"The world must feel alive. The player doesn't want to explore an area that is uninhabited. If the game is alive, it's enjoyable to be a part of that world.

"seeing the little details in levels and the joy of finding them all: little signs that have funny texts on them, rabbits running around, details that you really don't notice, but if they aren't there, the world seems to be lacking something."

Ravinder S Ruprai, Lead Artist, describes how they rebuilt a large part of London for *The Getaway*:

"The objective was to create visuals that would provide an ultra-realistic experience and blur the line between cinema and games. The result is a photorealistic rendition of London. Forty square kilometres of the city were faithfully recreated using over 20,000 digital photographs.

"The theme for the visual style was to depict an undercurrent of crime. Locations in *The Getaway* range from London's tourist hot spots and Soho backstreets, to the litter-strewn back alleys and arches of Southwark. Bright colors were deliberately darkened and desaturated to simulate a filtered look. Characters were actually cast, clothed, and then digitally scanned, with each character having their own style of wardrobe and car, and being put in locations that reflect their social standing.

"The overcast skies of London, the red buses, the everyday family cars and franchised coffee outlets provide an instantly recognizable simulation of everyday city life. The individual elements and concepts have been combined to create the illusion of a living, breathing city."

Opposite page, left to right: *Microsoft's* Flight Simulator *and* Combat Flight Simulator 2. Transworld Snowboarding *by Housemarque.*

Above left and center: Microsoft Train Simulator.
Above right and main: *Soho a-go-go*: The Getaway, *SCEE.*

LARGER THAN LIFE

A woman observed J.M.W. Turner as he painted.
"I've never seen a sunset like that Mr. Turner," she said.
He replied, "Yes, madam, but don't you wish you had?"

Sometimes reality needs a helping hand, particularly if you need to shoehorn it into game play. Exaggerating visual elements can make the simulation experience more dramatic and exhilarating. A flight sim may bring up more storms than statistics expect and make the lightning closer and more threatening. One place where bending the rules makes the game more thrilling is in *Transworld Snowboarding*. The descents are gut-wrenchingly steep and terrifying, while the beautiful and exaggerated lighting creates extra drama. The designer, Marko Laitinen, explains: "Stylish and realistic lighting. Without it, the game lacks depth. The movie industry has always been focused on lighting, but the game developers are just recently beginning to use it as a real tool."

Peter Edward, Producer of *Hardware: Online Arena* describes how he mixed the ultra-real with very unreal game play.
"SCEE's first online multiplayer game features tanks, jeeps, and other fast attack vehicles duking it out in deathmatch action. Our work is focused on making a multiplayer game that is easy to play, and which stars realistic-looking vehicles that players want to get into and drive like maniacs.

"The arena that the multiplayer action takes place in has been carefully designed. Viewed from ground level, the environment has a sophistication and complexity that lends a realistic atmosphere to the game. Viewed from above, it can be seen that the layout is really very simple, which allows the design and game play to be very finely honed.

"When it comes to the vehicles, you can see that we are aiming to give *Hardware: Online Arena* a military feel that appeals to the kind of people who like paintballing, or tank-driving weekends. It features the ultrarealism of highly detailed vehicles and environments, with the massive explosions and dazzling effects of a pure arcade action game."

Left above: Transworld Snowboarding *from Housemarque.*
Left below: Freekstyle, *EA Sports.*

Right: NHL, *EA Sports.*
Below: Hardware: Online Arena, *SCEE.*

"Games are not art; they are made to entertain," says André van Rooijen of Davilex Games.

"They are not made with the cultural elite in mind. Games are—or will be in the near future—a true mass medium, and that's something that cannot be said for art.

"Style has everything to do with polishing your world so it becomes more beautiful or frightening or funny—or whatever emotion you want to evoke. So visual style is very important. But does it also need to be distinctive? It is quite easy to completely alienate a player by offering a visual style that he or she doesn't understand. Just look at people's reactions to modern art and you can see what I mean.

"Personally, I'm always on the lookout for games that present a distinctive style, something that stands out from the Gothic, sci-fi, and fantasy styles that are so common in games. Most games stick to proven paths, but every so often you get something like *WipeOut* and *Rez* that try to move the medium forward. When you push the boundaries, though, you do run the risk of losing the player, because he or she doesn't understand what you're trying to say. If you're aiming at the mass market like we do, it's best to stick within the player's expectations. So we consciously choose not to go for a wacky look. Take *London Racer*. It offers the thrill of doing something that people can't do in the real world—that is, driving very fast while breaking every law possible. In order to give people that thrill, we have to present a world that looks real. Otherwise it wouldn't feel "illegal!"

"I think artists in the game industry need to be great communicators more than they need to be great innovators. At the same time, I accept that this will be an ongoing discussion just like the one in modern art."

Get an Eiffel: testing the mood effects of different lighting in Davilex's Paris Marseille Racing 2.

Paul McLaughlin, Head of Art at Lionhead Studios, believes that it is possible to identify regional styles:

"There has been a tendency for British game artists to be workmanlike, perhaps coming from a more technical background. Often the artists are young, male, and self-taught. They have lots of technical talent and great craftsmanship but little appreciation for the big esthetic picture. That is an over-generalization, of course, but I think it's what makes UK game artists different from, say, the French—very stylish, quite soft—or the Japanese—insanely quirky, but very well observed. Things are changing now as the employment market is becoming more critical. We are seeing more people with formal art training, and they're bringing with them broader influences. We're even starting to get some women."

Tancred Dyke-Wells, Lead Artist at Kuju Entertainment, agrees, but believes artists are only giving the customers what they want:

"Western gamers can be disappointingly conservative. A lot of kids didn't like the graphics of *Jet Set Radio*, and the cel-shaded style of the new *Zelda* went down badly in the US. The trouble is that teenage males who like computers do not tend to have the most sophisticated esthetic sense in the world. Ultra realism and a kind of sickly, over-saturated, cartoony look are the two most (if not only) favored art styles in the West. Hence for their next hoverboard game, *AirBlade*, Criterion ditched the comic-book, fluoro styling of *Trickstyle* in favor of concrete-gray urban realism.

"The really cool, radical-looking games almost always emerge from Japan. Think of *Rez, Freak Out, Parappa the Rapper, Vib Ribbon, Rakuga Kids, Mojibribon,* and *Space Channel 5.* Even the box art

for Japanese versions of games tends to be more interesting. I hope this will change, and with the flood of new talent pouring out of games art courses at colleges around the country, there's every reason for optimism."

Paul McLaughlin: "A pure artistic consideration of game art might lead to removing clutter. This means things such as text, lots of icons, and so on. However, a game is there to be used, so the ideal is not to strip away the interface but to find a way to integrate it with the art. It's only ugly if it's obtrusive. For example, the player's city in a real-time strategy game is actually an extension of the interface. You open the buildings like folders to get at the options inside. In fact, it's the same with the characters."

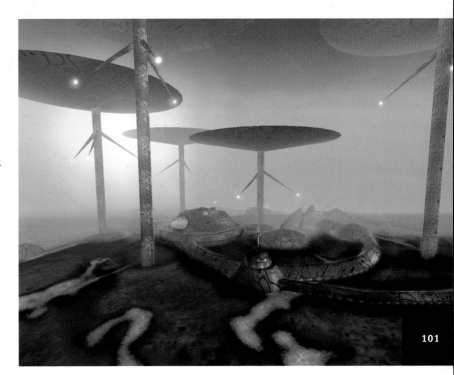

A truly alien vista from Westwood's Earth & Beyond.

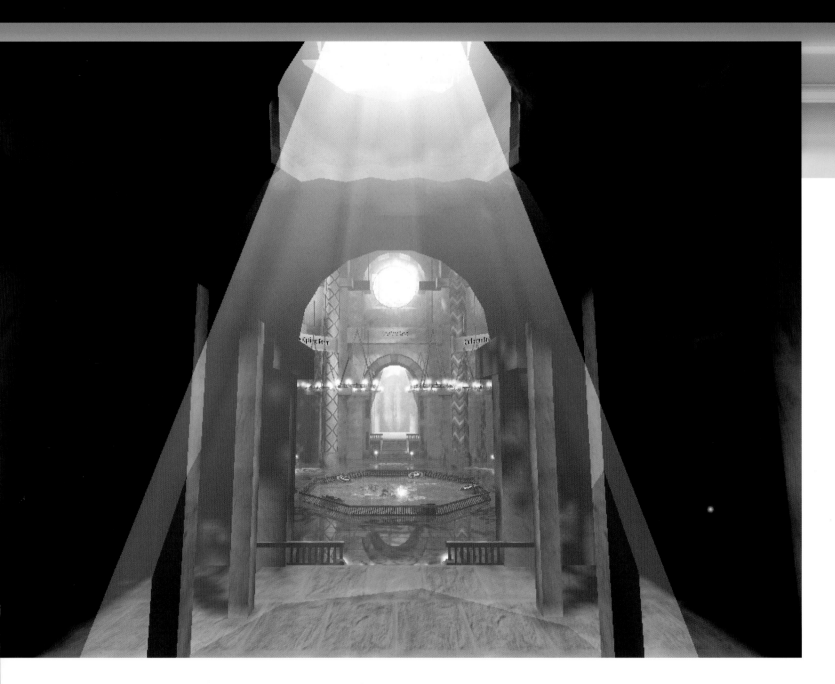

"This approach allows you to embed the interface in the game world and hopefully its use will be transparent to the player. Occasionally, the best way to find something or to clock on something is to use a Windows-type interface. It's simple, self-explanatory, familiar, and essentially quite elegant. Personally, I think there is a bit of a conflict with embedding interfaces into the world. When it works, it's great, but I'm more than happy to have a less 'clever' and arguably uglier onscreen graphic user interface if it makes sense in that particular game. The only dogma should be what plays best. Then try to make it look good."

The interior of the player's citadel in Black & White *was used as a 3D game options interface. A custom game graphics engine, separate from the game engine, was needed to render it.*

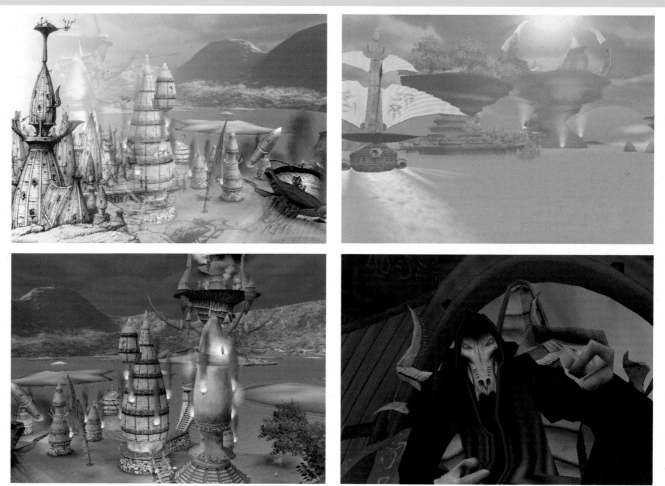

Haven: Call of the King
by Travellers' Tales

Tancred Dyke-Wells: "In-game interfaces should be dictated by, and limited to, what information is necessary to show for game play. It's an issue of intrusion. *Ico* is more like a first-hand experience because there is no interface laid on top of the visuals. Some *Medal of Honor* levels dispensed with the compass and health bar, unless you were taking hits, for the same reason. The trouble is that, for the artist, head-up displays (HUDs) are enjoyable to make and difficult to be restrained with. Like any other bit of art, one wants to make something impressive and stylized—military for a tank, an organic representation of the senses for a dragon. But basically the in-game HUD is equivalent to a station identification logo on TV: a distraction from the experience that adds another layer of removal. Less is more."

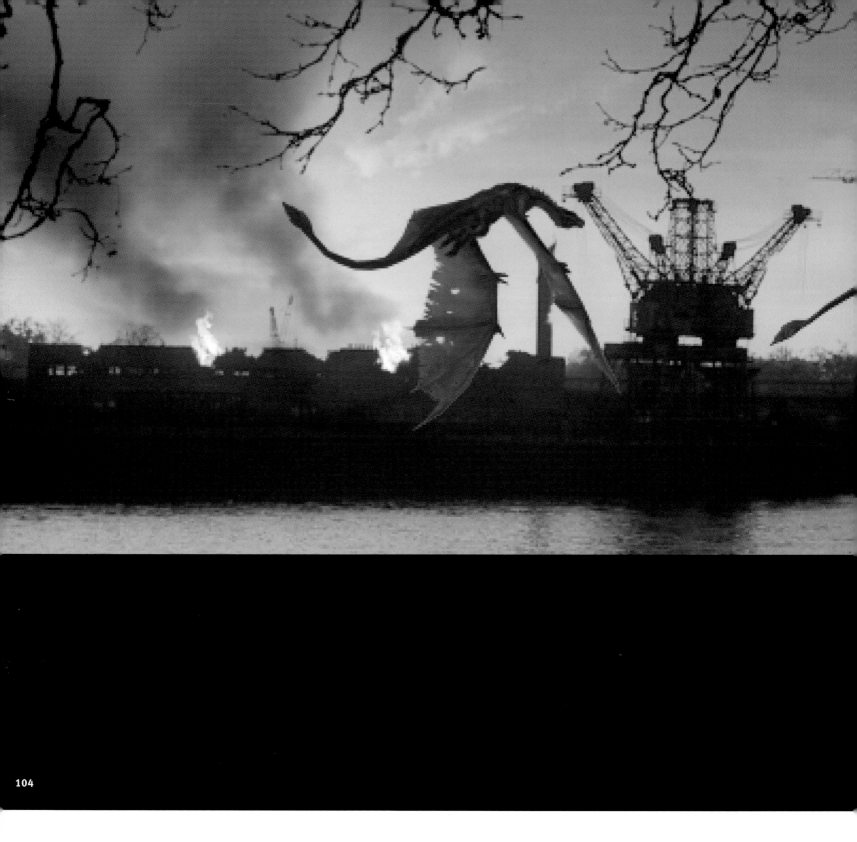

A BRIGHT CLEAN FUTURE?

Games have to a great extent taken over science fiction's role of imagining the future. In this section, we look in particular at game artists' assumptions and projections about what life will look like here on Earth.

Kuju's Reign of Fire.

THE SHAPE OF THINGS TO COME

How many futures are there? An infinite number in an infinite universe, perhaps. Although, if the cosmos is a chaotic system, then that infinity of possibilities consists of countless minuscule variations on a few broad themes. The majority of future visions still tend to reflect all-too human concerns and familiar perspectives.

First, there is the future of sparkling cities of steel and plexiglass, of classical skyscrapers criss-crossed with moving pavements. That's the future that H. G. Wells depicted as mankind's eventual reward after years of conflict.

Wells envisaged a future in which people built their cities underground so that the environment and weather could be perfectly controlled. Absurd? Walk through any British or American mall—or spend a day in Tokyo— and you soon understand that, in part, his future vision has been with us in the real world for decades. It might not always be the happy socialist paradise that Wells had in mind, but on the surface, it isn't miles away.

Then there's the crowded, rain-soaked, neon-lit, urban noir that's familiar from *Blade Runner* onward—a future where people still get wet, cold, dirty, and hungover, and where, if there are flying cars, you can bet the interiors smell of stale cigarettes.

Ironically, the more it becomes likely that our real-life future will resemble Singapore rather than Dagenham, the more that artists and writers have inclined toward visualizing dystopias. And even when the future is bright and clean, it usually masks a heart of darkness, as in Fritz Lang's seminal *Metropolis*, for example. Perhaps with good reason: it's difficult to believe in a paradise that has no human cost.

Writers of speculative fiction often say that there's no mileage in a utopia. If everything's perfect, where's the conflict? But there are a number of outstanding science fiction stories with utopian settings. The world of *2001: A Space Odyssey* is distinctly shinier and more outward-looking (clinical, even) than the real 2001 turned out to be. But there is still room for danger. The fact that there is no human villain, only poor bewildered HAL, is what elevates it to one of the greatest, if most enigmatic, fables of our time.

Utopias retain plenty of scope for conflict. Even in the most idealized future there challenges to overcome: for example, the problems of generational starship travel as explored in Arthur C. Clarke's *Songs of Distant Earth*. If you must have bad guys, there is also the possibility of adversaries from outside the utopia. For example, the Klingons and the Romulans threaten the humanist paradise of Gene Roddenberry's original *Star Trek* (once described as "the Kennedy administration in space"). Roddenberry was a smart storyteller. Most of the original *Star Trek* stories, like science fiction tales in general, were about mankind growing up.

Above: Quantum Redshift *by Curly Monsters.*

Opposite page:
Top left: *Ion Storm's dark future masterpiece,* Deus Ex.
Right and top right: *1960s cinema revisited:* Godzilla: Destroy All Monsters Melee *from* PipeWorks.

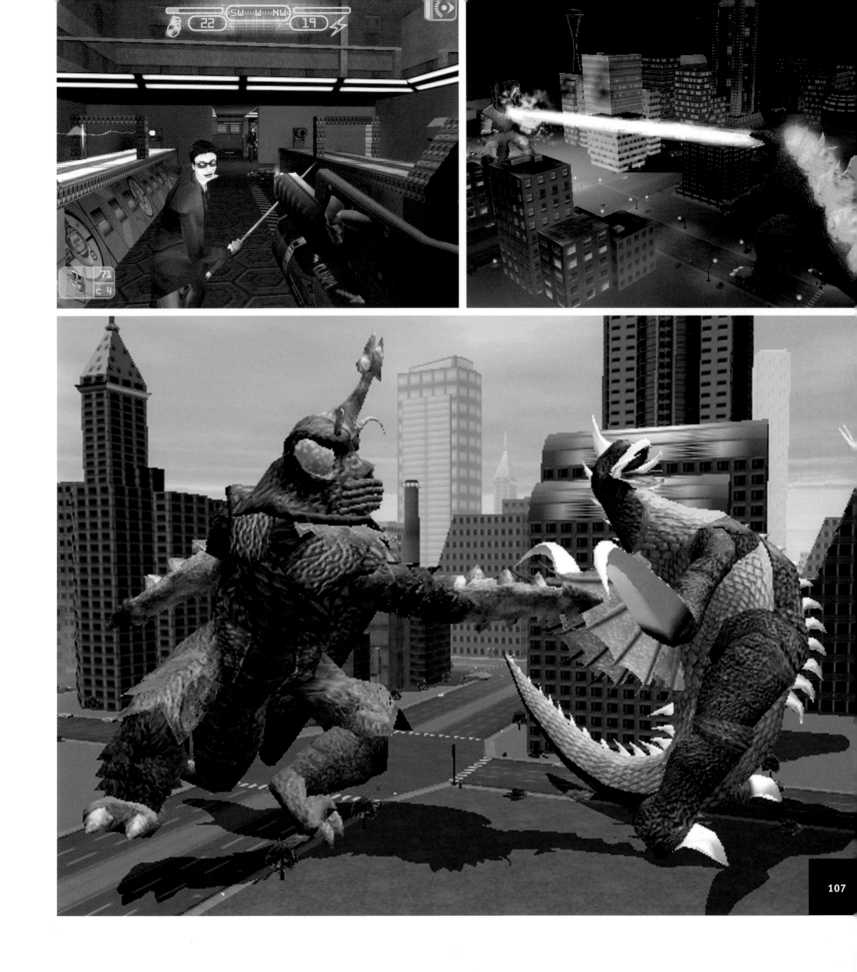

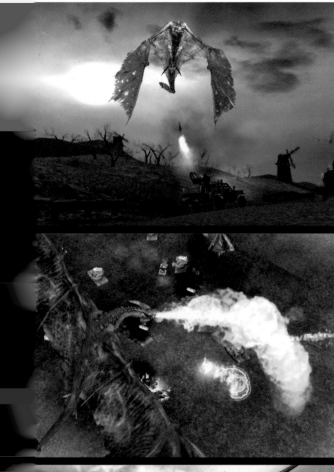

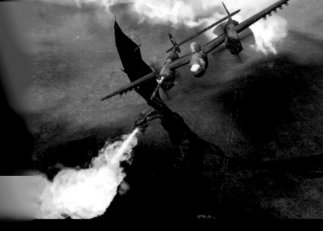

Alternately, you can have out-and-out villains like the crazed antagonists faced by Alan Moore's *Tom Strong*, defender of the retro-futuristic Millennium City. Even in a plausible paradise, there are serpents. It's one of Man's oldest, most resonant stories.

Most videogame artists find nothing to inspire them in the Modernist or Neo-Classical beauties of 1930s sci-fi cityscapes, preferring instead the squalid, inner-city jungles of cyberpunk. Sometimes, this choice is made for purely esthetic reasons: dark, rainy streets and smog-veiled sunsets look cooler and more convincingly urban, as pop video directors know. Indeed, the familiar imagery of cyberpunk may have been based on a misconception. Author William Gibson is said to have arrived for the first time in Tokyo and been surprised to discover that it was clean, well-lit, and crime-free. His imagined Tokyo was more thrilling, perhaps more Western.

More interesting still than the overused symbols of cyberpunk is the increasing trend among game artists to create wholly new visions of tomorrow. Hence *Reign of Fire's* future world, set a generation or two hence, which deliberately evokes a neo-medieval look to echo the grueling war between jeep-driving humans and fire-breathing dragons. As in Kalisto's *Dark Earth*—which takes place in a distant, post-apocalyptic future—the setting may be dark and full of danger, but you can hardly call them dystopias. Their theme is the triumph of the human spirit—a spirit which is often seen to be crushed in the teeming, brightly lit, superficially perfect future worlds discussed before.

Games have the potential to become the art form in which future worlds can be most vividly and thoroughly explored. Game artists can draw on politics, architecture, and biotechnology to build civilizations that are theoretically possible, and which let us examine our futures from the inside. While movies and novels can create an enticing facade, which we can populate in our imaginations, games let us go behind the scenes and play with a future that works.

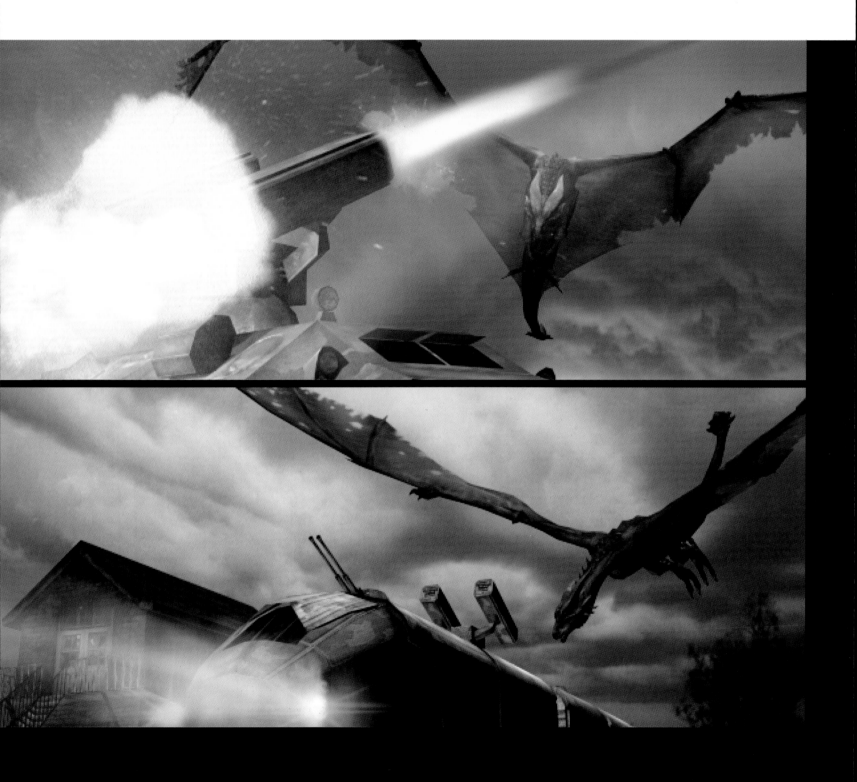

Left: *Boomer from Creative Attic's* Fangleworths. *Building a model from polygons in Newtek's Lightwave 3D modeling and animation program.* **Below:** *A character from Spellbound's* Robin Hood, *showing initial sketch, wireframe, and filled-polygon models, plus the final model with its texture map.*

Above right: *Stacks from* Fangleworths, *showing the underlying polygon structure.* **Below right:** *Creature from ZedTwo's* Pillage, *showing the relationship between polygons and the surface texture.*

The majority of modern games are played in a real-time, three-dimensional space. Even the graphics used in most of the games based on two-dimensional techniques have been prerendered from a 3D graphics program. The process of getting characters and environments into the final game starts with modeling, where the artist works as a digital sculptor and architect. They have to be skilled in the use of one of the popular 3D design and animation packages, such as Lightwave, 3D Studio Max, or Maya. The majority of 3D uses polygons as its building materials, coloring their surfaces with a 2D-painted bitmap known as a texture map.

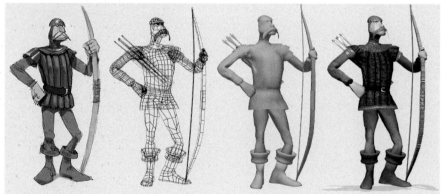

The virtual sculptor

The artist starts with a three-dimensional space of infinite size within the computer. This is defined by its origin, its center. From this point (0,0,0) distance can be measured along the X (side to side), Y (up and down), and Z (toward and away) axes. Giving X, Y, and Z figures in the chosen unit of measurement, such as mm or km, a point in space can be defined. This is the familiar system of Cartesian coordinates, supposedly thought of by Descartes when he considered the problem of defining the position of a fly in a cubical room.

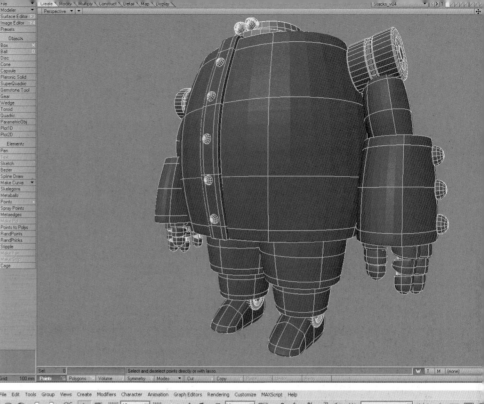

Once three points are defined, the computer can join them together and fill in the space, making a polygon. Objects are created by joining further polygons to the original. Although working in this way can be effective, artists usually draw on a workshop full of virtual materials and tools. They can construct from preformed "primitive" objects, such as cubes, spheres, and cones. These can then be scaled, stretched, cut up, or joined together. There are tools to create organic and free-flowing shapes, such as "metaballs," which attract and "gloop" into each other. With the power of modern computers, all of these processes are infinitely editable so the proportions of a face can be stretched and squeezed like clay, or cut and pasted to be used another day.

　　This process is common to prerendered film and to TV animation, as well. The difference is that 3D models in a game environment have to work in real time. This obviously has to be within the speed that the graphics hardware, in a computer or console, can calculate and display the 3D space as the player moves around inside it. Although, as with all computer hardware, graphics systems are getting more powerful, they still have limits to the number of polygons they can move around. The great skill of games modelers is to build very efficient, low-poly models. As the hardware becomes faster, so artists can work with more polygons, from the mere handful for a character of a few years ago, to several thousand and rising. With more polygons, curves can be less angular and models can include more detail.

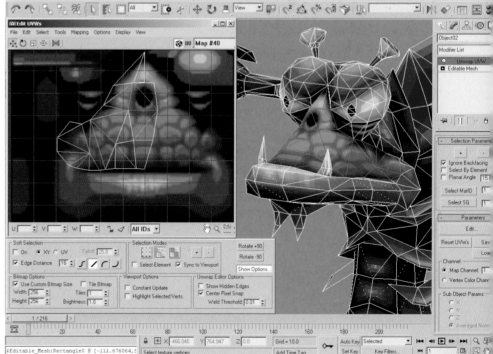

Map makers

Once built, a model then needs to be textured, or to have its surface painted. Although the polygons can be assigned colors, it is detailed painting that adds the real variety and richness. The process suffers from the same problems that cartographers face when depicting the world as a two-dimensional picture. The world has either to be stretched (Mercator projection) or peeled and spread out (Buckminster Fuller's depiction).

3D artists use a coordinate system called UV mapping, where they take their model, such as a character, cut it up, peel, and spread all its parts out flat for painting. This is all achieved in the 3D program, but a screengrab of the spread-out parts converts it to a bitmap that is loaded into Photoshop, providing a template to paint on. The resulting texture maps are often fascinating in themselves, like strange anatomical diagrams. Some 3D programs such as Maya have an integrated painting program that lets the artist paint directly onto the model in 3D, with virtual pens and brushes generating a UV map as they work. There are other stand-alone 3D paint programs such as Body Paint and 4D Paint, which have the same function.

Along with texture maps, the artist can provide the model with other maps that describe features. Reflection maps can isolate areas of the model that will reflect its surroundings. Specularity causes it to glint in the sun. Transparency, glow, and luminance can all have their own maps. Of special note are bump maps, which the latest graphics hardware can now support. An artist can paint a grayscale map that describes a 3D-surface texture, adding amazing levels of detail to a model. For example, bricks on a wall painted using a texture map look flat, but with an accompanying bump map, each brick stands proud of the cement around it.

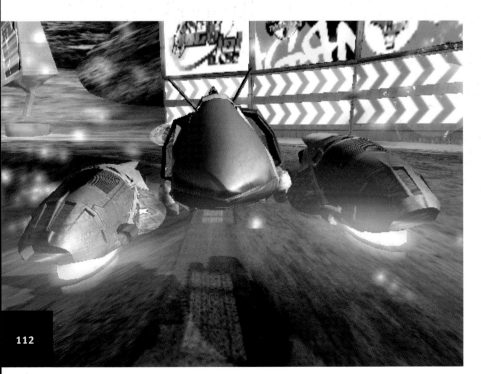

Left: Quantum Redshift, *by Curly Monsters. Polygons at work and play in the game.*

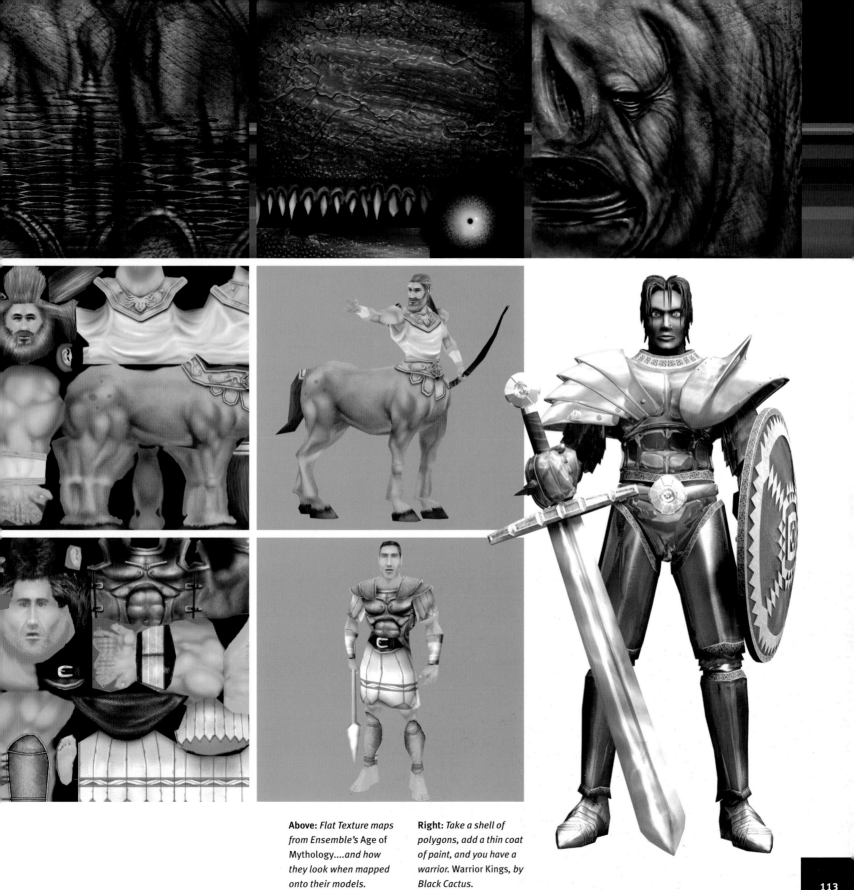

Above: *Flat Texture maps from Ensemble's* Age of Mythology*....and how they look when mapped onto their models.*

Right: *Take a shell of polygons, add a thin coat of paint, and you have a warrior.* Warrior Kings, *by Black Cactus.*

OUT OF THIS WORLD

Looking farther afield, game artists are boldly taking us beyond the solar system to the farthest reaches of the universe. The theory of relativity suggests that interstellar travel will never be practical in reality, but by the medium of the artist's imagination we can still voyage to those very distant shores. In this section we look at the final frontier: alien landscapes, strange new life forms, and the rediscovery of space opera.

Digital Reality's Haegemonia.

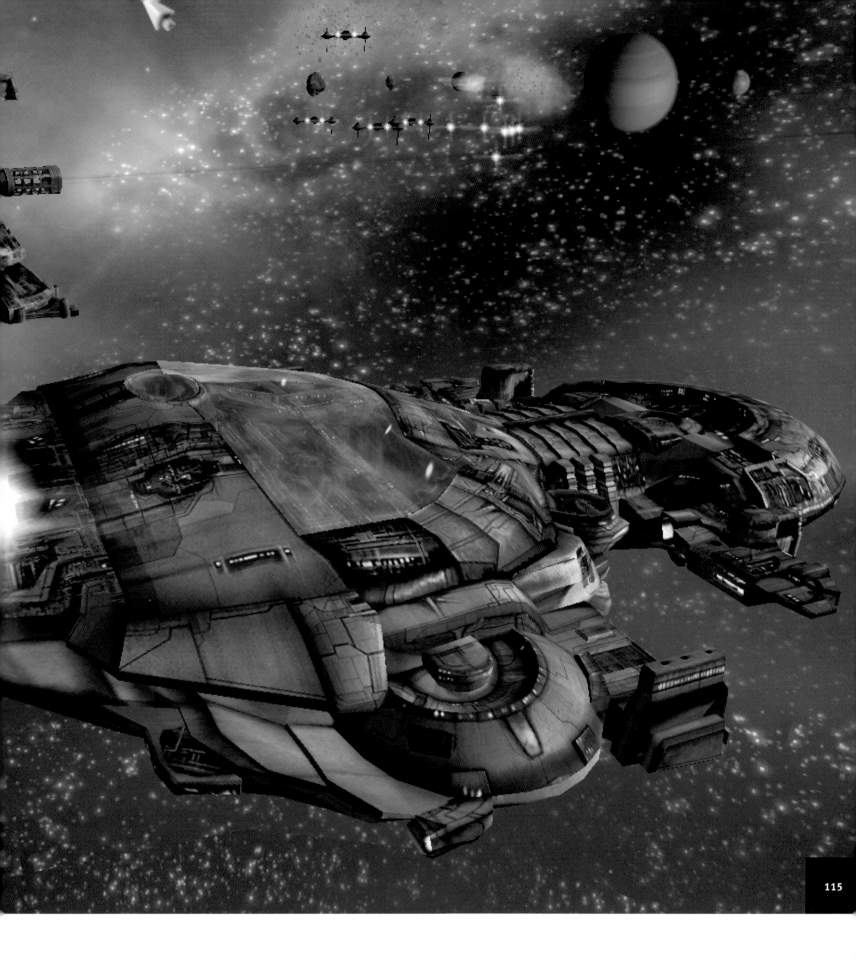

JUPITER AND BEYOND: THE INFINITE

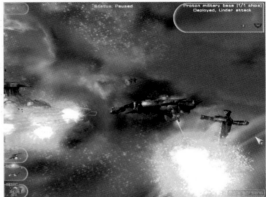

The literary science fiction of the 1930s, stimulated to excess by the voracious pulp magazine market of the Great Depression—and the unlimited budget that only the imagination can provide—created a monster of a genre in the "space opera."

It reached its literary zenith with E. E. "Doc" Smith, whose *Lensman* tales involve the destruction of galactic empires in interstellar battles on a scale that would bankrupt even George Lucas. Smith and his imitators took the imaginative sweep of the great SF pioneers like Wells to its logical conclusion. Why deal only with the future history of Earth, when new galaxies and mythologies could be explored?

In literature, space opera was not the pejorative term it has become today; it lacked the modern connotations of poor storytelling and cardboard characterization associated with soap operas, or the boy's own derring-do of the early cinema serials. "Opera"—in Smith's interpretation, at least—referred to the epic scale of the work and the formalized, heightened reality of its style. Empires rose and fell, centuries streamed by, and spaceships bigger than planets wielded death rays that could destroy a star.

All images: *Digital Reality's* Haegemonia.

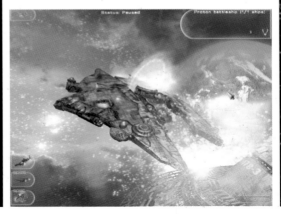

All images: *Westwood Studios'* Earth & Beyond.

In the context of such grand imaginings, the specks that are the lives of individuals achieve a poignancy that other genres cannot address. In terms of writing talent, "Doc" Smith is certainly no Tolstoy, but the scope and scale of the *Lensman* books is no less than that of *War and Peace*. Indeed, the heroism of Man is arguably more moving when set against the relentless, uncaring immensity of the cosmos. As Tennyson wrote:

"What is it all but the trouble of ants in the toil of a million million suns?"

Space opera never disappeared from literature, but it did evolve. Isaac Asimov injected a greater maturity of political and philosophical thought into the genre with his *Foundation* trilogy. The elder generation of space opera writers turned to new, more psychologically involving strands of SF. Most notable among them was John W. Campbell, who at one time was dispensing planet-busters with the best of them. Before the 1930s were over, he had penned the consummate mood masterpiece of horror SF, *Who Goes There?* (later to be filmed in various guises, such as *The Thing*). Other authors who had been pulp-fiction stalwarts made the hyperspace jump to film and television. Leigh Brackett, author of a host of Martian 'planetary romances' throughout the 1940s, is best known today as the co-writer of *The Empire Strikes Back*.

All images: *Relic Entertainment's* Homeworld 2, *for Sierra.*

For all that, space opera has only recently found a niche in TV and film, with the obvious exception of *Star Wars*, which succeeded by spawning a self-perpetuating, multibillion-dollar franchise and special effects business (including several cross-genre games). Lucas's oxygen-guzzling behemoth aside, the reason for the failure of the genre is the same as Khan's disadvantage in fighting Captain Kirk—two-dimensional thinking is inadequate for a three-dimensional world.

On TV, the Enterprise fired offscreen, then we cut to the Klingon ship being hit. That was pretty much the limit to which non-interactive visual media could convey the vastness of space and imagination. Granted, CGI allowed series like *Babylon 5* to flourish briefly, but for true space opera, none of this was enough, and the real action was studio-based. Further attempts to revitalize the genre will always be seen as yet more *Star Wars* wannabes, *Trek* impersonators, or even as Tolkien in space.

Now, though, we have interactive, real-time 3D games. Gamers can finally move closer to experiencing their fantasies at first hand. It's easy in a game to glide between two massive starships as they open each other's hulls to the cold vacuum of space with laser broadsides. Putting you in among a battle of a hundred vessels, separated by thousands of miles, is beyond most budgets to show convincingly, but it is easily realized in a videogame. Now we, like Roy Batty in cinema's epoch-defining *Blade Runner*, can see attack ships on fire off the shoulder of Orion. But again, Tennyson has the best phrase:

"Dull would he be of soul who could pass by a sight so touching in its majesty."

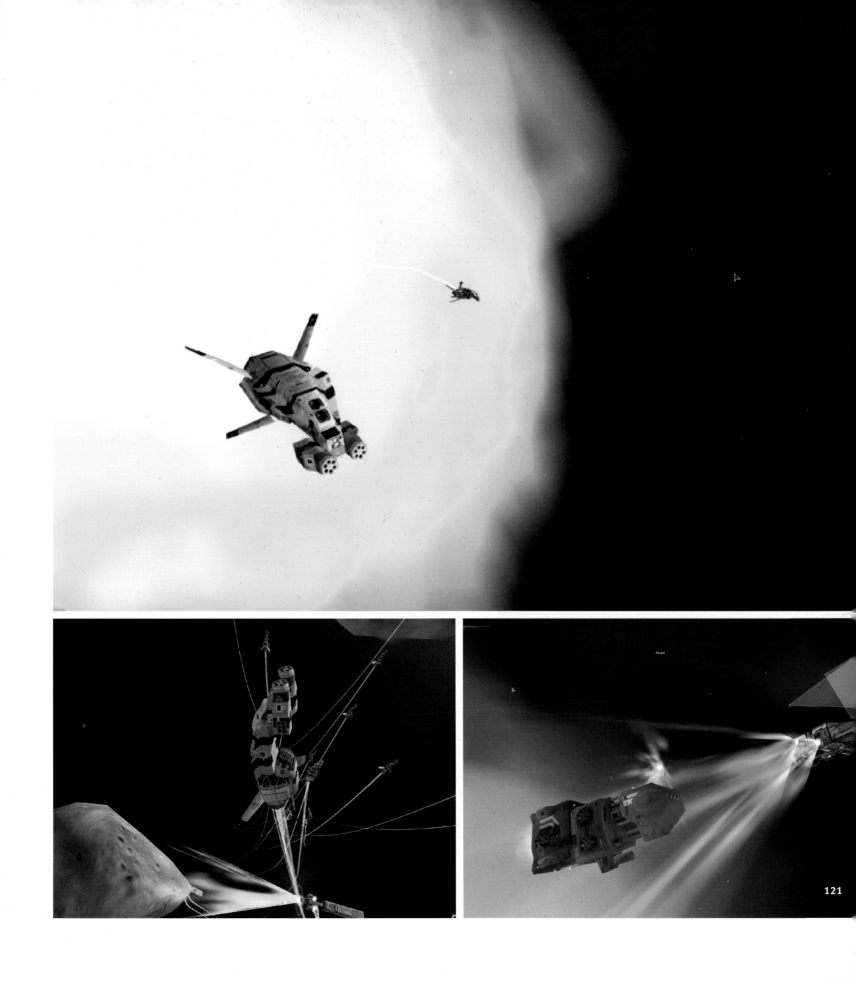

"Cut-scene" is the term applied to the noninteractive sequences that are used between levels in many games in order to advance the story. Full motion video (FMV) remains the most popular choice for cut-scenes, although some games have experimented with other storytelling techniques—for example, *Max Payne*'s graphic novel (see page 58), or the newspaper headlines used in *Respect Inc*.

FMVs can be animated or live action. The latter is rarely used without some form of CGI enhancement, however. Pure animation (usually 3D animation) is far more common. The production process for both animation and live action is the same. The first stage is a script describing the action, from which thumbnails and then a storyboard are prepared. The storyboard looks a little like a comic strip and depicts key camera set-ups and movements during the scenes.

The animation itself is usually done in a 3D package such as Lightwave. Because FMVs are often outsourced to a specialized animation company, rather than being made by the game developer, it used to be that the characters in the FMV bore little relation to the characters you saw in the game. Nowadays, the usual practice is to make hi-res versions of the in-game sets and characters.

At $15,000 a minute upward, 3D animation is expensive, although it does have an advantage over 2D in that you only have to build the models once. Once you have the sets, props, and characters, you can reuse them endlessly. You can even store common animation elements, such as a character's walk cycle, so that it does not have to be redone by hand each time. All of which means that 3D animation has advantages over 2D if you are making a lot of it.

Which is fine for a television series, but a game might only call for 30 minutes of FMV. Even using modified versions of the in-game art assets, that's still a lot of set-up cost for very little.

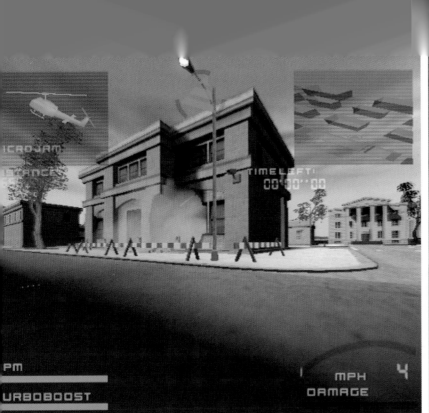

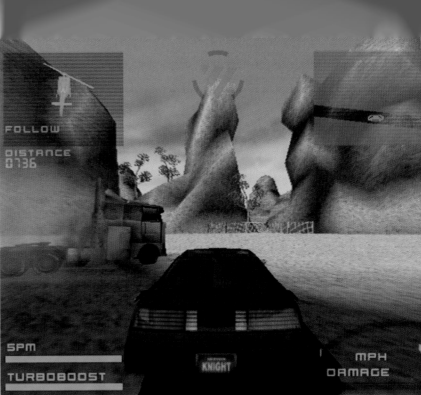

A cheaper option is to use the game engine itself to animate the characters. After all, you have built in not only the walk cycle but also physics, collision detection, and so on. With player control switched off, the game engine thus becomes a virtual puppet theater that you can use to create your FMVs. This technique, known as "machinema," is frequently used in modern games. A good example is *Outcast*, where it is possible, for example, to set off a chain of explosions in the game, trigger a cut-scene, and then watch the explosions continuing in the background while the characters act out the cut-scene.

　　The big advantage of machinema is that it is cheap—you're using exactly the same models and game engine that you've already built. Additionally, it has built-in continuity. If the hero goes into a cut-scene carrying an umbrella, then it's an umbrella that he'll be waving around throughout. In a preanimated sequence, it becomes harder to switch in different elements such as weapons carried, clothes worn, and so on. This helps make for a seamless experience, but the more fundamental problem of the remains. In this age of interactive entertainment, is there any place for scenes that aren't interactive?

"Cinematic techniques can be adapted for use in the games themselves, not just in cut-scenes," believes Paul McLaughlin of Lionhead Studios:

"Generally there has not been enough awareness in game development of how, say, recurring motifs can affect the player. For example, a color or sound might evoke a memory or create tension by warning of upcoming danger. At Lionhead, we're trying to maximize the potential of these techniques, but I think it's lacking in most games—apart from associating loud music with scary things that happen in dark places. What we've been trying with *Dimitri* is to use techniques like close-ups, cutting, and eye-lighting to enhance mood with the same effectiveness that you'd get in a movie. The challenge is how to integrate these cinematic tricks into an interactive medium."

CUT SCENE 1 'THROWN IN COOLER'

①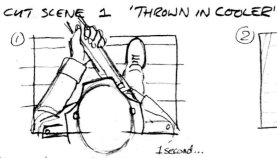

②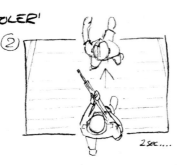
2 sec....

③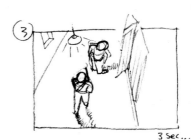
3 sec...

CAMERA: Close-up Bird's eye view ——→ zooms out

1 second...

→ lens tilts up to follow characters to the door.

CUT: ④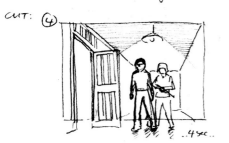
...4 sec..

⑤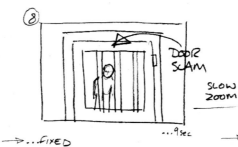
...5,6 sec

⑥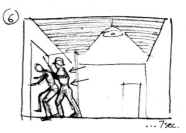
...7 sec.

CAMERA: →FIXED LOW LEVEL/HARSH LIGHTING ——→...FIXED CAM

→FIXED CAM.

CUT: ⑦
...8 sec

⑧
...9 sec

DOOR SLAM

SLOW ZOOM →

⑨

10..11..12 seconds to fade out.

CAMERA: FIXED

→...FIXED

→...SLOW ZOOM IN.

①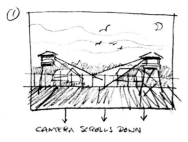

CAMERA SCROLLS DOWN

②

CAMERA RESTS ON PLAYER CHARACTER AS HE CLIMBS OUT FROM TUNNEL

③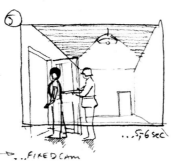

• CAM ZOOMS IN ON PLAYER AS HE TAKES A LOOK OVER HIS SHOULDER
• THERE IS THE RUMBLE OF DISTANT AIRCRAFT.

④

CUT: CAM LOOKING UP AT UNDERBELLY OF US. FORMATION.

⑤

CUT TO ALMOST BIRDSEYE VIEW OF CAMP PEOPLE RUN TO + FROM BUILDINGS AS AN AIR RAID SIREN STARTS TO WAIL

③b

CUT: CLOSE UP FRAMED IN EITHER A DOORWAY OR BETWEEN POSTS WITH WIRE FENCE BETWEEN CAM + GUARDS (ENCAGING THEM IN) FRANTIC MOVEMENT CARRYS ON

Left: *Thumbnails for a cut-scene from Wide Games'* Prisoner of War.

Opposite: Prisoner of War *cut-scene storyboards.*

124

1

Title caption: "Stalag Luft" ~ white text on black background.

Sound: Truck engine, ambient noise

2

CU on player seated in back of truck. The camera shakes and wobbles with the movement of the truck.

Sound continues from previous scene.

3a

The truck enters through the main gates. Camera pans to the right to follow the truck...

3b

continued –

...and tilts up slightly, to view the V2 rocket construction in the distance.

4a

Looking up at the partially-built rocket and scaffold, the camera gradually tilts down to show more of the rocket...

4b

continued –

... as Dr. Nemesis walks into shot.

5a

The truck comes to a halt in front of the barracks...

fixed camera.

5b

continued –

...the truck stops in front of the camera for a while...

Sound: voices, sounds of player being taken out of truck.

5c

continued –

...the truck pulls off, revealing the player and the EC and Barrack Officer, who show the player to his barracks.

There are whole universes of monsters to be vanquished, kingdoms to be saved, vile wizards to be thwarted, and truckloads of arms and armor to be sold. These are the worlds of fantasy role-playing—the ultimate in immersion—letting players live fantasy lives through their avatars, or onscreen alter egos.

MAGIC KINGDOMS

Morrowind *from* *Bethesda Softworks.*

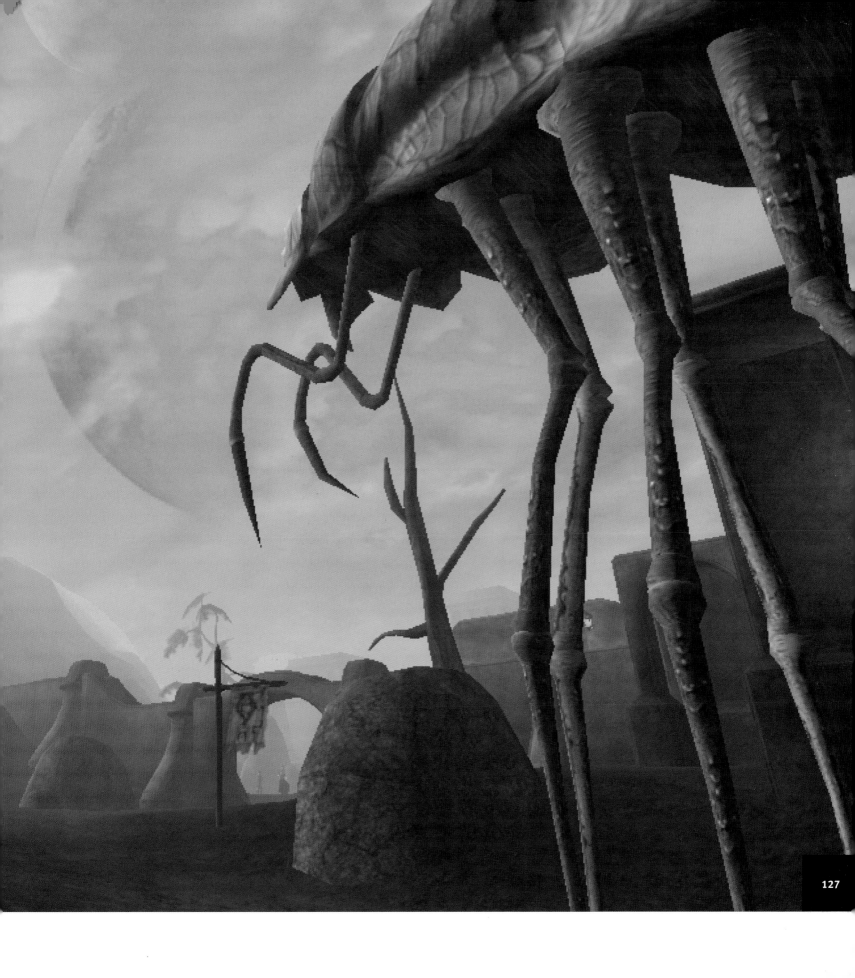

FAIRYTALES AREN'T JUST FOR CHILDREN

In fantasy videogames, the fairy-tale milieu has been so thoroughly and effectively subsumed by the *Dungeons & Dragons* style of role-playing that we may never think of questioning its tropes. Hence, magical places are always located below ground, priests of all deities dole out potions of healing, and warrior women put their trust in armor that's skimpy enough to make a monk blush.

Tolkien knew that wizardry and wild romance are not forces to conjure with lightly. His elves are more than new age travelers with pointy ears. They are an old race whose time has gone and, as the *Lord of the Rings* novels make clear, they do not think and feel as mortals do.

High fantasy is an often-derided genre. The best of it, though, like *The Lord of the Rings* or *The Worm Ouroboros*, transports us to another world that is beautiful and strange, yet familiar on a deep, almost atavistic, level. We recognize it as the landscape of our imagination that was first called into being by childhood stories, and which is rooted in a rich mix of history and folklore that touches different cultures. High-fantasy literature can take us on a journey of discovery about ourselves and the stories we tell about ourselves. The best role-playing games achieve the same sense of mystery and wonder.

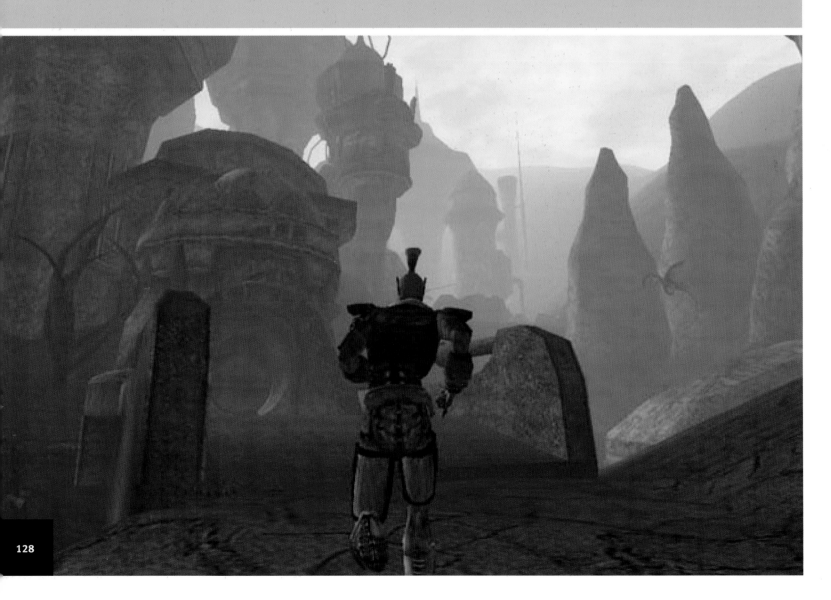

The universe of dragons, goblins, and elves is one rooted in our subconscious from childhood via the medium of fairytales.

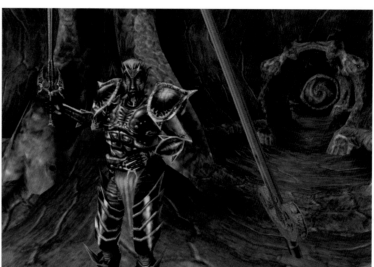

You're not in Kansas any more! Superbly inventive concept artwork and in-game visuals from Bethesda Softworks' role-playing game Morrowind.

A WORLD OF DIFFERENCE
GAS POWERED GAMES' *DUNGEON SIEGE*

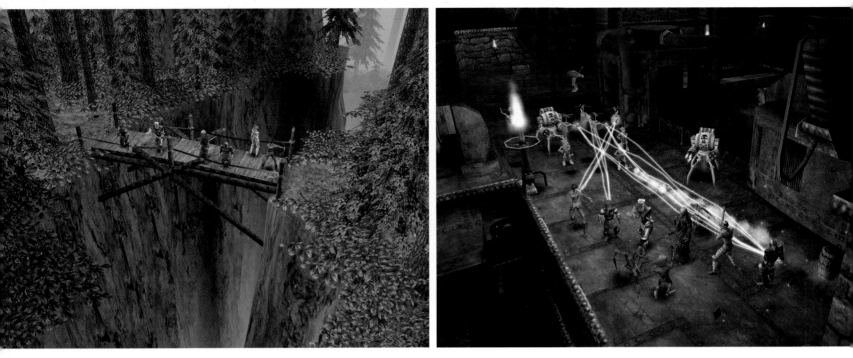

Dungeon Siege approaches its fantasy elements with a freshness and vitality that is rarely seen in the role-playing genre. The kingdom of Ehb, where the game is set, has its own history, culture, monsters, and nonhuman races. The effect is to draw us completely into the world of the game, where we soon learn to shudder at the thought of a Klaw lurking ahead in the forest gloom, and the mention of a Seck Mage is enough to terrify the bravest adventurer.

A glance at those extraordinary spider-legged, mechanical monsters encountered in the Inventor's workshops is enough to demonstrate how *Dungeon Siege* stands out from the plethora of Tolkien retreads that are common in the RPG genre.

In writing *The Lord of the Rings*, Tolkien was of course strongly influenced by the landscape around him. The smoke-spewing industrial towns of Britain's midlands (Blake's "dark, Satanic mills") evoked his vision of Mordor, while the leafy lanes and sleepy villages of England's countryside, the shires, became the hobbit Shire.

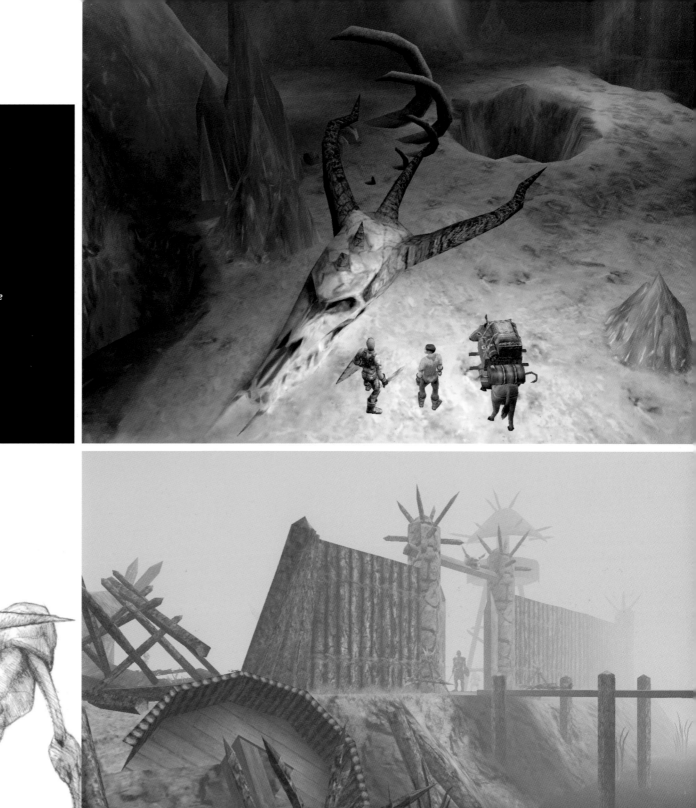

Far left: *The lush alpine forests of Ehb.*
Left: *Battling the Inventor's fighting machines.*

Right: *Adventurers reconsider the icy pathway.*
Below right: *The sinister Fortress Kroth.*
Below: *Concept art for the game's unique monsters.*

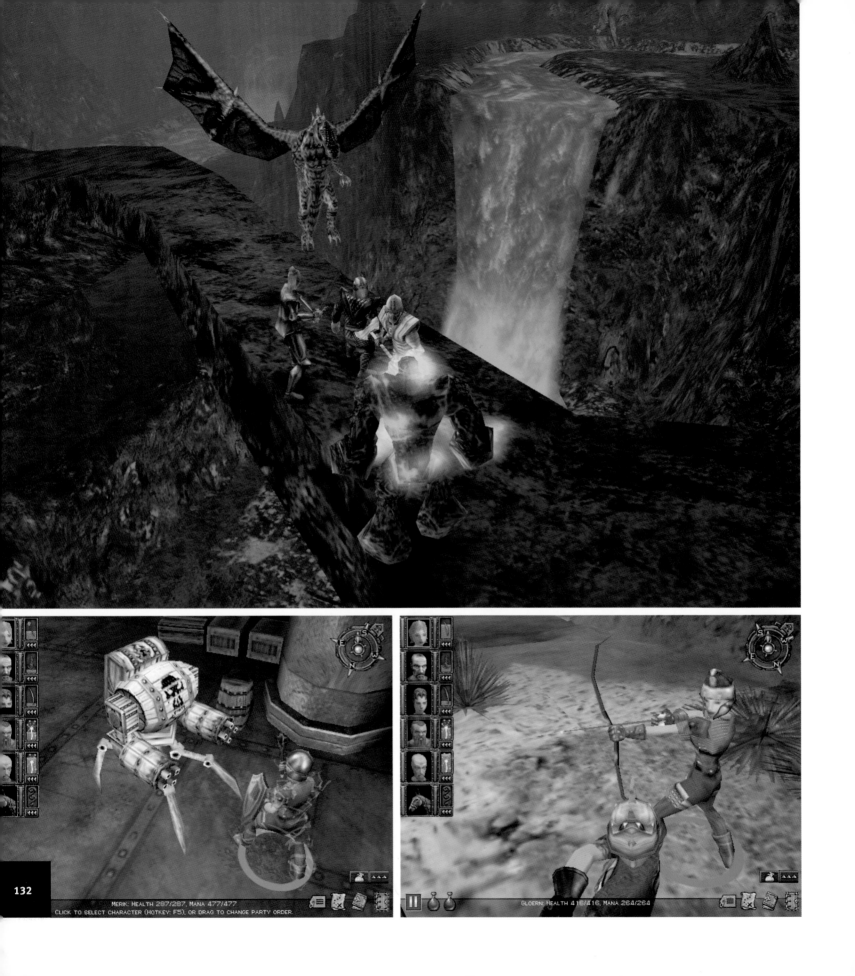

MERIK: HEALTH 287/287, MANA 477/477

CLICK TO SELECT CHARACTER (HOTKEY: F5), OR DRAG TO CHANGE PARTY ORDER.

GLOERN: HEALTH 416/416, MANA 264/264

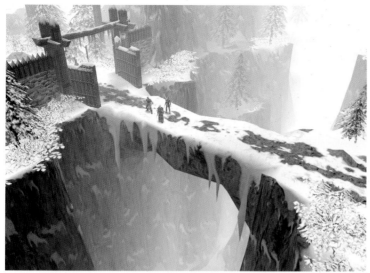

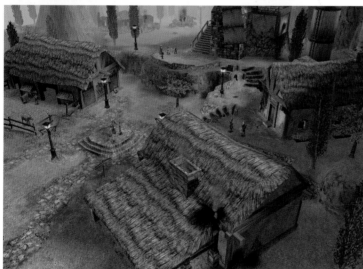

Opposite, top: *Encounters in a molten underworld.*
Opposite, below left: *Up close and personal with a war machine.*
Opposite, below right: *Comrades in arms.*

Above left: *Stonebridge.*
Left: *Entering Glacern.*
Below left, right: *More creature designs from Dungeon Siege.*

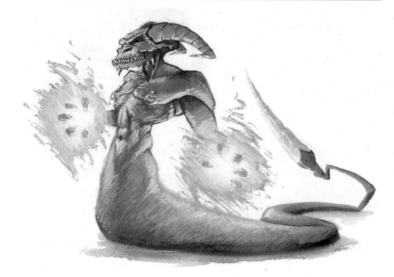

Part of what makes *Dungeon Siege* unique is explained by Steven Thompson, Art Director at Gas Powered Games:

"We're very fortunate to be located in the Northwest United States, where we have access to old-growth rainforests, mountains, oceans, lakes, and deserts. Much of our inspiration was obtained from our own backyard.

"The visual direction of the game begins with high-level inspiration concepts, sketches, and illustrations that inspire ideas for environments, characters, and even story elements. Making a richly interesting world is all in the details. If a game world has depth and detail, the player will see something different every time.

"Realism was our goal from the beginning, but achieving this look was an evolution. We continually added detail during the process, and made iterative adjustments to improve the visual quality. Quality and consistency are the keys, no matter what the style is."

133

ASHERON'S CALL

Asheron's Call 2 is another fantasy game that stands out by virtue of its originality and style. This belongs to the class of "massively multiplayer" online role-playing games. Thousands of players drop into the game world on a daily basis. This opens up the possibility of community-created art, in that, theoretically, players in such a game might develop entire cities, craft new costumes and devices, design in-game artworks, and so on.

Mike Sheidow, Lead Artist at Turbine Games, talks about the artistic and design choices in the game:

"The visual direction of *Asheron's Call: The Fallen Kings* is a collage of ideas from a number of artists and real-life culture. I wanted to create a world that was as beautiful as Riven, but edgy like a first-person shooter. Artists who influenced us ranged from Brian Froud and Roger Dean to Brom. Part of the challenge was to mix a number of ideas and make them feel cohesive. Our goal was to create a unique fantasy world that was new, but still familiar.

"The art direction process started with sketches of the avatars and their armor. It was important to gel all of these different influences into a new look. We realized that the world, the buildings, and the culture would revolve around the style of the characters. That's why we began by finding a strong look for the three-player races.

"As a player you need to relate to your character. You need to feel sympathetic to him when he's hurt, and you need to feel excited when he succeeds. Otherwise, you are not brought along with the game, you're just going through the motions. Abe, in the early *Oddworld* games, is a great example of this.

Above: *The band will be collecting tips after the performance.*

Above right: *Where there is friendship, there is also the potential for rivalry. Two factions vie for supremacy...*
Right: *Fantasy becomes reality once more.*
Far right, top down: *Online role-playing games are all about immersing oneself in a virtual world. Human avatars take your persona into another universe.*

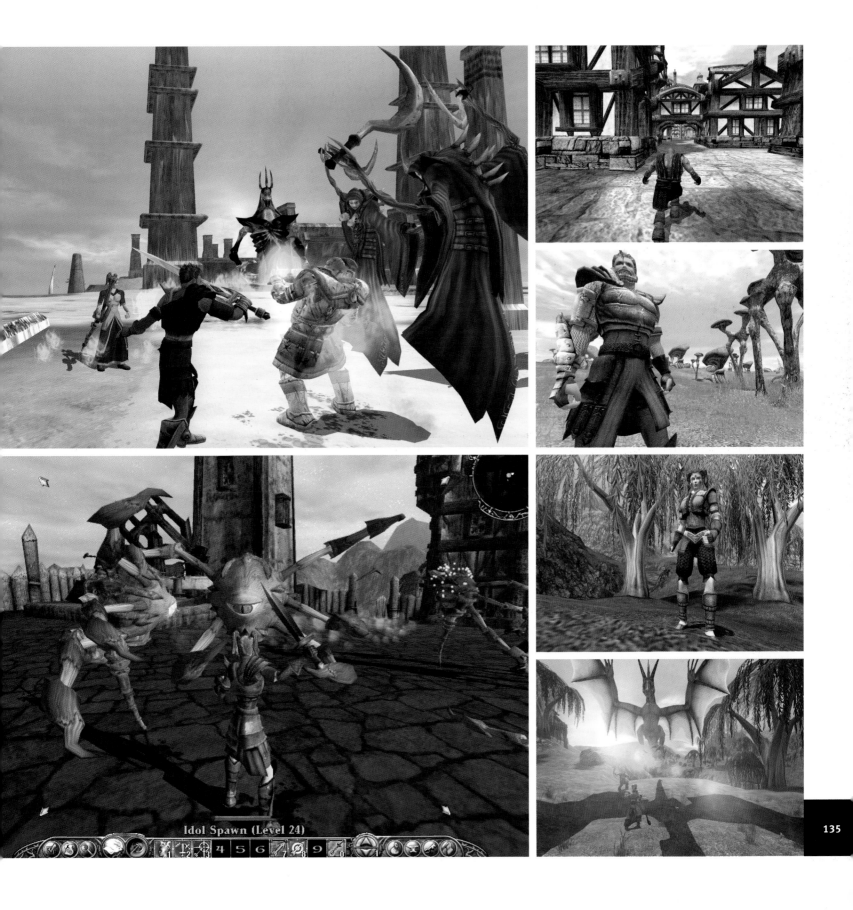

Idol Spawn (Level 24)

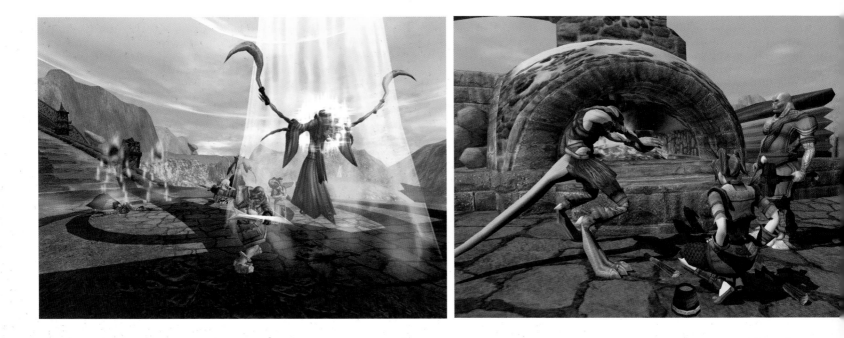

"Throughout the design process, the biggest concern was to make sure that everything felt cohesive. There were so many ideas in the beginning, with each artist bringing his own style to everything. I think I was very picky about certain details in the beginning, but once we had enough of the 3D art assets in the engine, it was easy to see what was working, and what wasn't. A drawing might look great, but might not transfer well to a model, so we needed to re-evaluate that specific design. Overall, I feel we stuck very close to the original vision.

"Personally, I appreciate when designs of armor, building, or contraptions in games look as though they might actually be able to work. It creates a sense of realism that I like. Texture and detail help to draw me in to this world and make me believe it's possible. The concept designs used for the *Star Wars* movies are great examples of this.

"The game world needs to have contrasting and unique environments. Without this visual variety, you don't have any incentive to explore. This is especially important for an online game. Players are going to be spending months or years in your world, so it needs to feel like there are different parts of the world with their own unique challenges, moods, monsters, and quests. The world must evolve and react to players' actions. In the case of *Asheron's Call 2*, Turbine provides this changing world on a monthly basis. Cities are destroyed, dungeons are unlocked, and new monsters await. The world must be compelling in order to keep players interested.

"Looking to the future, I definitely see game art experimenting with more painterly effects. There is a boom in cel-shaded games right now, and I wouldn't be surprised to see a watercolor-shaded game in the near future. Some companies will go with super realism, while others take the painterly direction. It's really up to an artist's imagination now, and not so much the technical limitations of the hardware. The online gaming market should be interesting to watch. It seems everyone is trying to jump on that bandwagon right now without realizing how difficult it is to make this type of game. The next couple of years should be pretty exciting."

Above left: *Being a fantasy hero means doing the hero thing.*
Above: *Online role-playing is as much about community as about fighting. Here, a group of heroes share a moment around the hearth.*

Right: *Before and after shots show the exquisite detail of the new Asheron's Call.*

IT'S IN THE BAG

The interface is a potential problem in many games, but especially in RPGs because of the need to convey so much information. Some game developers gave us their thoughts:

"The Dungeon Siege interface was designed to be functional, accessible, and customizable," says Steven Thompson, Art Director at Gas Powered Games.
"The player chooses which interface components will be visible. We also made the larger interfaces semi-transparent, so that players feel immersed in the environment even when the interface is fully expanded."

Mike Sheidow, Lead Artist at Turbine Games, adds:
"The interface should complement the game, not compete with it visually. The interface should be considered part of the artwork itself. It's part of the composition of the whole screen."

"Most role-playing games are basically massive databases," says Jamie Thomson, Creative Director of Black Cactus Games: "They're full of detailed and complex information that has to be made easily and conveniently accessible to the player. This makes good RPG interface design a real challenge. Some still use many different screens that you have to cycle through to find the info you want. That's the traditional RPG approach but other, more innovative, games are coming along that try to display as much information as possible through graphics and art rather than lists of text. For instance, instead of clicking on a menu button to get to a screen to show what beneficial spells are on a character, you use graphical effects to show that. So a character with a Haste spell gives off little wisps of light from his ankles, and so on."

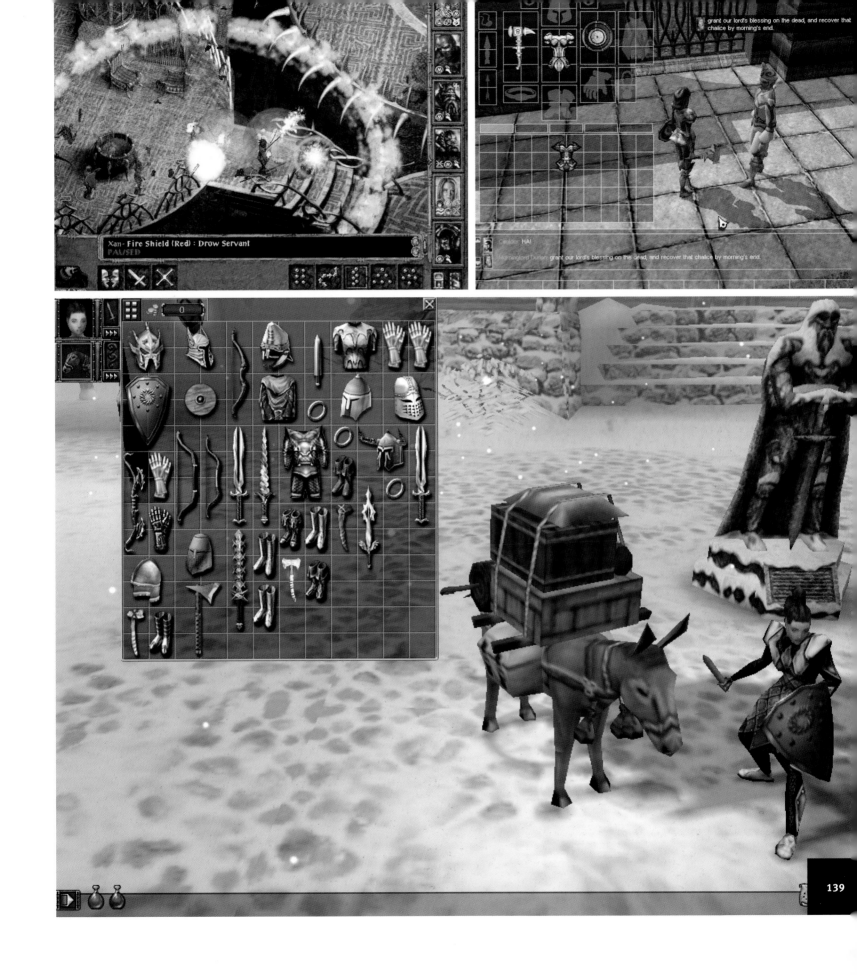

Xan- Fire Shield (Red) : Drow Servant
PAUSED

grant our lord's blessing on the dead, and recover that chalice by morning's end.

Morninglord Durlan: grant our lord's blessing on the dead, and recover that chalice by morning's end.

INSIDER SECRETS: CREATING A 3D WORLD

Few people understand 3D worlds better than games guru Sam Kerbeck, co-founder and CEO of Turn3D. Here he shares some of his knowledge. (The images were created in Turn3D's RealWorld engine with textures, height maps, and models by Richard Fletcher.)

"Terrain-based games are created using a variety of techniques, which directly influence the style of the virtual world they represent. Visual effects include a mesh level of detail, scale, height maps, textures, colors, lighting, and depth cueing. All of these will dictate how the world is perceived by the player. A flight simulator, for example, requires a large-scale world, whereas an adventure or strategy game with action taking place on the ground calls for high texture detail.

"The main component of any terrain world is the landscape mesh, which forms the structure and layout of the world. Landscape meshes receive special consideration beyond that given to standard polygon mesh models due to their inherently large scale and uniform layout. Typically, landscape meshes are constructed by overlaying a height field on a regular grid (fig. 1), which defines the world features and regions, such as mountains and valleys (fig. 2).

"Most of the visual techniques are applied primarily to the landscape mesh in terrain worlds. The grid uniformity allows the grouping of rendering effects by applying textures, lighting, shadows, and fogging consistently across the landscape. The size of the grid cells affects the mesh detail directly—reducing the size of the cells will increase the detail of the mesh.

1 2

Combine this with the correct coloring and lighting and a landscape region can be easily transformed into a seabed, for example *(fig. 3)*.

"There are many techniques used for rendering skies in terrain worlds. The most popular include a dome with sky textures placed over the landscape. Other variants are a cube, or cylinder. These can be modeled in the normal way and included in the terrain.

"Some systems such as Turn3D's RealWorld terrain engine uniformly utilize the mesh technology for generating the sky and sea in the world. The sky is a planar mesh rendered with an appropriate texture. Representing the sky in this way makes it possible to light different regions of the sky to depict atmosperic light variance. Similarly, the sea is a separate mesh rendered over the landscape.

Below, left to right:
1. A regular grid of vertices forms the basis of a landscape mesh.
2. A regular landscape grid with a height map applied to the vertices.
3. Landscape mesh with coloring depicting a seabed.
4. Dynamically changing height and shading on the sea mesh gives the illusion of waves.

The vertex heights and colors and texture of the sea grid cells can each be dynamically and uniformly modified according different equations to represent waves *(fig. 4)*.

"Regular 3D grids by are straightforward to manipulate dynamically. Changing the landscape in realtime can be an effective addition to a game's environment. For example, the landscape mesh can be deformed dynamically by meteorites, or show ripple effects with big explosions. In fact, the whole mesh can be morphed to a completely different landscape by interpolating each grid vertex to a new position."

141

3 4

Top left: *Using a smudge tool, this height map translates to a very interesting spiral in the 3D world.*
Centre left: *A simple technique with circles of varying intensity and dark lines to depict a volcano.*
Below left: *The plateau height map was created by merging an Xray image with clouds and a lens flare effect.*

Height maps

"Height maps, a popular method for generating landscapes, are 'contour' pictures depicting the elevation of vertices on uniform 3D grids. The height map is usually created in a paint package such as Photoshop, with the grayscale representing height. There are also algorithmic methods where the height map is generated by a set of equations or fractal systems. It is always amazing how these maps translate to 3D landscapes, as the accompanying images show."

Materials

"Materials are the most important component of any game graphics, directly influencing the look and feel of the game. Materials are the backbone for visual coherence. When a game design specifies a world, materials dictate the visual, physical, and atmospheric nature of the game environment.

"The shading model defines how materials behave when they are lit. When rendering a scene, the shading model combines the attributes of each material—things like texture, color, shininess, and translucency—with the attributes of light sources, including color and direction. Materials can then be shaded differently depending on their physical attributes. A metal surface would have high shininess factor, glass would have transparency, and so on.

"Experimenting with material attributes is a very effective technique when generating game worlds and objects. Additionally, materials' attributes can be modified dynamically, including color and even texture, enhancing the visual effects. This technique can be applied when animating waterfalls, fire, lava, clouds, and so on."

Top right: *A world with two light sources (one blue) and smooth shading applied to a material of medium shininess.*
Center right: *Materials can have the same texture, but different degrees of "shininess".*
Bottom right: *Landscape with only the raw texture applied, before the addition of lighting.*

Scale

"World scale is conveyed by texture detail and the sizes of polygons and objects relative to the game environment. Ambiguous texture detail with small objects on a vast landscape would give the impression that the world is viewed from a great height—useful for flight games.

"Techniques such as texture mip-mapping can be applied to ensure texture integrity at any zoom level. To create mip-maps, a texture is produced with different sizes. The renderer interpolates and selects the appropriate size of the texture for the size of the landscape polygon it is applied to. Smaller (and therefore more distant) polygons use the smaller (less zoomed-in) textures. This also greatly reduces the aliasing caused by certain types of textures.

"Scaling is a fine art. Unless the game is a simulation, or contains objects that can be easily measured or resemble real-life, the relationship between each of the components that affect scaling is very important. The genre (first person, third person, or tabletop) is a good starting point when deciding on scaling factors. Size and detail of one of the main objects in a game can be decided first. This sets a reference point for other objects' sizes and texture detail."

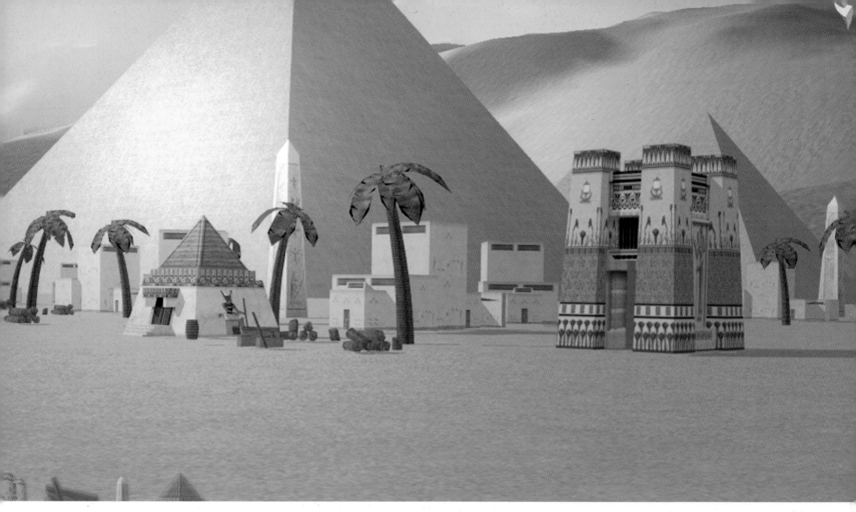

Above: *Models placed on the terrain, shaded according to the light source.*

Far left: *Using a selection of small objects in a landscape produces an impression of vastness.*
Below: *4-level texture mip-mapsranging from 256x256 pixels for close-up use to 32x32 pixels for distant objects.*
Left: *Mip-mapping ensures Texture detail is maintained close up*
Below: *4-level texture mip-maps: 256x256, 128x128, 64x64, 32x32 pixels.*

Objects

"In terrain worlds, 3D models are placed and registered with every landscape grid cell they cover. This defines in one step which objects are visible from a certain viewpoint.

"For vast terrain worlds, objects' level of detail will be necessary to avoid visual discrepancies. An object could be designed at three levels: high, medium, and low detail for rendering at near, middle, and far distances.

"In certain situations an object might consist of one polygon only, with a texture mapped onto it. This polygon will be made to always face the viewer—a technique called "billboarding." The best use of billboarded polygons is when representing forests. This allows the inclusion of hundreds of polygons with appropriate tree textures in a games world.

"Billboarded polygons, although effective, are very limited, however. Since they rotate to face the viewer, only symmetrical shapes can be used; otherwise the rotation will be clearly visible. Using certain type of textures helps reduce this side effect.

"Another problem occurs when viewing from directly above; only the topside of the polygon would be visible. To get round this, the polygon can be tilted slightly back as it is viewed from above, and, when viewed at the 90-degree mark, the texture can be swapped to one that represents the top of the tree. This texture swapping can be extended to include many frames so that it is as smoothly applied as possible."

11

A STEP FARTHER OUT

Project Nomads *by Radon Labs*.

Look through magazines and
you can see immediately that most
games look like other games. Each genre
has a set of common imagery, and so we
often see big machines, dark corridors, and
buxom girls with guns. Even the outstanding
games rarely break new ground visually.

And yet every so often there is a game
that is completely unique, instantly
identifiable by having a look and feel all its
own. In a medium that has many examples of
very fine art, these are the masterworks.

AN APPETITE FOR MARVELS

How many different kinds of dream are there? Role-playing fantasy has its roots in the medieval world as envisaged in Dungeons & Dragons, a cosmopolitan American theme park of feudalism where there's a dwarf in every tavern and elves and half-orcs are your next-door neighbors. SF games are not as homogeneous as that, but still share a set of common inspirational sources. Contemporary fantasy is dominated by dystopian urban imagery—a dark, brooding look that is fast becoming as traditional as Wedgwood china.

There are shared images in any creative medium. Think of horror films throughout the 1930s. James Whale was successful in creating a whole new look with *Frankenstein*, but success breeds imitators, and many later films borrowed the same imagery. Today we still see the influence of *Blade Runner* and *Aliens*—movies from two decades ago—in games, even though sci-fi film-makers have moved on to fresh pastures.

When imaginary landscapes become familiar, even comfortable, we know that fantasy is losing its edge. The value of fantasy is that it can take us on a journey of the mind, imagination, and spirit. That is why it feels so exhilarating when we come across a game that does it all differently. Such games—very often Japanese or French, it must be said—simply astound with their originality.

If videogaming achieves recognition as an art form, then in a hundred years' time these are the games people will marvel at in the Tate.

Above left & center: Little Big Adventure 2.
Above right: Myst III: Exile.

Top right: Crimson Skies
Right: Atlantica.
Below right: Oddworld.
Far right, above: Azurik.
Far right: Myst III: Exile.

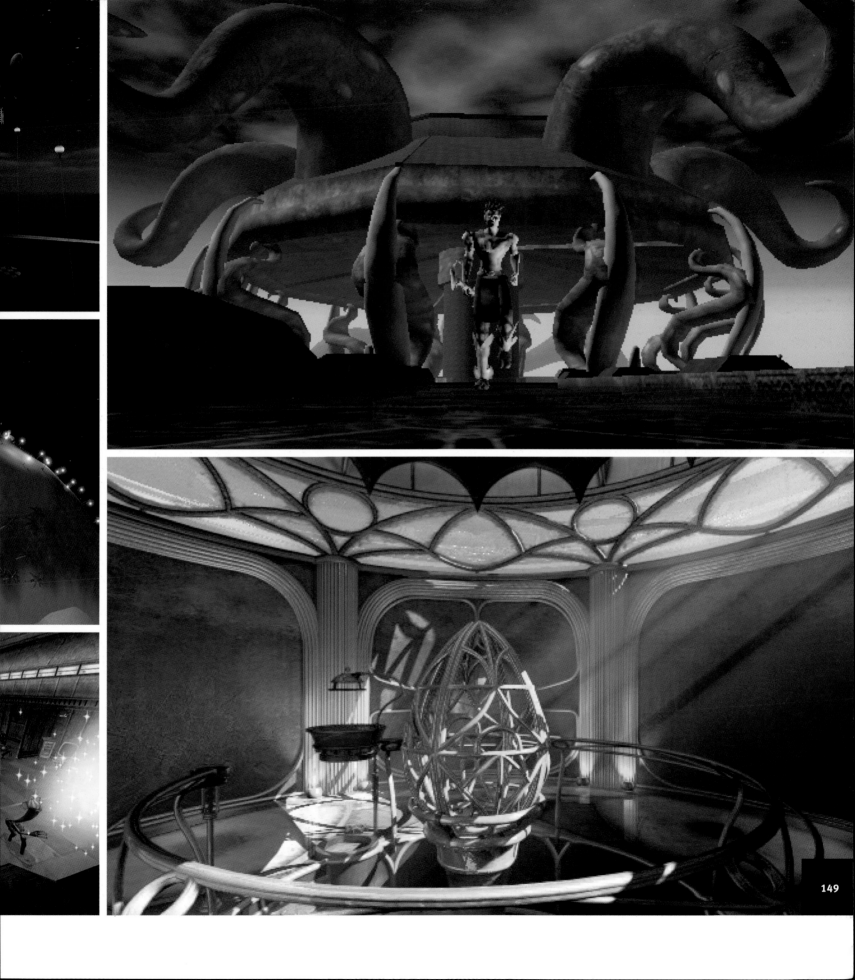

EL DIA DE LOS MUERTOS

LucasArts' Grim Fandango takes its inspiration from the Mexican Day of the Dead festival.

The setting is El Marrow, the city where the souls of the recently dead arrive to begin their journey to the afterlife. The land of the dead is depicted as sleepy and full of secrets. It has a sultry, dreamlike quality, but all the same, things happen there. By contrast, the land of living is composed of brashly hued snapshots. It's a garish, glossy world which, the designers seem to be saying, is full of bustling action and yet shallow and meaningless.

Day of the Dead imagery juxtaposes life and death. In an inspired inversion, characters in the *Grim Fandango* world are dispatched with guns that sprout flowers through their skulls and ribcages. The effect is beautiful and eerie, and at the same time more effectively shocking than the desensitizing carnage found in the majority of videogames.

Because the plot involves mystery and danger, and the hero never knows who he can trust, *Grim Fandango*'s film noir styling works perfectly. The guides of the dead are depicted as private eyes and their offices are located in an art deco building typical of the 1930s. Except that there's a subtle twist. Where art deco drew to an extent from ancient Egyptian design, the *Grim Fandango* version uses a restyled art deco substituting motifs from the pyramids of the Aztecs and Maya.

If the border town of El Marrow is Mexico as it used to be, the living world is 1950s US, brilliantly rendered in a style reminiscent of the collages and painted-over photographs of Pop Art practitioners such as Richard Hamilton. Taken as a whole, *Grim Fandango* displays what is perhaps the most imaginative and internally consistent art direction of any video game yet produced.

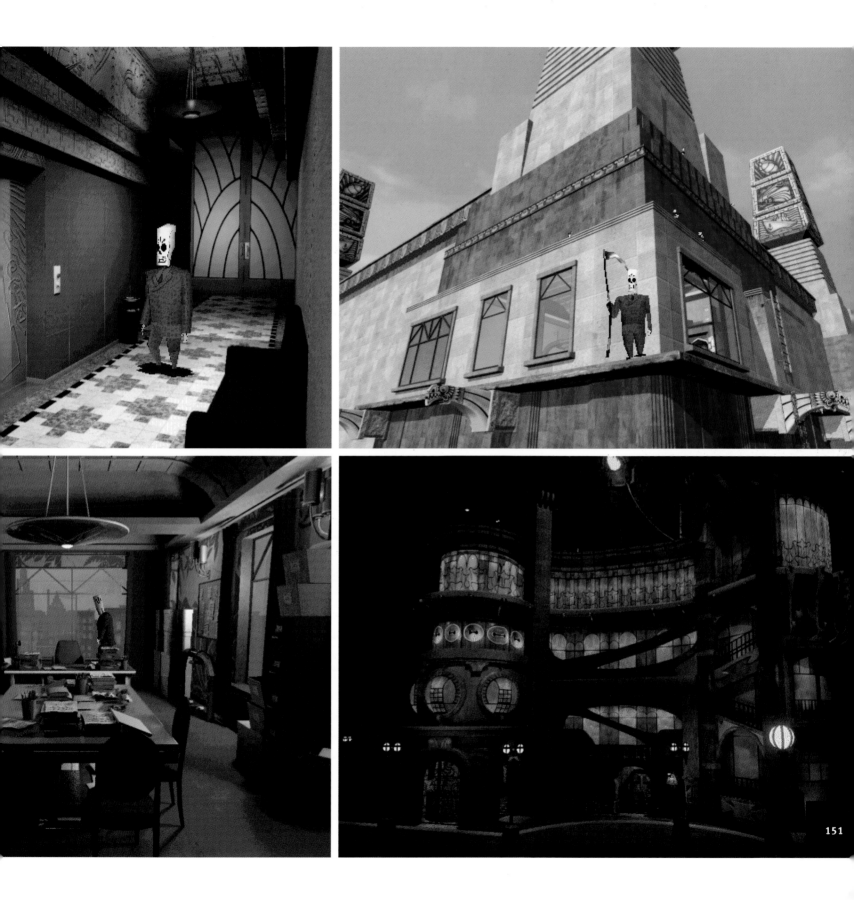

ULUKAI TE HO!

At first glance, Appeal's game **Outcast** belongs to the adventure genre. The truth is that **Outcast** does so many things its own way that it really defies definition.

Our hero is Cutter Slade, a Navy SEAL who is roped into a dimension-hopping experiment that takes him to an alien world. There he learns that he's a legendary hero whose coming has been prophesied for years. Hitting the ground running, Cutter has to lead a revolution, rescue the girl, and save the Earth from destruction.

Sounds familiar? Not the way *Outcast* does it!

To begin with, most story-based videogames even today are very linear. The story is constrained into a linear form. The problem with such an approach is that linear storytelling is something with which other art forms already cope very well. *Outcast* lets the player explore the story in the same way that he or she explores the landscape: by roving freely between different territories, picking up information in no particular order, ignoring elements that don't interest, and concentrating on others that do. No two players' experience of the *Outcast* storyline are exactly alike. In structuring the story like this, Appeal recognized that in interactive storytelling, the player is as much the author as the designers are.

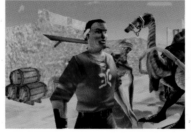

It also helps that *Outcast* has a witty, intelligent script that sustains our interest and makes us care about the characters. The musical score, performed by the Moscow Symphony Orchestra, would do credit to a great Hollywood epic. The voice acting is superb, and the sound effects are highly evocative. As we walk through the market of Talanzaar we hear

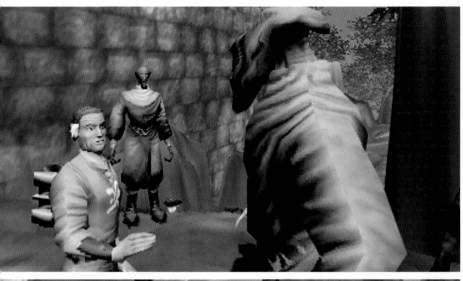

the babble of voices, the strains of pipe music, and the trudge of alien feet on sand. We can easily forget that there are only a few characters visible onscreen at any one time. It feels like a teeming city.

Moreover, *Outcast* is far beyond the usual simplistic conflicts common in science fiction and fantasy. Cutter's enemies don't do things simply because they are evil. Characters have real, complex motivations. And what makes it all the more believable is that the bad guys aren't orcs or vampires, existing solely to do evil acts; they are an army drawn from the same population that they terrorize.

But all those things merely show that *Outcast* can do great storytelling as well as any movie. The really important factors are the unique stylistic touches that help make *Outcast* more than just an interactive adventure movie. They make it a trip to an amazing new world.

Outcast is full of great locations. The landscapes are set against alien skies that were painted as dioramas by lead artist Franck Sauer. There are points during the game that you have to forget about the adventure for a moment and just stop and marvel at a breathtaking view.

The Talan aren't humans with a few bobbles stuck on their heads, like in so many TV sci-fi creatures. They really are alien. Their unusual look is a clever way around the limitations of the graphics, of course. We don't have the same expectations that an alien face will display detailed emotion, so we quickly get used to taking emotional cues from their gestures and tonal inflection instead. But that's just the technical question. Most importantly, the quaintly comical Talan with their clumsy splay-footed gait and childlike innocence are endearing. We get to like them, and so saving their world ceases to be a cliché or a mere game objective. It becomes personal. It's something we want to do.

Outcast is distinguished by hundreds of tiny details that reveal the care and artistry that have gone into its creation. The rusty streaks that stain the stonework of Fae Rhan's palace; the unique and clearly alien flora and fauna; the simple yet engrossing subplots; the breathtaking otherworldly vistas; the humor and the humanity. All contribute to a work of digital art that ranks among the greatest yet produced. Cutter Slade goes on an adventure. And we go with him.

ISLANDS IN THE SKY

Gravity-defying islands float in an early evening haze, supporting structures of rusting mechanical equipment. Weaving among them in a display of aerobatics are moustachioed flying aces of the 1900s. Radon Labs have created an unexpected extension to a place in history that we know well. In taking this route they have agreed to work within a defined historical style, but instead of letting it restrict them, they have used it as an imaginative springboard. While recognizable biplanes of the period skit about, other invented contraptions lumber about belching smoke into the waning sunlight. A closer look reveals machines that could have been made in the 1920s, with leather-belted canvas canopies and rusty corrugated exhaust pipes. Their shapes, however, are strange and alien, designed in an era that became mired in time.

 The artists have found equal variety in the islands that act as aerial aircraft carriers. Some are entirely industrial, like great flying oil platforms burning off their excess gas in bright jets of flame. Others support micro landscapes whose flora change from spring greens to fall browns. Yet more err on the side of the preposterous, like the lava-spitting flying volcanoes. The pilots posture in every variation of flying ace behavior imaginable, in their flamboyant leather-encased aviator suits.

 The imaginative use of such design is enhanced by the whole atmosphere of *Project Nomads*. The designers have been able to take an action flight simulator with all its rushing speed and violent explosions and give it the visual splendor of a 19th-century oil painting. Through innovative design and the trained eye of an artist, *Nomads* extends the visual boundaries of the virtual landscape into the realm of art.

154

"It's always interesting to see the way that games try to simulate reality," says André van Rooijen of Davilex:

"Lighting is a very important and elusive factor in creating a believable world. It's very hard to get right. The *Gran Turismo* series is an excellent example of the superb use of lighting."

"The exteriors in all levels of *Prisoner of War* use cold or neutral colors and detail maps to evoke a hostile environment," says Tim Fawcett, Senior Graphic Artist at Wide Games:

"This is the perfect environment in which to set objects with complementary, brighter, saturated colors. The red- and white-striped sentry boxes and red and white flags [*above left*] bring balance to the palette. Against such a backdrop, the characters stand out well with their more intense coloring, some with ruddy face textures. The interiors use a warmer texture palette and are enhanced by vertex lighting which can provide a chiaroscuro effect. This creates visual variety by contrasting two different-feeling environments within the level." [*above right*]

Ben Hebb, Senior Graphic Artist at Wide Games, adds:

"*Prisoner of War* is based on a daily routine which the player character and all other prisoners must follow. You are continually moving around the camp, to and from mealtimes, to and from exercise—all in real time. It is during these movements that the player can observe sentry patrols, interact with the other characters, and plan his or her escape.

"The day/night cycle was crucial, therefore, to both the playability and the visual esthetic of the game. This image [opposite, above] shows the morning and evening roll calls that were compulsory for the player, his absence triggering a camp-wide search.

"We experimented with the position of the sun and moon and their relative arcs of rotation. Needless to say, we went for what looked good rather than a realistic movement rising in the east to setting in the west! Altering the positions allowed for more dramatic lighting across buildings and the shadows cast by them. An important question was what color to light our scenes at night. You still had to see everything to play the game while maintaining the claustrophobia of darkness. Our conclusion [opposite, below] was to use blue light for this effect—the same solution often seen in films."

Apart from the technology of creating a world, there is also the question of what makes the world appealing to players. Tancred Dyke-Wells of Kuju Entertainment believes two factors are important: "First, a strong sense of place, an atmosphere that evokes in the player some reminiscence of somewhere they may have been in real life. Shigeru Miyamoto talks about these influences with reference to *Legend of Zelda*—caves discovered as a child and so on—although the game is a bit too saccharine for this to be evident. But in *Ico* you can almost feel the sun on your face and shiver when you walk into shadow. Environmental sound is, if anything, more important than graphics with regard to these sensations—the chirruping of night insects, or the howling wind when on a high pinnacle, for example. Some logical detail in the environment is also important. The scene at the start of the original *Tomb Raider* where wolf tracks in the snow could be followed back to their lair was strongly immersive and atmospheric.

"The second thing is consistent rules, whereby the same things apply to the player as to enemies. For a game to feel like a self-contained world, you need to feel that events are emergent qualities of a rule-governed system, the denizens of which are self-determining agents rather than heavily limited by scripting. Investigative exploration is only interesting where things can happen differently each time you play. To put it another way, if the same little elf always pops out from behind the same tree every time you go there, it's boring."

INTIMATE WORLDS

Games have often self-consciously looked to cinema for inspiration, but perhaps it would be more logical to see games as a new form of television. After all, most of us experience our games via the TV and the diversity of genres and the lack of formalism are more characteristic of television than cinema. This section looks at the games that engage us on a personal level, paving the way for interactive entertainment that appeals to the whole family within the "ten foot experience" of the living room.

Domestic disturbance: Ghost Master from Sick Puppies.

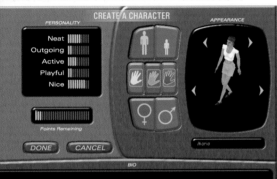

The unmistakable look of Will Wright's seminal game The Sims, developed by Maxis for Electronic Arts.

"The cinema seems to have been invented to express the life of the subconscious," said Luis Buñuel, adding that the act of watching a film was a "nocturnal voyage into the unconscious."

Certainly, in the act of watching a movie, the conscious mind takes a back seat. This is true of most movies today. Even comedies are staged at a distance—we are not expected to deconstruct what we are watching or enjoy it as artifice. Cinema, now a formalized art form, wants our respect. The New York film critic, Pauline Kael, wrote that this was not true of silent comedies, "which, when they were good, kept the audience in a heightened state of consciousness. When we join in laughter, it's as if the lights were on in the theater."

That was before television, which has taken over as the popular, "low" form—Kabuki to cinema's Noh. When we watch a television show, we're happy to pick it apart. We acknowledge the fiction, we talk about what the writers are trying to do and who that actress was dating last week, and why this evening's show isn't as funny as that classic episode in the first series.

This is not only because we are usually watching television as part of a group of people who wish to hear our views (unlike at a movie, American cinemagoers please note!). Nor is only because the lights are on, as Pauline Kael put it. It is because television on the whole presents itself plainly and invites us to respond to it with a robust, enthusiastic, and intimate relationship. Television doesn't care about our respect.

Computer games are in a curious gray area. Superficially, they invite comparison with movies, if only because that's where game designers draw their visual inspiration. And yet they are usually enjoyed not as a special occasion, but by the groundlings in front of the TV set who are far from the passive, channeling, hypnotized, liminal dreamers who constitute a movie audience.

Games, like television shows, don't on the whole take themselves too seriously. This may be why some games are beginning to recognize that their true spiritual home is not cinema, but TV.

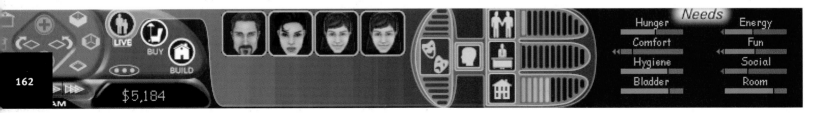

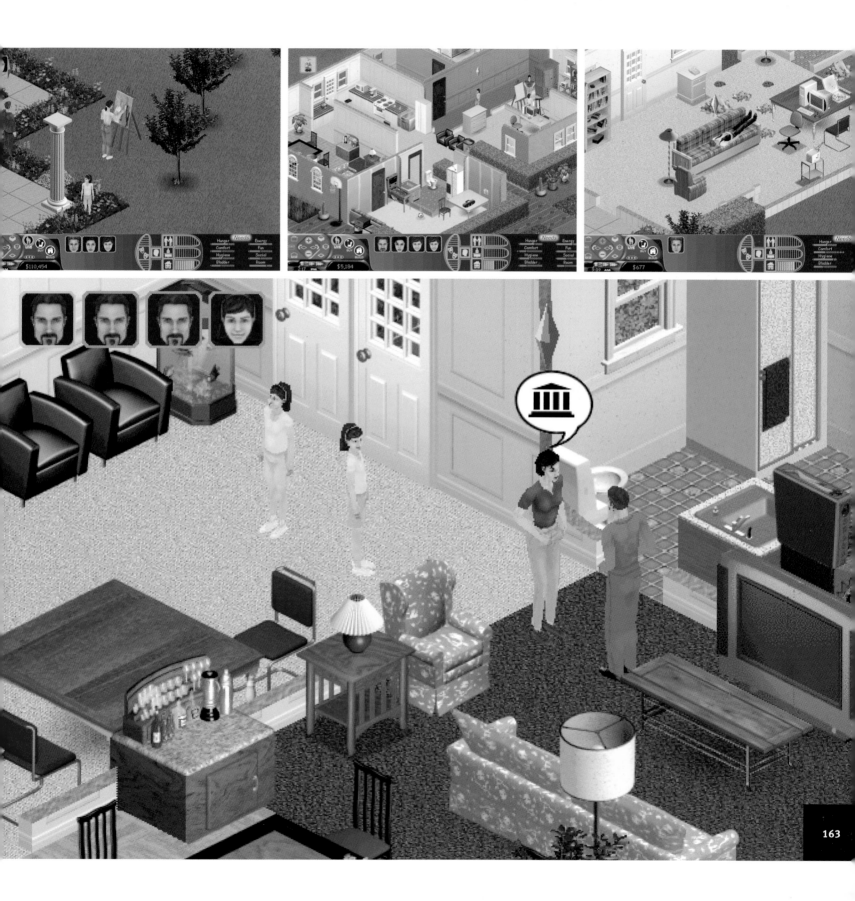

What characterizes the 'TV' style of game? Looking at something like *The Sims*, we may start by saying that it is enjoyed by casual gamers. But even this analysis is misleading. It assumes that people can be categorized as types of game player. However, the inversion of that analysis is equally valid in depicting gamers as participatory viewers.

If you look at a group of young children playing a game like *Barbie Race & Ride*, you will see that they respond to it not as a competition or set of rules for interaction so much as an entertainment 'hearth'. The game becomes a catalyst for conversation and a focus for imagination. The children will undertake activities and competitions within the frame of the game, but as often for the sake of exploration as for the intrinsic experience of gameplay. Playing *Barbie Race & Ride* is like a pony trek through a richly involving landscape. It's not dissimilar to the way that getting together to watch a soap opera or sitcom can serve as a bonding ritual and discussion point among friends.

Crucially, TV-style games can be enjoyed by spectators as well as the people playing. Watching *Quake* over someone's shoulder is about

as enjoyable as putting your head in a spin dryer. You can however call out suggestions for things to do in *The Sims*—or indeed just sit back and watch what happens.

From an artistic standpoint, the main effect of gaming moving into the television space is the declining influence of comic book graphical themes. We use the term 'comic book' here, incidentally, as William Goldman uses it in *Adventures in the Screen Trade* in relation to movies—i.e. not in any pejorative sense, but to signify material that is constructed for a narrow, deep audience. Comic books contain many great examples of modern art and storytelling. Televisual styles avoid cluttering detail and obfuscating cinematic darkness in favor of the bold, simple graphics and clean lighting that we see in, say, *Ghost Master*. Similarly, the characters in this new generation of games tend to be either minimally styled (the artfully but subtly designed characters of *The Sims*), or family-friendly cute (*Parappa the Rapper, Space Channel 5*). Guns, aliens and leather-sheathed breasts are, for once, not in evidence.

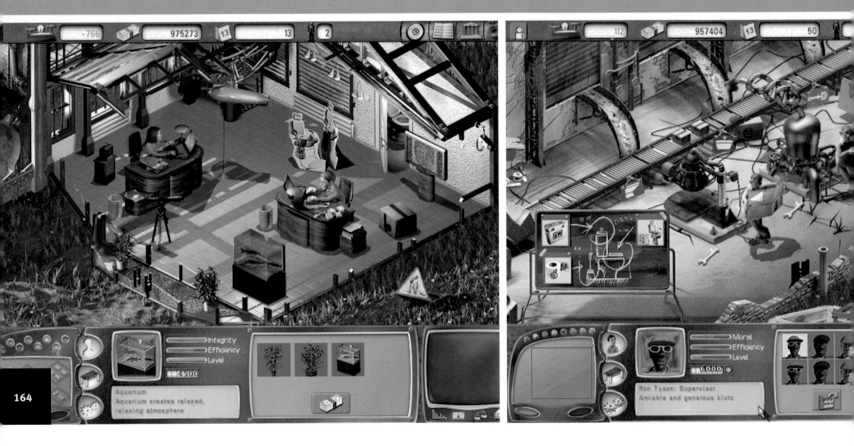

Below: *A whole virtual neighborhood in Nintendo's Animal Crossing.*
Below left: *Monte Cristo's Crazy Factory.*

165

WHO YA GONNA CALL?

Plasm: 148

Ghost Master represents a new kind of game. In most games, the act of playing carries the player through a script created by the designer. This script can be very tightly defined, as in an adventure game like *Max Payne*. There, the player has only limited freedom of control—the choice of weapon, exactly where in the room to shoot the bad guys, or whether to instead blow them up with grenades. The story is not affected by the player's decisions, and puzzles are constrained to a single solution. A strategy or sports game might appear to have a greater degree of freedom, but in most cases the arc of the activity is heavily defined by the rule set. There are several ways to achieve victory in *Age of Kings*, but few opportunities for real emergence.

In *Ghost Master* there are puzzles to be solved, but the gameplay is not a question of figuring out the solution that the designer had in mind. You might need to open a door. One option is to find the key. Another is to get someone to hack the door down. Or you might start a fire to burn the door. Or maybe you could figure out another way to reach your objective without needing to go through the door at all...

Ghost Master is a game in which you don't have complete control. Whereas in a game like *Monsters Inc.* you get to steer the characters around, in *Ghost Master* you have to convince them to do what you want. You do this by scaring them, though the point isn't to amass 'scare points'. Scaring just happens to be what ghosts do. You are in charge of a bunch of ghosts and you have to work within their limitations to induce the protagonists (the living characters) to do what you want.

This deceptively simple game mechanic puts *Ghost Master* in the lead as one of the most interesting developments in the medium since a pixel first glimmered into being on a computer screen. Paradoxically, restricting the players' ability to control events actually gives them a far greater degree of freedom. The game now becomes whatever the player wants to make of it, and there is even the possibility of discovering solutions that the game's designers never thought of.

Perhaps even more importantly, *Ghost Master* takes the reality TV style of *The Sims,* but makes it far more intimate for the players. The characters in *The Sims* are like our pets. We don't feel too much for them—it's like being a ten-year-old boy with a bunch of bugs in a jar. If they all burn to death in their beds then we're a bit sad, but we can always spawn some more. Sims live their lives under our microscope.

What makes *Ghost Master* different is that the medium of interaction is personified. Instead of plonking down furniture and buildings using icons picked from the interface, we are right there in the midst of the action telling our ghosts how to get a reaction from the human characters. This gives the player a place to be within the story. Our make-believe is that we are the ghost master, which lets us believe in the characters and their predicaments. And it also means that we can sit back and watch with our friends, enjoying the experience whether or not we're the one with our hands on the controller.

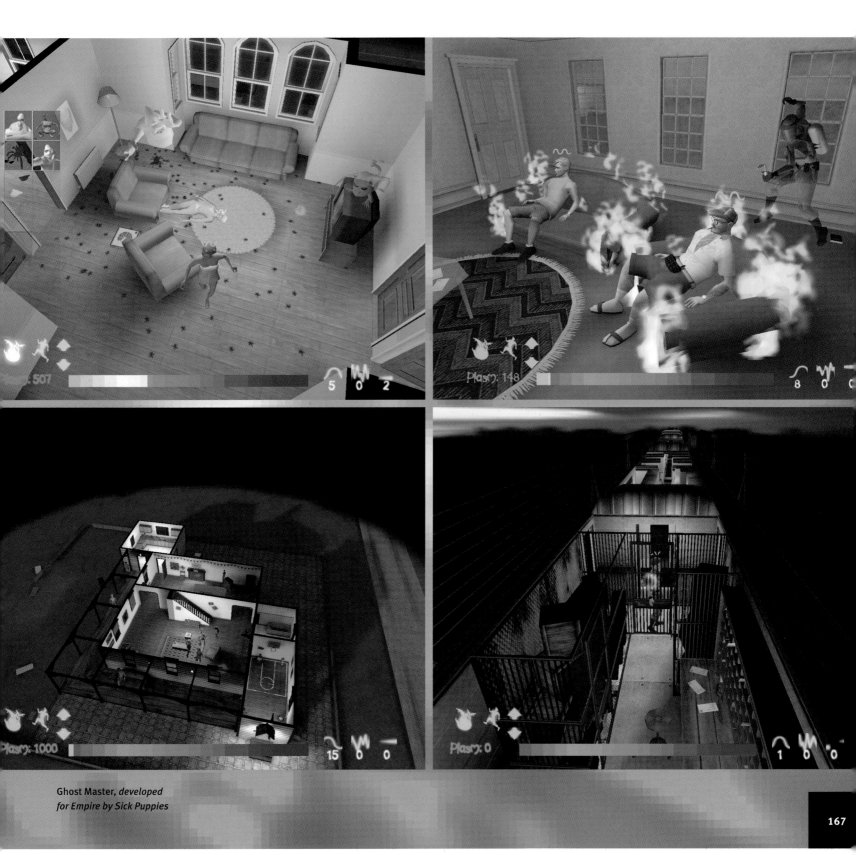

Ghost Master, *developed
for Empire by Sick Puppies*

INSIDER SECRETS: CREATING ARCHITECTURE

Left: *Paris in wireframe — a production shot from Davilex's* Paris Marseille Racer 2.

Right: *Recreating Colditz for* Prisoner of War, *by Wide Games.*

Tim Fawcett, Senior Graphic Artist at Wide Games, describes the quest for architectural authenticity in *Prisoner of War:*
"In order to design the Colditz Castle level, we went to Colditz and took hundreds of photos. The entire castle was modeled to scale, then rescaled and chopped around several times. The aim was to create an effective game arena, while at the same time maintaining as much authenticity as possible.

"Elements of the castle were then separated into bite-sized chunks for ease of authoring, the stone arch to the chapel [shown here]. Architectural features such as the stone archway and the bell tower add elements of interest to what is otherwise a fairly bland environment.

"We used artistic licence by whitewashing various walls to add variety and tonal rhythm to the courtyards. The walls shared a small number of primary base textures that work from a greater distance, while a tiled detail map was applied to give a rough, gritty feel close up with a couple of mip-map levels that fade out beyond a set distance.

"In reality, the courtyards of Colditz are smaller than those used in the game. The whole castle was in fact scaled up by 50% to facilitate game play. Doorways, windows, and corridors had to be widened to allow for the movement of the computer characters.

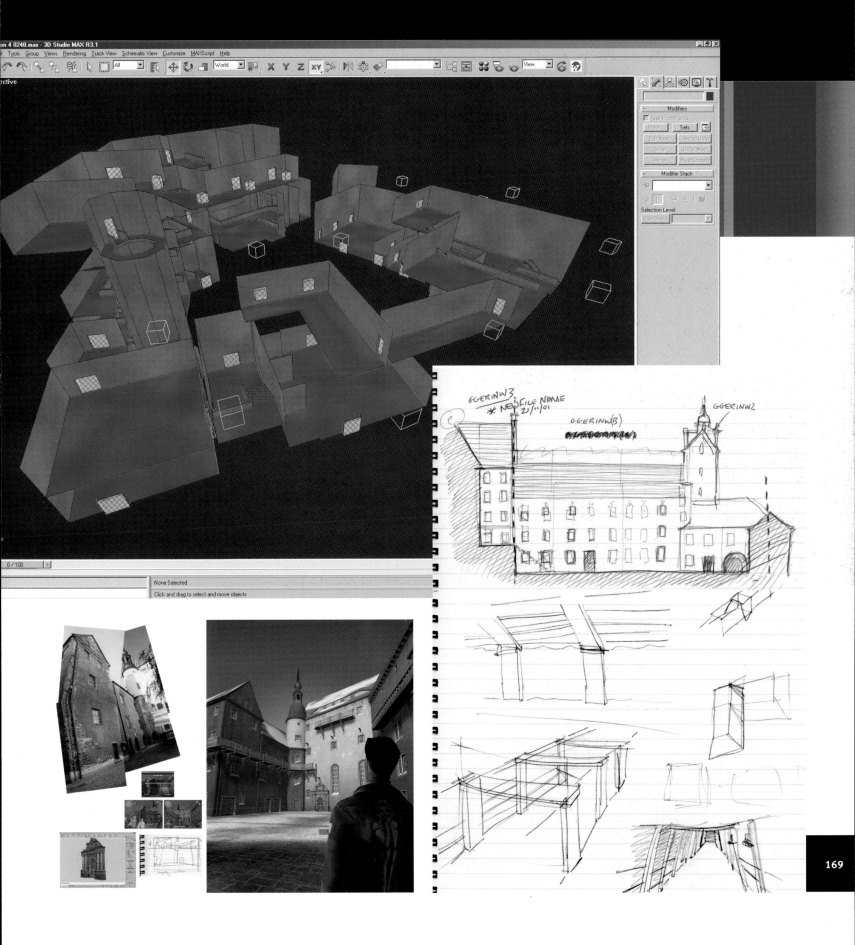

169

Above: *Eerie architecture from* Ghost Master *by Sick Puppies.*
Below:*The protagonist's house from Lionhead's ground-breaking project,* Dimitri.

"Rooftop walkways were constructed where there were none in reality, again to widen the player's range of options. There were in fact some high wooden platforms that were fitted to the castle during the war. These were incredibly useful as we could place them anywhere—within artistic licence—to enhance the gameplay.

"The elevation sketch of the German courtyard [*see page 169*] shows some of the height differences across various building sections. In reality, this courtyard slopes down from left to right, so we had to do some leveling out to allow the free movement of the characters. All floor and ceiling heights were precisely calculated so that steps and staircases would connect without problem.

"In this concept sketch [*page 169*] of a tunnel you can see how the bowing of the ceiling joists gives the impression of depth and weight of the soil. The screenshot showing the final effect does indeed have a certain cramped and claustrophobic feel."

Right: *Distinctively London streets created by Davilex for the game* London Racer 2.

QUO VADIS?

Where next for game art? The crossroads of opportunity presents developers with a choice. One direction leads toward realism, or at least toward intricate detail and verisimilitude. This is the trend that will create fully immersive virtual worlds. A clear alternative is to eschew detail in favor of abstraction and stylistic flourishes designed to evoke an alternative response—not the simulated versions of reality that invite the conscious mind to a game of "let's pretend," but an outright substitute for realism that may find anchor instead in the imaginative subconscious.

Behold the man—from Lionhead's BC.

Main picture: Black & White: *The landscapes were all created within custom tools written specifically for the game.*

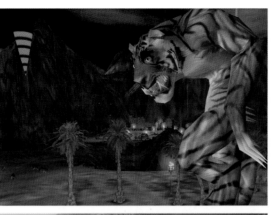

Top right: Black & White: *The graphics and animation elements of the creatures were brought together in the in-game "creature editor." Here the evil tiger tests his look-point animations. Note the black and red cone in the foreground; this represents his current viewpoint.*

Right: *From Intrepid's BC. Caustic effects simulate the sun's rays refracting through the water surface. As the diver swims below the coral banks, the waters darken. A raptor recoils as the player strikes the creature about the head. Many animations in BC are blended sequentially to provide reactive, realistic and organic movement.*

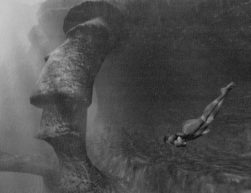

Below right: *Here we see the full interior of the diner from Dimitri. "Graphics requirements must be planned years ahead when working on such a big project," says Head of Art, Paul McLaughlin. "We're working on scenes that run incredibly slowly on current machines."*

Far right: *Experimentation with various rendering methods is one of the exciting opportunities open during the early stages of development. This effect is designed to lend a 1940s feel to the Dimitri diner set.*

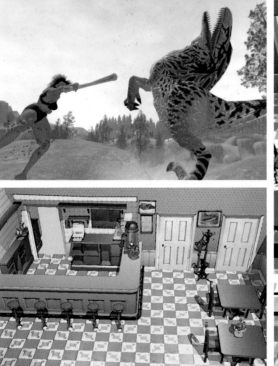

Outside of Japan, there is probably no game designer as consistently original as Peter Molyneux. After a string of inventive and highly successful games at Bullfrog, the company he cofounded to release *Populous*, he set up Lionhead Studios and established a satellite scheme in which other teams could be nurtured within a creative network.

Lionhead's first title, *Black & White*, is discussed in Section Three. This game won two BAFTA awards in 2001.

Dimitri (a working title) is an ambitious project in development at Lionhead Studios that extends beyond the accepted definitions of the "computer game." Set in an immersive and familiar environment, it ignores all the clichés and focuses on empathy, emotion, and social interaction between humans.

Among the sources used in designing *Dimitri*, Lionhead's art team has looked at the paintings of 20th-century American artist Edward Hopper. This may signal a move among game artists generally to turn to broader influences from the whole art world.

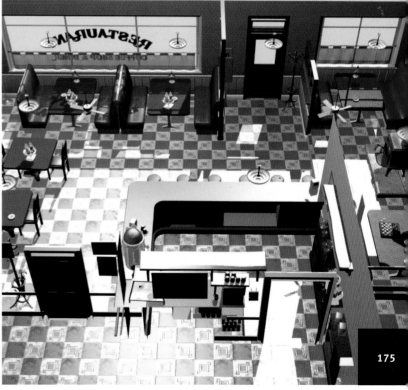

Big Blue Box, one of Lionhead's satellites, is developing *Fable*, an interesting new step in the role-playing and adventure genres. Players guide the hero through his entire adventuring career, the idea being that the hero's physical appearance becomes a record of what he's done. Battles take their toll in scars, and boozy nights in the form of a beer belly. Physical exertion in the outdoors will give you muscles and a tan, while late nights over the spell books will leave you with the gaunt look of an authentic wizard.

Since not only your character's appearance but also the world around you will change in response to your actions, *Fable* is one of the first examples of a game whose look is determined by the individual player.

BC, from Intrepid Games, is a recreation of the kind of mythical prehistory where Racquel Welch in a fur bikini shares the Earth with Harryhausen saurians biting great gory chunks out of each other.

Above left: Dimitri *is a game about emotion, making it essential that characters are individual and are capable of the full range of human expression.*

Above: *"We really wanted to maintain the authenticity of post-WW2 America," says Andy Bass, Lionhead's 3D architect on Dimitri. "There's such a rich vein of design and visuals from that time and everyone's so familiar with it. It just has to be done right!"*

Above and right: *The ultimate in immersive adventure—a selection of striking shots from Big Blue Box's game,* Fable.

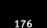

THE FUTURE OF GAME ART

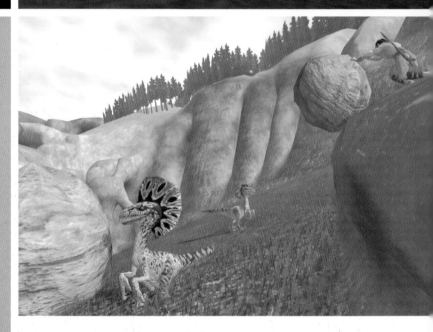

André van Rooijen, Art Director at Davilex Games, comments:

"I see several ways in which game art will develop over the next few years. First there is the hardware factor. The graphic power of PCs and consoles will keep on growing rapidly so there's no way to tell how many polygons we will be able to render in five years' time. I also believe that we will use those polygons until there's almost no difference between the rendered world and the real one.

"By the time we get to that stage, the question will become how useful it is to recreate the real world. It is similar to the question asked among painters when photography was invented. You can create an exact copy of reality—but why bother? Why don't we use all that processing power instead to create worlds and experiences that no one has ever seen before? For painting, this was the dawn of abstract art. What will it be for game art? Maybe we'll see the creation of some sort of subgenre between art and entertainment. The results will be interesting.

"The games industry, on the other hand, will always look for the big market and use the technological advances to create more beautiful and immersing worlds with more lifelike characters to interact with. Certainly game graphics will become much more detailed than they are now with all kinds of multilayered textures and sophisticated real-time lighting.

"Worlds will become very large. Already complete cities are built, so it's only a matter of time before a whole country will serve as your playground. Many things in these worlds that are now static, like grass or leaves on a tree, will become animated features, making the worlds more alive.

"The really interesting question is which studios will be able to afford all the artists needed to create such worlds. A small, independent studio just doesn't have the manpower to realize such an environment. It could be like Hollywood, where only the big studios can afford to make a blockbuster."

**"For good or bad, further convergence with cinema is inevitable,"
says Tancred Dyke-Wells, Lead Artist at Kuju Entertainment:**

"The *Reign of Fire* game was advertised along the bottom of the movie poster. A game/ movie DVD bundle will go on sale and the consumer will be able to watch the movie or play the game on the same console. George Lucas is clearly starting to put scenes into the *Star Wars* films

Above left: *Adrenium's* Azurik: Rise of Perathia.
Left: *"The artificial intelligence that drives the raptors is adaptive and will modify the behavior of creatures in packs so that group tactics are used, presenting a greater challenge for the player."—Joe Rider, Intrepid Games*

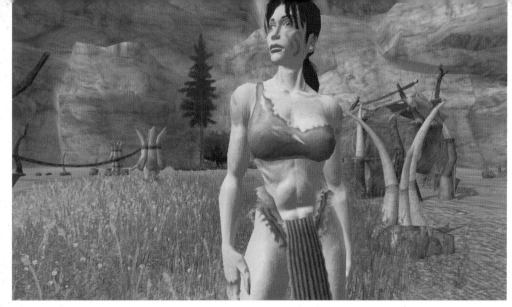

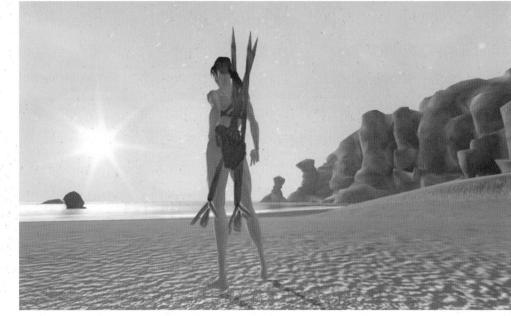

Above right: *One million years* BC.

Right: *"The surf and the specular highlights on the water surface are generated by successive layers of animated texture maps. As the sun sets, the shadows lengthen and the bump mapping on the ground is accentuated because the angle of incidence between the light source and the horizon is reduced."* —Joe Rider of Intrepid Games

Left: *Also sprach Haegemonia.*

with videogame sequences in mind. *Spider-Man* and *Lord of the Rings* are franchises in which the movie and the game are both parts of the whole package.

"The downside is publishers' increasing lack of faith in the ability of game developers to generate original concepts. The subsequent prospect of whipping boy status with respect to the TV and movie industries should be a warning for the industry to break out of their sci-fi/ Dungeons & Dragons ghetto. Of course, it runs the other way too. *Resident Evil* and *Tomb Raider* have been filmed and there are plenty of other games waiting in the wings to make the transition to the big screen. It's just that they tend to be dreadful.

"The main development, which will signal a big leap in game art quality, is proper specialization - the emergence of permanent cross-project departments devoted to special effects,

vehicle and character design, terrain and scenery, and so on. These will arise within bigger, consolidated developers and as specialized outsource companies. This is happening already to an extent, but it's been held up because the typical method of game production is much more jumbled. The shift toward specialization is a shame, because a big part of the appeal of working in games has been the opportunity to be a jack-of-all trades and mess around in all these areas. But ultimately the only way to improve quality is to build on and concentrate specialized experience."

INSIDER SECRETS: CREATING DETAIL

"Coherency, structure, and detail are the key things," believes André van Rooijen of Davilex Games. "A level might have a set of rules or an esthetic that is completely out of this world, but as long as the world is coherent, the player will accept it:

"Structure is important both visually and for the layout of a game level. It adds logic to a level, which is very important for a player because it's easier to accept something when you understand its logic. Nothing is more pleasing than when you try something out based on your previous experiences, and find that it actually works.

"I tell artists to study the way a building, for instance, is constructed before they start modeling one. Players can instantly see when windows are too close to each other. The same thing applies to the way a city or a piece of outdoor scenery is constructed. It has everything to do with scale, proportions, and rhythm, and it is as important as color and light for the realism and believability of your world, no matter how outrageous your theme might be.

Below: *Thousands of objects are being modeled in meticulous detail to recreate the world of 1940s America for Lionhead's Dimitri.*

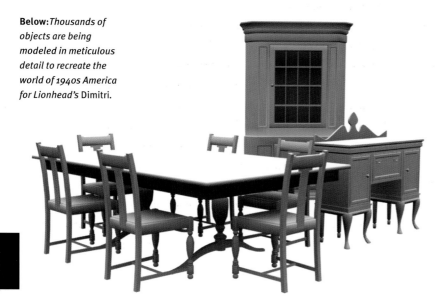

"Detail is what makes your world come to life. It gives the player the notion that there is a world beyond the one he sees at a first glance. These layers of visual information are what make it worthwhile to explore a world. It adds depth to your scenery."

Modern graphics technology continues to improve at a rapid pace, making realism an achievable goal. But creating a realistic world entails a lot of work. The choice now becomes whether to include high levels of detail. If a player is exploring a convincing city and can go down an alleyway, he or she will reasonably expect to find strewn bits of newspaper underfoot and graffiti on the brickwork. What about the headline on the newspaper? What about the classifieds? Are your artists going to create a dozen different graffiti styles to reflect the street gangs of the city?

Procedural methods can help cope with the problem. Procedural modeling uses basic rules for creating a tree, say, and applies those rules to spawn hundreds of different trees. Procedural texturing can be used for fractally repeating patterns—the fabric on sofas, the fine detail of brickwork, the pollen dusted on a flower petal, and so on.

Unfortunately, procedural techniques cannot help in creating the unique artistic elements of an environment. Might these be bought in from a "virtual set designer," the way props were reused in the old Hollywood costume dramas and westerns? That is one option, but only if you don't mind the bar taps and wagons and Winchesters in your cowboy game looking exactly like the ones in that other game from your competitor.

Mainstream animation faces a similar problem. One solution is to outsource much of the hard work to art factories in parts of the world where labor is cheaper. In China, Africa, India, Eastern Europe, and South America, there are production studios with over a thousand artists apiece. However, using this method requires a high degree of upfront planning and an administrative infrastructure that has taken years for the animation industry to develop.

Stylization provides a way around the horns of the dilemma. Instead of attempting to faithfully recreate every detail of our world, the stylized game defines its own esthetic rules. Even so, the eye expects detail and the player of a game has more leisure to look around for details than the viewer of a TV show or a movie.

"The increasing amount of detail that is now possible and often expected is quite scary," says Paul McLaughlin, Head of Art at Lionhead Studios. "We could easily put a team of hundreds of people on a game and have them being genuinely productive for two or three years, but that's not the way we like to work. One of the reasons we're at Lionhead is because it's a tight, talented team. It operates at the level of individuals rather than a herd.

"Many producers and production managers love the idea of using off-the-shelf modules to cut down on the time it takes to develop a title. I think it's fair to say that the attitude doesn't transfer to development staff, though. We all know that books use essentially the same words just rearranged a little, but games and other visual media can't work like that. Most libraries of objects, for instance, consist of items that either have been constructed for a specific purpose or are so general as to be useless. If I want to create and furnish a 1920s French villa, where am I going to find a suitable library?

Above: *The stonemasons who built the colleges of Oxford discovered centuries ago that work progressed more efficiently when each artist was given some creative freedom. One architect estimated that masons who were allowed to improvise their own fine detail design within the overall structure worked 30% quicker than masons who had to follow elaborate directions about even the smallest detail. The principle still holds for modern games companies like Davilex. These billboards were designed and created by the level artists on* Knight Rider. *Even though it's primarily a driving game, such variety and detail adds immeasurably to the gaming experience.*

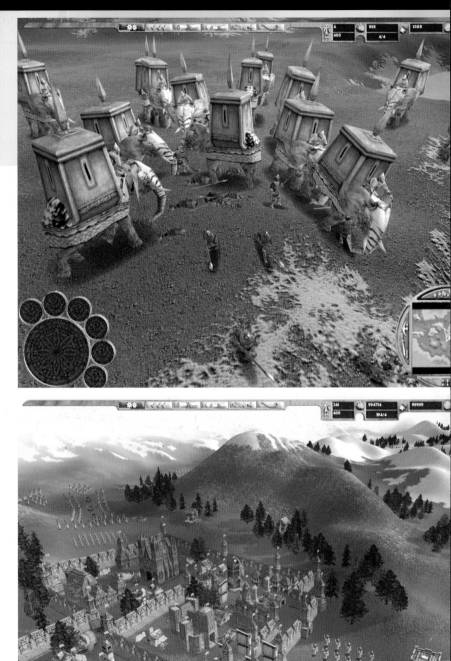

"The only way is to create what's required is to do it ourselves. That way we can be sure it is in the required style, it will have the required number of polygons, it will be textured in a way that suits the game, and the physics and other technical requirements will be tailored to the game engine that we're creating. Even if I could find ten percent of the required resources in a library, I wouldn't use them as they'd impose so many stylistic restrictions on the bespoke objects that the trade-off simply wouldn't be worth it.

"Outsourcing is in theory a good solution to the content production problem. We would need to find a suitable team, brief them well, and manage the pipeline, but it's a promising area to investigate. It means our core team is unaffected and we don't have a lot of people scratching their heads, wondering what to do when the project ends. The problem is finding a reliable and talented team that you can entrust the work to.

Left and right: *An eye for fine detail characterizes the games of RTS developer Black Cactus,* as evidenced by these *graphics from* Warrior Kings Battles.

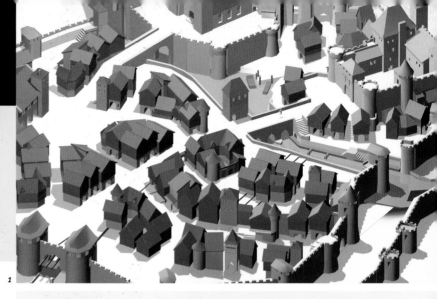

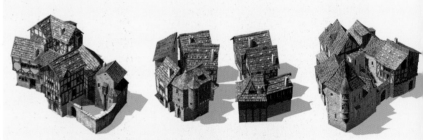

"Much of the artistic value of games lies in interactively experiencing an environment that has sprung from the minds of artists and world builders. Another alternative to the increased requirement for content production is to move sideways a little and avoid the problem creatively. At Lionhead, we're currently exploring uses for increased hardware performance and storage capacity other than just adding more "stuff." There are lots of stylish ways to soak up processor power: post-production filters, depth of field, motion blurring, radiosity lighting, and so on. All these add materially to the gaming experience, but the development hit is a relatively small coding one rather than a large art/craft one. The effects would still be overseen by the art director, though, as all of this has to add something more than just technical wizardry."

1. The city of York from Spellbound's Robin Hood. First, the maps are built roughly in a 3D modeling and rendering program to create a 3D sketch. This allows testing for the best placement and orientation of each building and landform according to game play and the mission goals.

2. Next they are sketched by hand, then modeled and textured in 3D.

3. As the last stage in the 3D process they are rendered with default cameras and lights to create 2D bitmaps. It's as though the computer takes a photograph. The buildings, objects, and shadows created in the 3D process are then cut out using a mask called an alpha channel and placed on layers in the 2D painting program, Photoshop.

4. Two weeks of touch-up are done to bring the picture to completion.

5. Many final details are added such as patina, foliage, river depth, and, of course, the detritus of everyday life.

6. Different versions of the map are painted to reflect day, night, the seasons, and weather such as snow, ice, and mist.

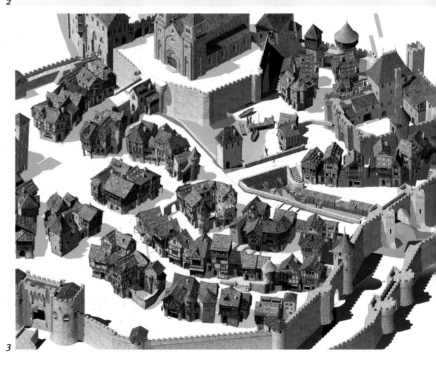

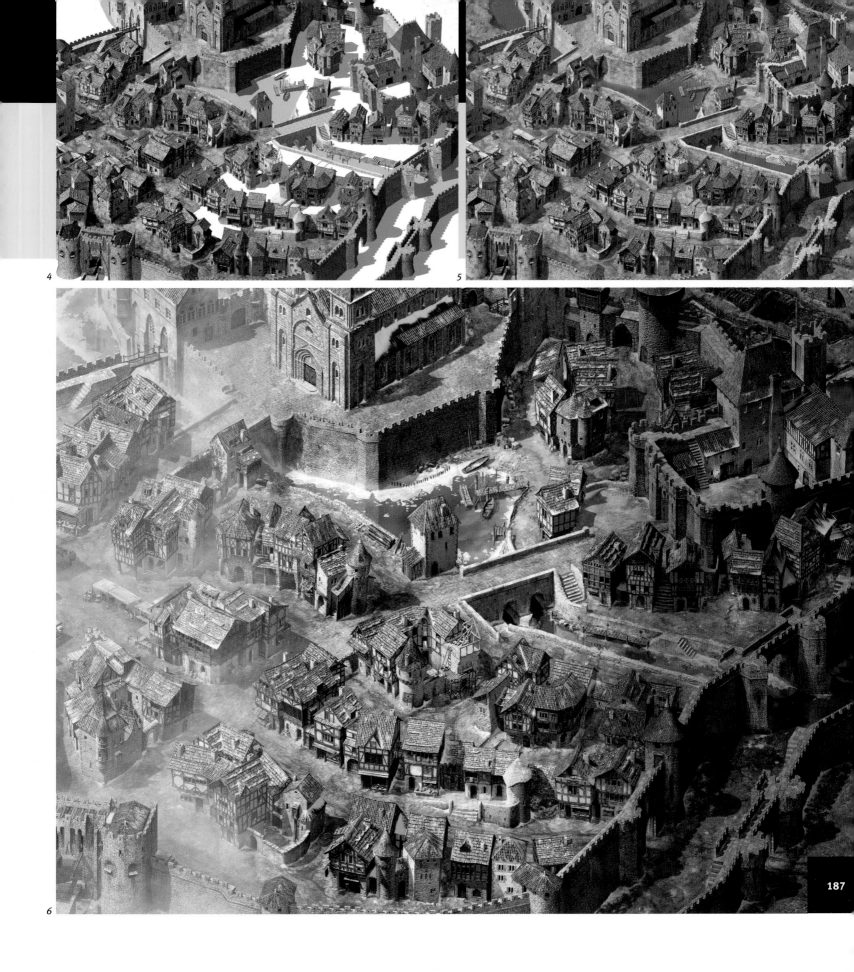

REFERENCE

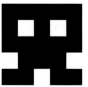

190

GLOSSARY

Bitmap
A method used by computers to store graphics. Images are treated as a grid with color information held in each cell. In the early days of computer games, all graphics consisted of bitmap 'sprites' for the characters and bitmap backgrounds. Bitmaps still have a place in today's 3D graphics, where they are used as texture maps for 3D objects.

Camera
In the context of 3D computer games, the player's point of view of the virtual 3D environment.

Cel shading
A type of 3D rendering that gives the image a stylised, cartoon-like appearance, as seen in games such as *Jet Set Radio Future*.

CGI (*Computer Generated Imagery*)
While this can refer to any computer generated image, it usually refers to pre-rendered 3D stills or animation sequences, such as a cut-scene.

Cut-scene
A non-interactive scene inserted between the levels of a game to advance the story.

Development team
The group of designers, artists, and programmers involved in the hands-on production of a game. Development teams usually work for a publisher who will handle the final distribution and marketing.

Engine
A computer program that performs a set of routine tasks. For example, a physics engines models the mass, velocity, and other physical attributes of objects, while a graphics engines renders images on screen.

First person shooter
A popular form of 3D action game, typified by titles such as *Doom*, *Halo*, and *Time Splitters*, where the player fights through complex 3D levels from a first-person point of view.

FMV (*Full-motion video*)
A non-interactive video sequence used for a cut-scene. While these are usually CGI animations, they can also be live action or even a mixture of the two.

Middleware
A specialist form of software, which may include technical tools, 3D graphics engines, physics engines, and/or sound engines, sold to development teams to provide the backbone of a game and free up resources for more creative tasks.

Model
A digital representation of a person, creature, building, or any other object in 3D space.

Motion capture
A technique used to record a person's movements precisely in three dimensions so that the data can be used to animate a 3D character model.

Multiplayer
A term used to designate games that are designed or provide support for more than one player. An increasing number of games are now created with Multiplayer use as the prime objective.

Platform game
One of the oldest game formats, the platform game has the player in control of a character who has to climb and leap around a dangerous environment in pursuit of certain objectives. Originally 2D, the platform game moved to 3D with the launch

of Nintendo's *Super Mario 64* and the original *Tomb Raider*.

Polygons
3D objects consist of hundreds or thousands of polygons (usually triangles) joined together into a 3D model.

Pre-rendered
CGI images or animations that are calculated from 3D data and stored as complete frames or animations ready for use in a cut-scene or film.

Realtime
Graphics that are rendered as required, as opposed to being pre-rendered. In-game graphics are usually realtime, as they need to change rapidly to reflect the actions of the player. By conteast, while cut-scenes can be produced in realtime they are more often pre-rendered.

RTS (*Real Time Strategy*)
The dominant variant of the basic strategy game. Older strategy games and wargames had players and a computer player taking turns to move units or build facilities, but in real time strategy it all happens at once, in real time.

Rendering
The process by which images are taken from the 3D virtual environment and presented to the viewer. Rendering can be realtime or pre-rendered.

RPG (*Role-Playing Game*)
A type of game that takes its name from the old *Dungeons and Dragons* style of tabletop game. Players take on the role of a character or group of characters in a large game world, taking on quests, attacking monsters and gathering treasure and experience.

These games traditionally have a fantasy or science-fiction setting.

Rotoscoping
A technique of creating animation by tracing over live action photographs.

Simulation
A game that recreates a particular activity with the emphasis on giving an impression of realism. Driving games and flight simulators are perfect examples, but simulations can also cover more fantastic subjects, such as space combat. The approach matters more than the subject matter.

Texture map
A bitmap image that is wrapped around a 3D object to give it the appeearance of having a material or texture, or add surface detail.

Vector graphics
A method of storing and displaying graphics within a computer. All the computer needs to store are single points in a mathematical space, joining them with lines to create 3D images.

Virtual
In computing, something which doesn't physically exist but which is made by software to appear so. In games, the term is used to refer to any artificial construct in the computer, such as the virtual environment the protagonist wanders around in.

Wireframe
A 3D model consists of hundreds or thousands of polygons connected together into a mesh. When no texture or surface has been applied, it is referred to as a wireframe. Early 3D graphics, as in *Battlezone* or the *Star Wars* arcade game, consisted entirely of basic wireframes.

ACKNOWLEDGMENTS

Thanks are easy. Everyone starts with thanks. Let's start with apologies.

Apologies first to all the people whose work we didn't feature. You might think there are some pretty glaring omissions, but the fact is that Game Art was never intended to be a comprehensive look at the whole history of games. A whole art gallery couldn't go far towards achieving that, never mind one book. So we decided from the start that we would just have to grit our teeth and leave a lot of games out. Even great classics. It's no reflection on those works, just the inescapable restrictions of time and space.

Apologies too to those who gave us material for the book but it didn't get in. All we can say is that the game development community has been generally so helpful in providing artwork and comments that we've been overwhelmed – emotionally, of course, but most of all physically. We could fill three hard drives with the material we've collected. All of it is great, great stuff. The hardest part has been deciding what to leave out.

And so to thanks. There are too many to list, so let us say thank you to all the kind people in the game industry who have helped us compile this book. Among the multitude we can single out, in no particular order: Alexis Mervin of LucasArts; Stephanie Moses of Electronic Arts; Sam Kerbeck, co-founder and CEO of Turn3D; Christopher Lye and Demelza Fryer-

Saxby of Microsoft; Estelle Faulkner of Ubi Soft; Matt Carter-Johnson, Creative Manager of Eidos; Mark Green and Jason Fitzgerald of Sony; Ian Baverstock and Tancred Dyke-Wells of Kuju Entertainment; Steve Jackson and Paul McLaughlin of Lionhead Studios; Sam Lake of Remedy; Franck Sauer of Appeal; Lance Hoke, Tony Goodman, Greg Street and Brad Crow of Ensemble; Adrian Arnese of Empire; Doug Thompson and Steve Thompson of Gas Powered Games; Bernd Beyreuther of Radon Labs GmbH, Corey Wade of Rockstar Games; Jamie Thomson, Mark Tatham and Charlie Bewsher of Black Cactus Games; André van Rooijen, Angelo Bod and Teun de Haas of Davilex; Carl Jones, Ben Hebb and Tim Fawcett of Wide Games; Hillary L Crowley of Sierra; Mike Sheidow and Mike Hogan of Turbine; Jon Murphy of Konami; David Lau-Kee, Teri Shorricks and Nicola Kirby of Criterion; Chris Gibbs of Attention to Detail; Andreas Speer of Spellbound; Iñigo Vinós of Pyro Studios; Gabor Feher of Digital Reality; Arthur Parsons of Traveller's Tales; Anna Kitaitseva of New Media Generation; Andrew Brazier of Headfirst Productions; John Tyrell of Cake Media; Pete Hines of Bethesda Softworks Marko Laitinen of Housemarque; Christian Johnson, Paul Salmon and Steve Pickford of Zed Two; Cathy Johnson and Jenny Shaheen of Oddworld Inhabitants; Ian Lovett at Big Blue Box; Joe Rider of Intrepid Games; Martin McKenna, and Richard Fletcher. And everyone else who helped out.

Picture Acknowledgments

All images in this book are copyright of the respective developers and/or publishers and are used with their permission. Every effort has been made to track down the copyright holders of images and obtain permission for their use, but in some cases, particularly older games, this has not been possible.

p50 Screenshot and render taken from *AirBlade* on PlayStation®2. Developed by Criterion Games. Published by Sony Computer Entertainment Europe. Copyright © 2001 Sony Computer Entertainment Europe.

p74, 148: *Oddworld: Munch's Oddysey* © 2002 Oddworld Inhabitants, Inc. All Rights Reserved.

p85: *Silent Hill 2* © Konami Corporation 2002

p114-117: *Haegemonia* © 2002-2003 Digital Reality and Wanadoo. All rights reserved.

p126-129: *The Elder Scrolls III: Morrowind*™ © 2002 Bethesda Softworks LLC, a ZeniMax Media company. The Elder Scrolls, Morrowind, Bethesda Softworks, ZeniMax and their respective logos are registered trademarks or trademarks of ZeniMax Media Inc. All Rights Reserved.

p.150-151: *Grim Fandango* © LucasArts Entertainment Company LLC. All rights reserved.